BALENCIAGA AND HIS LEGACY

MYRA WALKER

BALENCIAGA AND HIS LEGACY

HAUTE COUTURE FROM THE TEXAS FASHION COLLECTION

yale university press new haven and london in association with the meadows museum dallas

Balenciaga and His Legacy: Haute Couture from the Texas Fashion Collection
is published to coincide with the exhibition organized by
the Meadows Museum at Southern Methodist University, Dallas Texas,
in association with the Texas Fashion Collection at the University of North Texas.

Meadows Museum, Dallas
4 February–27 May 2006

Major funding for this exhibition at the Meadows Museum is provided by
The Meadows Foundation
with additional support from
Modern Luxury Dallas Magazine, NBC 5, and WRR 101.1 FM

Printed in Italy by Conti Tipocolor

Designed by Paul Sloman

Digital color photography by Michael and Rosalyn Bodycomb, New York © 2005

Library of Congress Cataloging-in-Publication Data

Walker, Myra, 1954–
 Balenciaga and his legacy : haute couture from the Texas Fashion Collection / Myra Walker
 p. cm.
 Includes bibliographical references and index.
 ISBN 0-300-12153-9 (cl : alk. paper)
 1. Balenciaga, Cristobal, 1895–1972–Exhibitions. 2. Fashion design–Spain–History–20th
 century–Exhibitions. 3. Fashion design–France–History–20th century–Exhibitions. I. Title.

TT502.W35 2006
746.9'2092–dc22

 2006010122

FACING PAGE Cristóbal Balenciaga, c.1964. Detail from an evening dress of black silk crepe
with silver embroidery attributed to Rébé. Gift of Claudia de Osborne.

ENDPAPERS Cristóbal Balenciaga, c.1955. Detail from a pillbox hat of purple silk satin
with large bow loops. Gift of Claudia de Osborne.

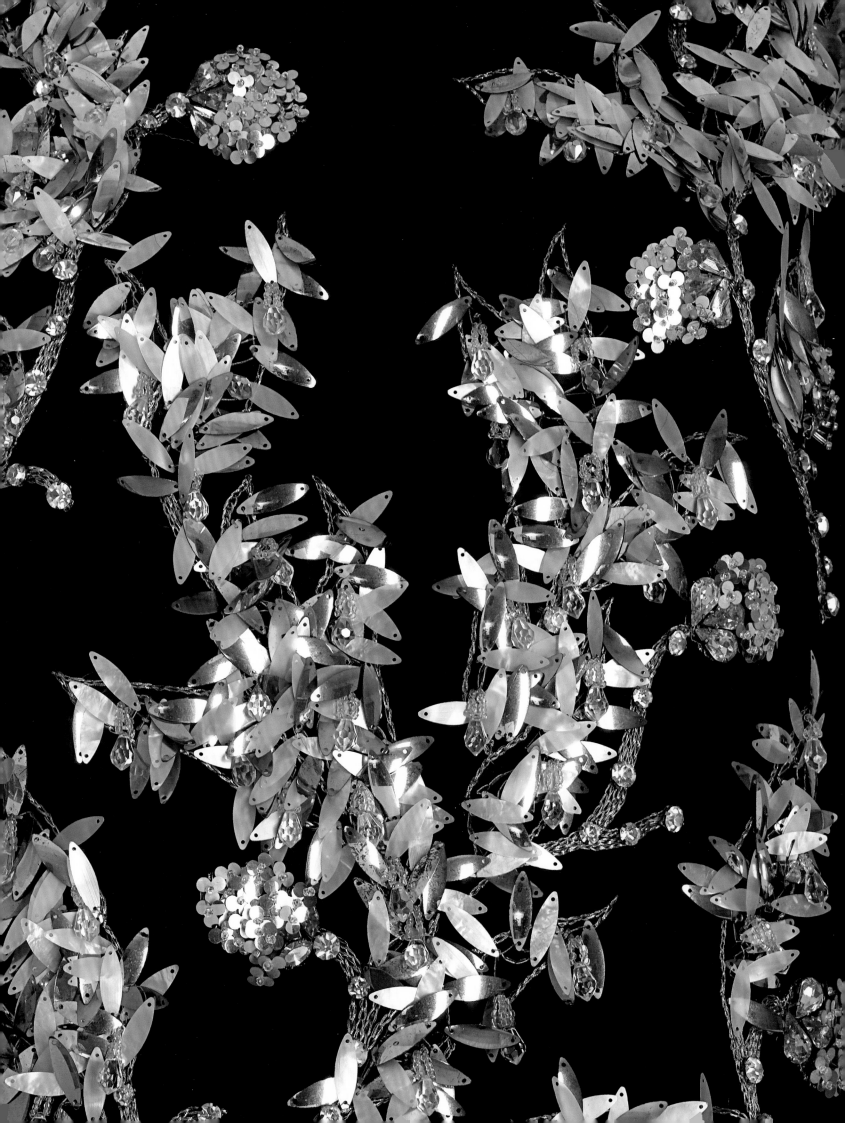

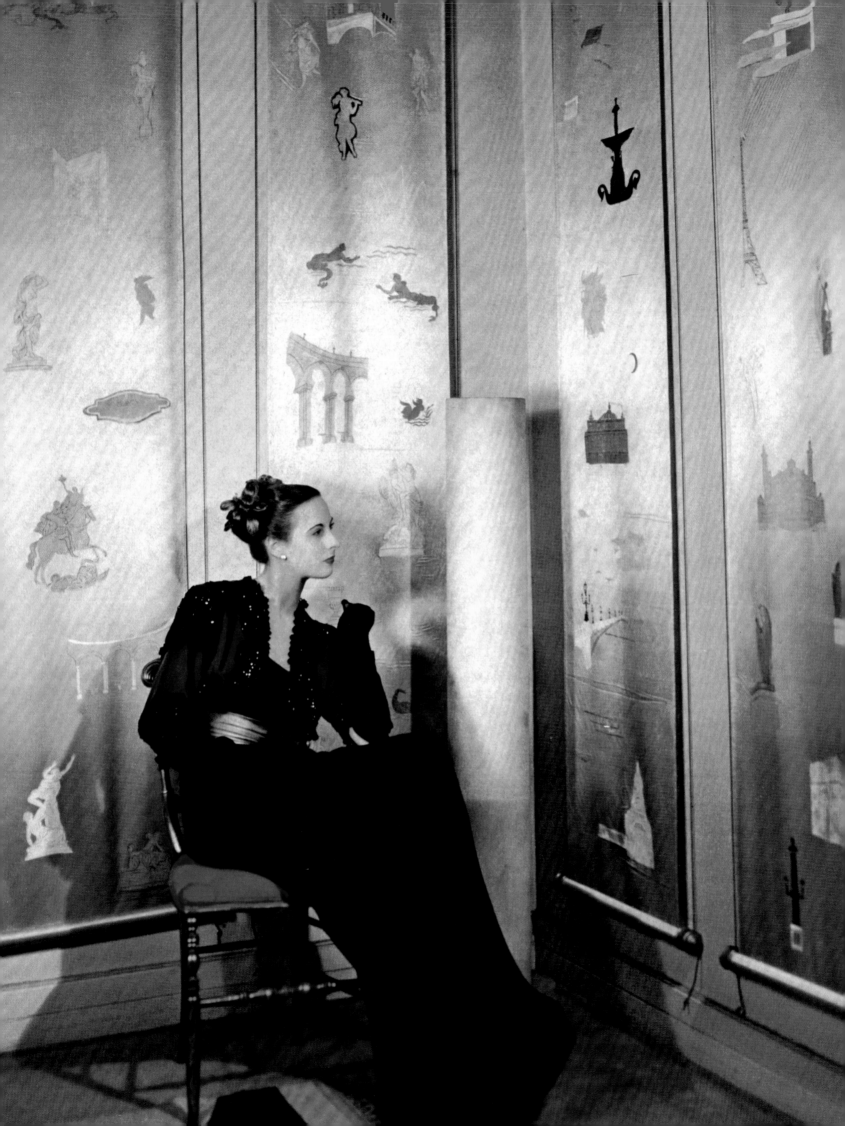

CONTENTS

(facing page)
Photograph by Louise Dahl-Wolfe.
Model for *Harper's Bazaar* wearing
an evening dress by Balenciaga, 1939.
Courtesy of the Museum at the
Fashion Institute of Technology, New York.

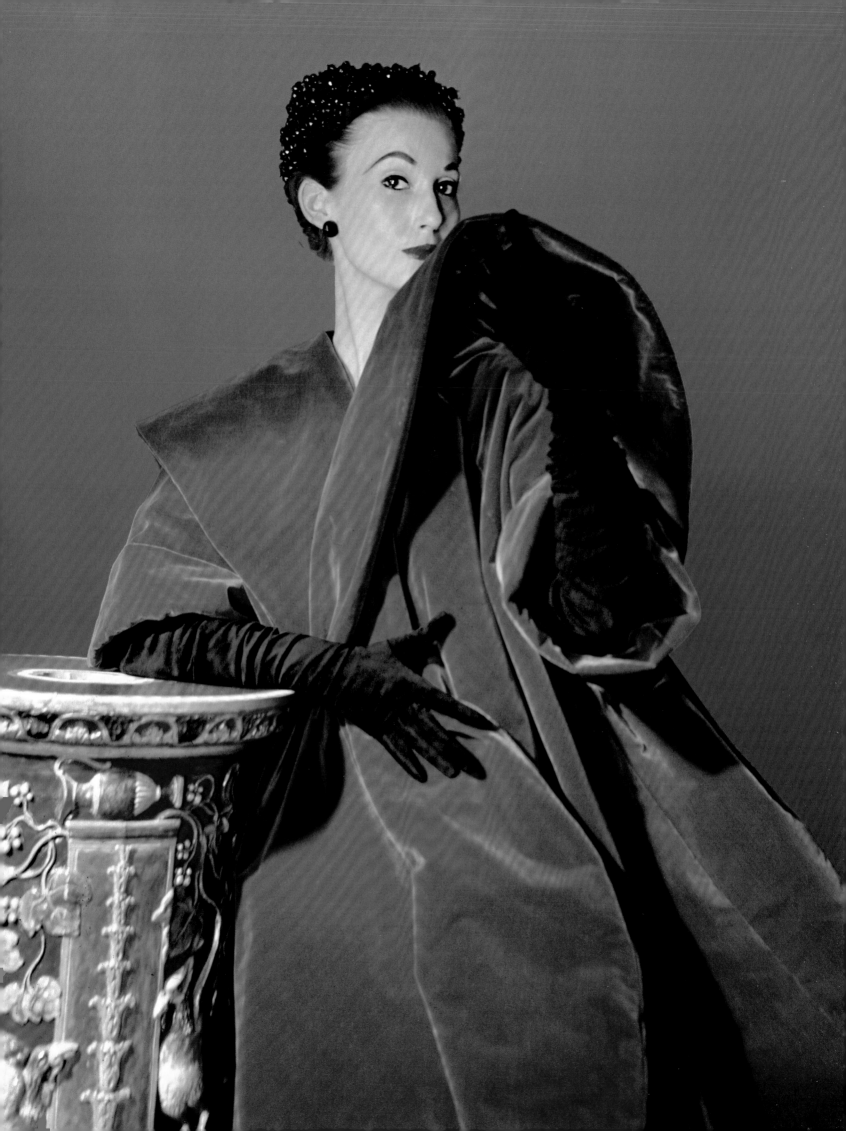

FOREWORD

For me, Director of the Meadows Museum of Southern Methodist University, the presentation of *Balenciaga and His Legacy: Haute Couture from the Texas Fashion Collection* represents a foray into another frontier in the arts, that of the history of fashion and dress. When in 2001 I moved from Madrid to Dallas to work in this distinguished university art museum, just a few months after the grand opening of the new facility, I could never have imagined that one of the greatest Spanish designers of all times, Cristóbal Balenciaga, was so well documented nearby, at the University of North Texas in Denton. Along with the Dean of the Meadows School of the Arts, Dr. Carole Brandt, I toured the Texas Fashion Collection in amazement. Curator Myra Walker showed us numerous Balenciaga creations that day and shared with us her enthusiasm and her desire to mount, in the near future, an exhibition at the Meadows Museum. Five years later, this idea has become a reality.

Cristóbal Balenciaga was one of the most innovative, influential, and yet mysterious figures of twentieth-century haute couture. From modest beginnings in San Sebastián, Spain, Balenciaga rose to become the epitome of success in Paris between 1937 and 1968. He was celebrated for his balanced, understated, and architectural sense of design, and his atelier on the avenue George V became the ultimate destination, with regard to luxury fashions, for a sophisticated and dedicated clientèle which included European aristocrats and Hollywood stars. Many of his haute-couture designs were influenced by distinctly Spanish styles, such as the short jacket inspired by a bullfighter's costume or his use of *madroños*, an ornamental trim of tassels. Balenciaga's shapes and colors often echoed his strong religious and artistic heritage and referenced such works of art as Goya's depiction of *majos* and *majas* in their regional dress or the stoic habits of monks rendered by the seventeenth-century artist Francisco de Zurbarán.

It was a natural collaboration for the Meadows Museum, known for having one of the finest collections of Spanish art outside of Spain, to organize this publication and accompanying exhibition with the School of Visual Arts at the University of North Texas, which houses the Texas Fashion Collection, one of the greatest collections of its kind in America. The extraordinary holdings, both in number and quality, are in great measure due to the generosity of Claudia Heard de Osborne, Bert de Winter, and Mercedes T. Bass, as well as some of the most relevant commercial visionaries, such as Neiman Marcus. The collection's holdings include more than 300 creations by Balenciaga and other important designers, such as Hubert de Givenchy, Oscar de la Renta, Emanuel Ungaro, and Andre Courrèges. As this exhibition celebrates Balenciaga's legacy also, visitors will see how this Spanish designer influenced his peers, both American and European.

The curator of the exhibition, principal author of this publication, and director of the Texas Fashion Collection, Professor Myra Walker, has spent over a decade researching archives in Europe and the United States as well as interviewing some of the individuals who knew and loved Balenciaga. Professor Walker has worked with great passion and spared no efforts in the realization of this exhibition. I am honored also to have worked with the designer of the exhibition, Winn Morton, and with the late Harry Lewis. Together their professional

(facing page)
Photograph by Louise Dahl-Wolfe.
Model for *Harper's Bazaar* wearing
a Balenciaga dress of black taffeta and
coat of purple velvet, November 1951.
Unpublished image from the original contact sheet.
Courtesy of the Museum at the
Fashion Institute of Technology, New York.

expertise and sophisticated vision have been crucial to this project. I am grateful for the dedication of the Meadows Museum's staff, including Bridget Marx, Tara Steinmark, Steven Price, Jo Szymanski, Lesley Clover-Brown, Carrie Hunnicut, Kirsten Peterson, Irene Davies, and Dana Johnson. I would also like to extend my deepest gratitude to the entire staff of the Texas Fashion Collection at the University of North Texas for their efforts in organizing this exhibition.

The publication would not have been achieved without the assistance and support of Gillian Malpass of Yale University Press, who supervised all aspects of this ambitious undertaking. I thank also Michael Bodycomb, whose beautiful digital photography is reproduced in the catalogue. In addition, I thank the rest of contributors to the publication, Agustín M. Balenciaga, Lawrence Marcus, and especially Hubert de Givenchy, for sharing such a personal and honest portrait of Balenciaga.

An exhibition of this scale and a publication of this importance could not have been mounted without the generous support of the Meadows Foundation. I am indebted to Linda Evans, President and CEO of this major philanthropic institution, as well as its entire board, for their commitment to the realization of this project.

It is truly exciting for the Meadows Museum to feature an exhibition on a Spanish designer of such historical importance. I trust that the fashions featured in the show will be a feast for the eyes for anyone who loves beauty, since all of the works selected for the show are indeed artistic expressions of the highest quality and taste. The accompanying book, which brings to light newly discovered documentation and critical commentaries by individuals who knew the great designer, affirms Balenciaga's influential vision and his enduring legacy.

Mark A. Roglán, Ph.D.
Director
Meadows Museum, SMU, Dallas

To anyone enamored with fashion, the name Balenciaga evokes a visceral response and instant recognition of all that Paris fashion represents. That a man born in the late nineteenth century in northern Spain should rise to the top of his profession, commanding the attention of the twentieth-century elite, is no mean feat. Balenciaga's name continues to flourish today as that of a prominent international company, imparting his sensibility to a new generation. This sense of continuity and consistency is a hallmark of Balenciaga that can be found in his extant work: the hundreds of suits, dresses, ball gowns, and cocktail ensembles that are housed in museums and private collections around the world.

This exhibition has been more than thirty years in the making. The initial groundwork can be deemed part of the legacy from the scores of donors to what ultimately became the Texas Fashion Collection, at the University of North Texas in Denton. The original collection was founded in 1938 by Stanley and Edward Marcus of the internationally famous Dallas department store Neiman Marcus, in honor of their aunt, Carrie Marcus Neiman. Lawrence Marcus, their younger brother, carried on the tradition with his steadfast involvement with the collection. All worked directly with designers from all over the world to bring the best of high fashion to Neiman Marcus's customers.

The Fashion Group of Dallas, which founded the Dallas Museum of Fashion, took over stewardship of the Neiman Marcus collection at the Apparel Mart in the 1960s. The combined collections were exhibited in Dallas and were moved to the Denton campus of the university in 1972, largely owing to the efforts of Edward Mattil, the chair of the art department, and his wife, Betty, who taught fashion design. The Mattils understood that fashion history was an important component of education and worked tirelessly to promote what became known as the Texas Fashion Collection. It was a coup for the university to be selected as the repository of such an important and exemplary collection of designer creations, today boasting more than 15,000 historic fashion artifacts.

Much of the history of the creation and development of the Texas Fashion Collection reflects personal vision. The Neiman Marcus store was founded in 1907 in Dallas by Herbert Marcus, his sister, Carrie, and her then husband, A. L. Neiman. At that time, most historical costume collections had been established by theatre companies, usually as a result of a staff member's recognition that period costumes were valuable as objects of study and inspiration. There was an acknowledged need for active preservation that stemmed from the very nature of the theatrical enterprise. In the early to mid-twentieth century, many of these early collections made their way into museums. It is, therefore, remarkable that a department store, even one committed to haute couture, such as Neiman Marcus, should have had the foresight to form a historic fashion collection in this period.

In demonstration of a similarly remarkable commitment, the Fashion Group of Dallas was the first such group in the United States to establish a museum entirely devoted to fashion, the Dallas Museum of Fashion, during the late 1950s. These early visionaries knew instinctively that what they intended to do would prove significant. Neiman Marcus not only donated designs from the store but encouraged its clientèle to offer items to the

museum. The Fashion Group solicited donations directly from many of the top professionals in the fashion industry. The vision and dedication of its members have been crucial to making this exhibition possible.

●

While a student at the University of Texas in Austin, Edward Marcus met Claudia Heard from Corpus Christi, Texas, and they became life-long friends. Ms. Heard's humble beginnings did not inhibit her ambitions to lead a glamorous life. Who could have predicted that she would marry Señor Rafael de Osborne of Spain and live as a wealthy European socialite? Her first encounter with the House of Balenciaga was after World War II. Until then, she had been a devoted client of Neiman Marcus and often ordered her clothing directly from Carrie Marcus Neiman, who was in charge of the couture department. After her marriage and move to Spain, her curiosity was piqued by a mysterious Spaniard, Cristóbal Balenciaga, who had made a name for himself in Paris since his arrival there in 1937 to open his own fashion house. Claudia de Osborne embarked on a close friendship with Balenciaga and was an exclusive client until his retirement in 1968. As the world of haute couture changed during the 1960s, she never wavered in her devotion. Beginning in 1975, Mrs. de Osborne began to donate many of her beloved Balenciaga creations to the collection at North Texas. These donations, which continued over several years, were the result of the encouragement of Edward Marcus and of Mrs. de Osborne's friendship with the entire Marcus family. While her generosity may not have been based solely on envisioning the future, she felt it was essential to preserve the work of Balenciaga.

Bert de Winter, on the other hand, was a woman who had an almost prophetic understanding of the fashion business. The focus of her career was to be ever vigilant in pursuit of the ultimate in taste and style. The work of only one designer fulfilled this mission: Cristóbal Balenciaga. This exhibition spotlights the career of Bert de Winter, who was a millinery buyer in business with Neiman Marcus during the halcyon days of 1950s fashion. On her frequent buying trips to Paris, Ms. de Winter bought countless ensembles, ranging from day dresses and suits to sensational evening wear. Over the years, she donated many items from her personal wardrobe to the Dallas Museum of Fashion, and upon her death, the Mattils were invited to make their choice of designer items from her estate. That incredible circumstance, more than thirty years ago, led to securing many of the Balenciagas that are displayed in this exhibition.

This book and exhibition concentrate on the holdings of these two major donors, Claudia de Osborne and Bert de Winter. Along with donations from Neiman Marcus, selections from the wardrobes of the two women are the focal point of the exhibition. Other individuals, such as Mrs. Frances Billups, were also encouraged by their desire to preserve the work of Balenciaga to donate their clothes to the Texas Fashion Collection, and they too will feature in the display. What is unmistakable in the exhibition, however, is the extraordinary vision of Balenciaga himself. From his work, specifically the more than 300 examples in the Texas Fashion Collection,

selections have been made that focus on the arc of his most creative period after World War II. *Balenciaga and His Legacy: Haute Couture from the Texas Fashion Collection* is inspired by Balenciaga's Spanish heritage and by French fashion traditions.

·

Balenciaga had a devoted family, some of whom were involved in the business. But he also had a family of co-workers with whom he shared his expertise with on a daily basis. Among these devoted assistants were André Courrèges and Emanuel Ungaro, both of whom worked for many years at the House of Balenciaga before establishing their own ateliers during the height of 1960s fashion.

Another young designer in Paris, Hubert de Givenchy, longed to meet Balenciaga, but did not do so for many years. The much-desired meeting finally took place in New York, and after that encounter, Balenciaga served as a mentor and friend to Givenchy. Many in the fashion world consider Givenchy as the true heir to Balenciaga. Mrs. de Osborne was directed to the House of Givenchy by Balenciaga when he retired in 1968, and many of Givenchy's works reveal the essence of Balenciaga's influence.

The artistry of Balenciaga struck a chord also in the community of his peers. Most fashion professionals have expressed their deep reverence and regard for Balenciaga's contributions to the craft of haute couture. Christian Dior and Coco Chanel paid him great respect; Norman Norell, James Galanos, and Charles James were among the distinguished American designers who admired him and were in awe of his mastery. Oscar de la Renta, inspired by both Balenciaga and his own Spanish heritage, has artfully incorporated these aspects within his own design sensibility. In fact, the work of de la Renta is replete with references to Balenciaga, yet without compromising his personal style.

The combination of legacy and personal vision has been fundamental to this project: it can be seen in the vision of privileged clients, department-store buyers, and manufacturers who recognized Balenciaga's genius at an early stage; in the imagination of fashion writers and editors who passionately promoted Balenciaga's work just as they eagerly anticipated each new collection; in the foresight of museum curators and collectors, private and corporate, who remarked the excellence of his work and the need to preserve it for future generations. The artistry of Cristóbal Balenciaga, a man who rose from humble origins to become the master of twentieth-century fashion, continues to fill the world with awe.

Myra Walker
Director and Curator
Texas Fashion Collection, School of Visual Arts
University of North Texas, Denton

CURATOR'S ACKNOWLEDGMENTS

There are many individuals whom I wish to thank for their time and contributions to this project. The primary person, who inspired confidence in my ability to undertake the challenge of researching Cristóbal Balenciaga, is Mme Marie-Andrée Jouve. The highly regarded curator of the Balenciaga Archives for more than twenty-two years, in the 1980s and 1990s, Mme Jouve is considered the preeminent resource on Balenciaga. For two decades she maintained and protected the photographic portfolios of the original collections presented at the House of Balenciaga, as a result of which efforts the archives were saved from an uncertain fate at a time when the records were not being used by the company. She also made many new acquisitions during her tenure as keeper of the archives. I have worked with Mme Jouve off and on this project since I first met her in 1987 while on a tour of Paris organized by the Costume Society of America. She has generously continued to research Balenciaga's oeuvre and consult with museum curators and scholars on Balenciaga collections around the world. Her book, *Balenciaga* (1983), is regarded as a signal achievement in costume history. The objects featured in this present book and in the exhibition it accompanies would not be correctly dated without her patience, expertise, and cooperation.

Mme Jouve introduced me to key individuals who had dedicated many years of their lives to working at the House of Balenciaga: Mme Florette Chelot, Mme Odette Sourdel, and Michelle Handjian. These lovely, gracious women provided invaluable comments and oral histories. Mme Jouve also arranged for me to meet Agustín M. Balenciaga, the grand-nephew of Cristóbal Balenciaga, whom I interviewed in Madrid. Agustín generously contributed his time and offered significant personal insights regarding the impact of Balenciaga.

I should like to thank the Director of the Meadows Museum of Art, Mark Roglán, who extended unwavering support and enthusiasm for this project. Other museum professionals at the Meadows have been equally committed to working as a resourceful team: Jo Szymanski, Tara Steinmark, Bridget Marx, and Carrie Hunnicutt. This exhibition is the result of a collaborative effort between the Meadows School of the Arts at Southern Methodist University and the School of Visual Arts at the University of North Texas, which is home to the Texas Fashion Collection in Denton. I want to acknowledge the leadership and administration at both SMU and UNT. I should also like to thank particularly Dean Robert Milnes and Associate Dean Don Schol for their continued encouragement.

It has been a tremendous pleasure to work closely with Gillian Malpass of Yale University Press, London. Keenly aware of the importance of fashion and art, Gillian has worked diligently in support of this publication and has provided a great deal of guidance throughout the process. Dr. Ted Pillsbury and Dr. Rick Brettell introduced me to Gillian and were great advisors during the early stages of the Balenciaga project.

I want to express my gratitude to Norma Stevens, Director of the Richard Avedon Foundation, for her generous participation in the publication. Gretchen Fenston of the Condé Nast Archives in New York was extremely helpful with my research for images from American *Vogue* and *Glamour*. Leigh Montville assisted with obtain-

ing permissions for many Condé Nast photographs. Irving Solero, photographer at the Museum at the Fashion Institute of Technology, was most gracious to work with regarding the photographs of Louise Dahl-Wolfe. Etheleen Staley of Staley-Wise Gallery in New York was very cooperative. The staff of the archives at the Creative Center for Photography in Tuscon, Arizona, were very accommodating and flexible.

The Texas Fashion Collection has been maintained by Collection Manager, Heather Imholt, over the past four years. I should like to acknowledge her professional contributions both to the collection and to the Balenciaga project over the course of a very demanding schedule. Heather's steadfast commitment to keep accurate records and endless lists during the last two years, while managing many other curatorial tasks, made it possible for me to remain productive and focused. I thank also my student assistants, Marie Bernard, Mona Lisa Hart, and Nicholas Chui, who all dedicated long hours to the project. Graduate student Amanda Blake provided her research skills along with a fresh viewpoint at a time when details were in constant flux. Olivia Niwagaba and Kimberly Kroll were talented additions to the team.

Heidi Dillon of Dallas has emerged as strong advocate of the Texas Fashion Collection and of this exhibition. She generously purchased for the Collection a recent Balenciaga cocktail dress, designed by Nicolas Ghesquière, which appears in the exhibition.

The beautiful digital photography of the Balenciaga pieces in the collection for the book was created by Michael and Rosalyn Bodycomb of New York. Their sensitivity to lighting, color, and detail was impeccable. A large amount of work took place while shooting on location in Denton, with even more work as the image files were artfully manipulated to perfection. The photography sessions involved the creative input of numerous individuals. The late Harry Lewis was the head stylist: this project would not have been the same without his unerring taste and keen sense of style. Arlene Waghalter of Austin, Jenny Rivera of Dallas, and Ray Souders, who is the Senior Stylist for Neiman Marcus, also worked as stylists during the photography sessions. Management and preparation for photography was overseen by Heather Imholt. I thank also Laura Lee McCartney for assistance with dressing mannequins for photography.

The exhibition concept and design is by Winn Morton of Dallas. His command of space and eye for detail provided a dramatic setting for the work of Balenciaga in the Meadows Museum. Morton's career, which spans more than fifty years of design work in New York and Dallas, lends a distinctive flair to the presentation. Winn Morton as the head designer worked closely with his partner, the late Harry Lewis, to produce a lavish, thoughtful, and ultimately unforgettable environment of light, color, and staging.

A talented, creative team brought their skills to the exhibition. Larry Leathers has a very special gift for making mannequins come to life. I should also like to thank the following people who have invested so much energy into the artful arrangement of the exhibition: Arlene Waghalter, Bob Cook, Jenny Rivera, Ray Souders, Kelly McCall, Melanie Sanford, and John Ahrens. Steven Price, exhibition designer for the Meadows Museum,

provided expert attention to all details, David Newell and Caralee Smith gave me invaluable advice throughout the course of the preparation period. Many thanks go to industrious student assistants as well as to numerous volunteers, especially to the RAG Ladies, our dedicated support group of women from the Dallas fashion industry.

Balenciaga and His Legacy: Haute Couture from the Texas Fashion Collection is the culmination of numerous years of research. It is the responsibility of a curator to know as much as possible about his or her own collection and to pass on accurate information for future study. I am grateful to the late Pattilou Cobb, who was curator during the time of the donations from Claudia Heard de Osborne, for her care and professional cataloging of hundreds of objects. My subsequent research led to many trips to Europe over the years. I am grateful for the support of the University of North Texas for my faculty development leave in the spring of 2005, so that I could study in this field for a concentrated period. The Stella Blum Travel Grant from the Costume Society of America also funded my research and made it possible to finish my work.

My travels were made most memorable by the people I met, some of whom have been named above. I thank my dear friend Bernard Cantos, whose friendship, generosity of spirit, and hospitality made it possible for me to stay in Paris for extended periods of time. In Spain I encountered many helpful people as I continued my work. I am grateful to the Vice-President Mariano Camio Uranga and Julián Argilagos, Pi of the Balenciaga Foundation. While visiting the Balenciaga Archives in Guetaria, I was courteously assisted by Aberri Olaskoaga Berazadi, Igor U. Zubizarreta, and Elizabeth Echeveste during my stay. In Barcelona, Sra Rosa M. Martin, former curator at the Textil I d'Indumetaria, shared many hours of her time instructing me on the cultural history and art of her native city. In Madrid, I was given a personal tour of the costume and textile collection at the Museo del Traje by the director, Andrés Carretero, which was kindly arranged by Agustín M. Balenciaga.

I thank Lawrence and Shelby Marcus of Dallas for their valuable contributions about the history of fashion at Neiman Marcus. Mercedes T. Bass, from New York and Fort Worth, graciously assisted me with contacting Hubert Givenchy in Paris. Mrs. Bass has generously donated hundreds of beautiful couture designs by Givenchy and Oscar de la Renta to the Texas Fashion Collection. Many thanks to all friends and family members who graciously responded to my phone calls, e-mails, and endless questions about Claudia Heard de Osborne and Bert de Winter. I appreciate their time, patience, and thoughtful comments. I thank also Ignaz Gorishek of Neiman Marcus for his support of the Texas Fashion Collection. Brian Collins, of the Dallas Public Library made the Neiman Marcus Archives available to me and assisted with questions.

Mr. Evert Johnson, former curator of the Museum at Southern Illinois University, who put me through his own version of "basic training" for curators, was responsible for my choice of a museum career. I can still hear his stern admonitions about "getting it right" and shall always be grateful to him. Other museum colleagues who

have been a great source of inspiration are Jean Druesedow, the late Richard Martin, Harold Koda, Valerie Steele, and Andrew Bolton. I want to acknowledge also the creative talent of the late Randy Carrell, who contributed so much to past exhibitions at the Texas Fashion Collection.

Finally, I thank my husband, Eben Price, for being my rock of support throughout my career, and specifically on this project. Karen Weiner and Donna Dalton have offered me their unwavering friendship. I thank my parents, M. B. and Bonnie Walker, who have always believed in me and have attended every major exhibition with which I have been involved with great interest and pride.

In closing, I express the hope that this book and exhibition will shed new light on the fascinating career of Cristóbal Balenciaga of Spain.

Myra Walker
Director and Curator
Texas Fashion Collection, School of Visual Arts
University of North Texas, Denton

REMEMBERING BALENCIAGA

When I was growing up, I lived with my family in the country, in Beauvais, the area to the north of Paris from which my mother's family came and the home of the famous Gobelins tapestries. My grandfather was the curator of the Manufacture des Gobelins. I had many cousins, all of whom aspired to dress well. I was often in the company of one cousin in particular, just to see how she made dresses for herself. I read all of the newspapers and magazines that featured fashion reviews, and even at that time I would read about Balenciaga. He was my favorite designer: his work was so beautifully designed, so direct. The architecture, the artistry, everything he did represented the best to me. Of course, my mother and the rest of my family asked, "Why are you always looking at fashion magazines? You must do something else. Men should not always be with the women, thinking about dresses." I also loved fabric. My grandmother had a great collection of antique fabrics and my reward, when I obtained a good mark in school, was to be shown the textiles that she kept in her closet. I would say to her, "I have a good grade in Geography, or in French. May I see your fabrics?" She would answer, "Oh, that's enough. You always want to see fabrics!" She would then open the closet and show me these marvelous pieces from such places as India – from everywhere. My grandmother was a great collector of fabrics and textiles, and that influenced me from a young age.

When I was a student, Balenciaga was always on my mind. After the war, when I was seventeen, I finished my studies. I had some sketches in a book and I decided to take the train to Paris. I wanted to see Balenciaga himself, which was quite arrogant of me. I arrived at the House of Balenciaga on avenue George V and there encountered Mlle Renée, the Directrice. I said, "Mlle Renée, I want to see Mr. Balenciaga"; she replied, "But young man, Mr. Balenciaga never receives anybody." I pleaded: "But, you know, I just want to get his advice and see if he says my designs are good. Then I may be able to convince my mother that I should continue in that direction." Mlle Renée said, "Unfortunately, no. Mr. Balenciaga does not receive anybody." Naturally, I was disappointed.

I decided instead to ring the bell at Jacques Fath, who at that time was a new designer. I was hired by him and worked there for several years. I still never met Balenciaga, though I continued to admire him, but our paths did not cross. I worked for Fath, Piguet, Lelong, and Schiaparelli. When I was twenty-four years old, I decide to open my own couture house. A year later, I traveled to New York for the "April in Paris" ball at the Waldorf Astoria. I had been invited by a fashion committee, and one evening, Iva Patcévitch, who was then President and CEO of Condé Nast, asked me to a cocktail party. Patcévitch, who was Russian, was known in New York as a great friend of Marlene Dietrich, and he gave wonderful parties.

I went to his party in his luxurious apartment where the other guests included the editorial director of *Vogue*, Alex Liberman, along with his popular wife, Tatiana, and her circle of friends. That night, Chilean beauty Patricia Lopez Wilshaw said to me in Spanish, "Hubert, haven't you always wanted to meet Balenciaga? Well, he is here." I said, "He is here? Where?" "In the salon," replied Patricia. "But this is not true – that Balenciaga is in New York – since he does not travel at all." She took my hand and we crossed the salon to find Balenciaga sitting by him-

self, wearing dark glasses. I was so shocked and yet so happy finally to meet him. It was very emotional for me, and we talked for hours. He was very complimentary, saying nice things such as, "You know Mr. Givenchy, I admire your talent. I have seen a few things you have designed." He was so charming to me. He described some of the clothes that I had designed in the last collection. We made a date for lunch the next day in New York, at L'Aiglon, which was a famous restaurant at that time. From then on we became lifelong friends.

I began to learn more and more about Balenciaga, and I have wonderful memories. His style was such a great influence on my work, because I never formally studied fashion. My admiration for him was beyond that for any other designer, including Dior. I was around twenty-five or twenty-six when I met him, and I was greatly impressed by getting to know him, finally.

At a later date, Balenciaga suggested to me, "What you need is to have is a good pattern-cutter. You have your own personality, you have your own ideas, but you need to have the right technician to work with you." What Balenciaga then did for me is quite extraordinary. He selected two of the best people from his atelier, Carmen and Gilberte, telling them, "Now you will leave my house and go to work for Givenchy." The two women said, "But we don't want to go to Givenchy. We want to stay with you Mr. Balenciaga." He told them, "In a few years, very soon, I shall close the house. You will have more opportunity with Givenchy, for the future." Anyway, they both came to work for me and they stayed for many years. That was a generous gift from Balenciaga.

Balenciaga helped me in many other ways, but I never worked directly with him. I regret this a great deal, but we talked often and I learnt a lot from our times together. He was passionate about his work and knew so much about all aspects of design. The cut of a sleeve could be a topic of discussion for hours. I shall never forget all that Balenciaga said to me because I understand that he really wanted to help me improve as a designer. It was absolutely marvelous for me as an aspiring, young designer to be with this great master. He understood my fascination with his work. It was a fantastic experience for me to know him.

After his death, of course, Balenciaga's influence was experienced by me on a different level. I made many collections over the years, and what is marvelous, when one admires someone so much, is that as I worked on each collection, I might pause and remember his advice. Thinking of what he might say, I would also feel his presence in spirit, like an angel on my shoulder. I would hear his voice tell me, "Don't do that. It is too much. Be more calm. Be more sensitive." I recall many things he told me in my youth, especially that the work was very difficult. He always emphasized that, as a designer, you could never cheat or be dishonest with your work. He would say, "Hubert, you must be honest with your customer. Do not try to do something that is only amusing. Be serious in your work. Be conscientious. If you use flowers, then place the flowers in an intellectual manner. Do not place flowers just to add to the drape or cut, if it does not make sense." A funny saying he had was, "Don't try to make *mouton* [sheep] with five legs! That is what another designer would do, just to surprise the press or the customer; not you. It is more important to be conscientious and always aware."

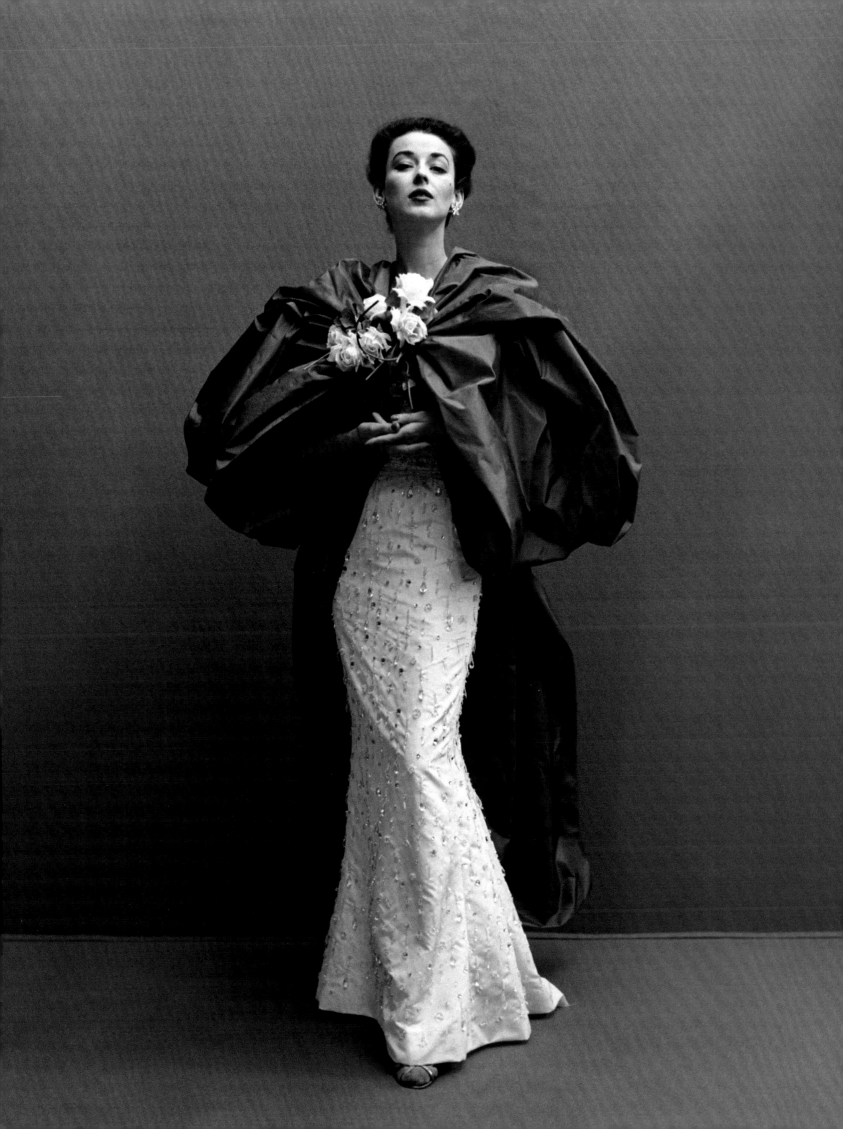

My dream was to work for him, but, unfortunately, I did not. Balenciaga said that, possibly, it was better this way. If I had worked alongside him in the atelier, I might have learned more; however, one can absorb much from conversation and sometimes we would talk until one or two o'clock in the morning. I would try not to speak so much, just to listen and understand. Of course, I had great experiences working for other designers – Fath, Piguet, Lelong, Schiaparelli. But what I admired in Balenciaga was not only that he was a great genius of fashion, but that he was so ahead of his time. The architecture of Balenciaga's work is superb, because he really was an architect. He would constantly tell me to work hard to perfect a sleeve. The sleeve was so important for him. He would often say, "You know, a sleeve does not lie in repose. The most important point is the center of the shoulder, where the suit or dress must be balanced." He had many design recipes. I speak of the recipes of Balenciaga, because he knew so much about the body, which is what enabled him to create elegant clothes. He was like a great surgeon, who intimately knew all the good and bad parts of the body; he was a good doctor. This is something about fashion that may not be easy to comprehend, but I found it utterly fascinating.

In my opinion, much of current fashion is rapidly produced and seems to lack attention to construction. Balenciaga's genius was that he could create a coat or suit with the best architecture and achieve a light, airy feeling at the same time. In a very amusing way, for example, he would say, "There are different kinds of ruffles. Some ruffles must be very, very elegant and light you know. You must make it become an intelligent ruffle. The flounce cannot look heavy; it should be soft and light. That is the way you make a ruffle." This is what sets his work apart. If one examines the interior of a Balenciaga dress, it is perfect because he always focused on construction.

Balenciaga's clothes are the most extraordinary things. He designed clothes that moved around a woman's figure, caressing it. This was very appealing to his customers, of course, because the clothing was flattering. One of Balenciaga's absolute pronouncements was: "La robe de suivre la corps de la femme; c'est pas la femme qui de suivre la robe." ("The dress follows the woman's body; it's not the woman that follows the dress.") In his collections, one sees the dress moving in that way. A dress of Balenciaga moved like the wind.

He was an extremely religious person. Not only did I admire the designer, the grand couturier, but I admired Balenciaga as a man; he embodied the true image of a real man, one who possessed everything. He was handsome and also projected great strength of character. He was a generous man who was extraordinarily gifted and talented. At same time, his religious convictions also made him a very discreet and humble person. It would be difficult not to be in awe of such a man.

I have adored fashion my entire life. My own couture business thrived for more than fifty years, and I still dream of making a collection. Now, it is very rewarding for me to work with the Balenciaga Foundation and Museum in Gueteria, Spain. I am completely devoted to the legacy of Balenciaga and to his reputation, and I shall do my best to promote both because that represents for me an opportunity to continue living my own dreams. Balenciaga is still my god.[1]

1 This essay is based on an interview with Hubert de Givenchy by
Myra Walker in Paris, France, 8 March 2005.

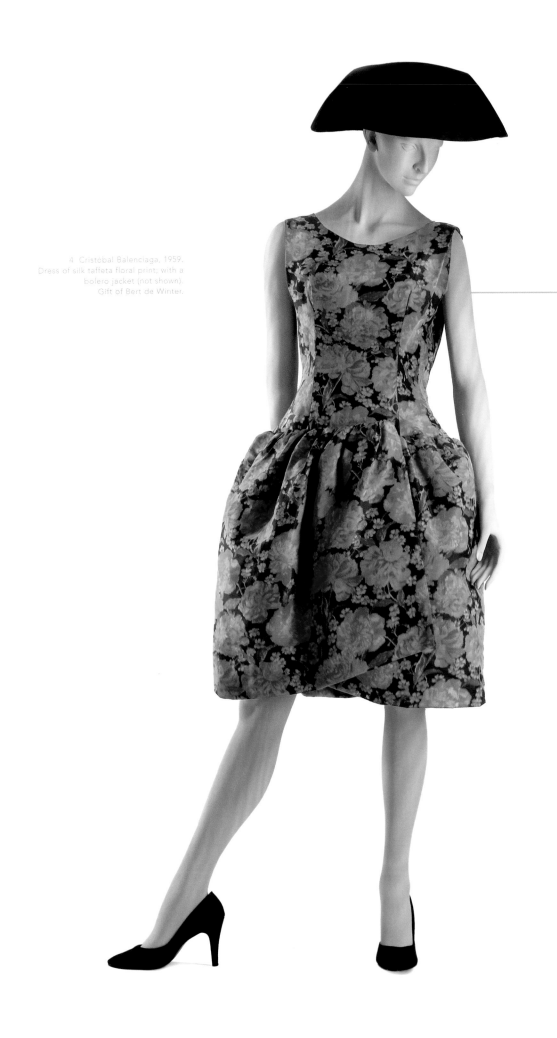

4 Cristóbal Balenciaga, 1959.
Dress of silk taffeta floral print, with a
bolero jacket (not shown).
Gift of Bert de Winter.

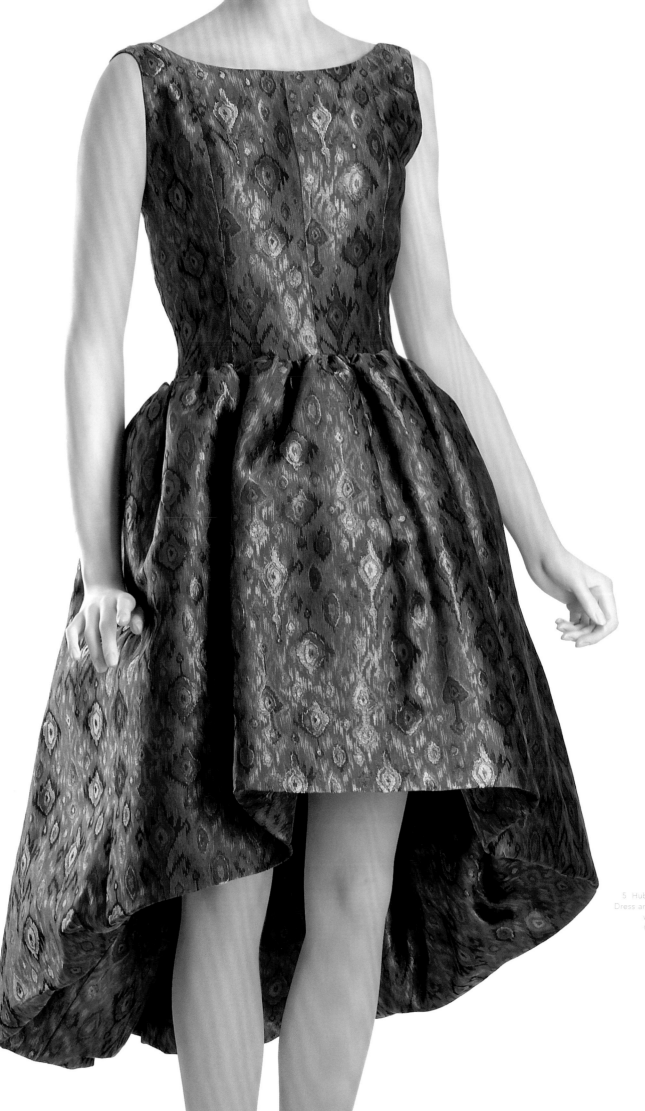

5 Hubert de Givenchy, c.1989.
Dress and jacket of gold ikat silk
with jeweled embroidery.
Gift of Mercedes T. Bass

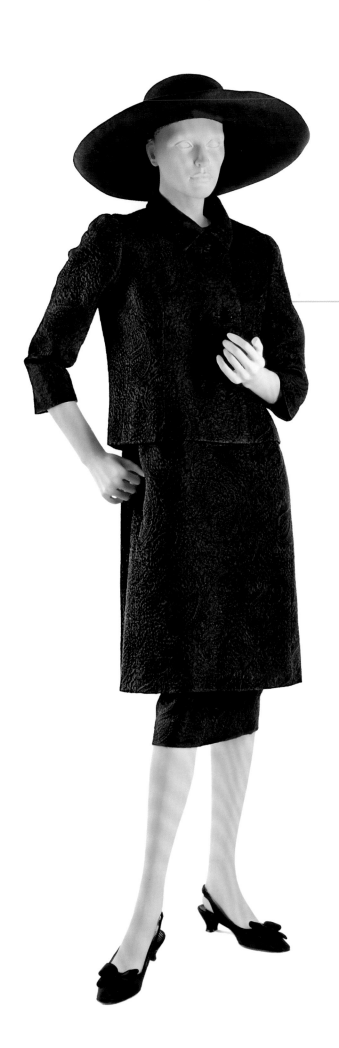

6. Hubert de Givenchy, 1963.
Ensemble of black silk damask
with tunic dress, underskirt,
and matching double-breasted jacket.
Worn by Audrey Hepburn in the film *Charade*.
Gift of Mr. Hubert de Givenchy
in honor of Ms. Audrey Hepburn.

7 Cristóbal Balenciaga, 1957.
Dress of black wool with matching jacket
with a large jeweled button.
Gift of Bert de Winter.

8 Hubert de Givenchy, c.1959
Evening jacket of embroidered flowers
with chenille trim, embroidery by Lesage.
Gift of Julie Benell.

9. Hubert de Givenchy, c.1970.
Tunic top of pink mink with black satin
knickers and a black ribbon sash.
Gift of Claudia de Osborne.

10 (facing page and below)
Hubert de Givenchy, c.1972.
Coat dress of black gazar with red and
white dots worn over a sleeveless black
dress, fabric by Abraham.
Gift of Claudia de Osborne.

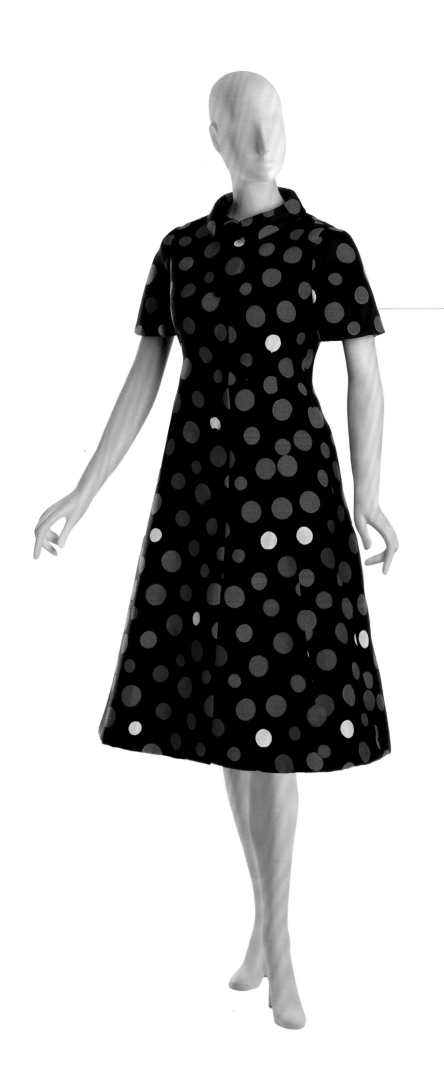

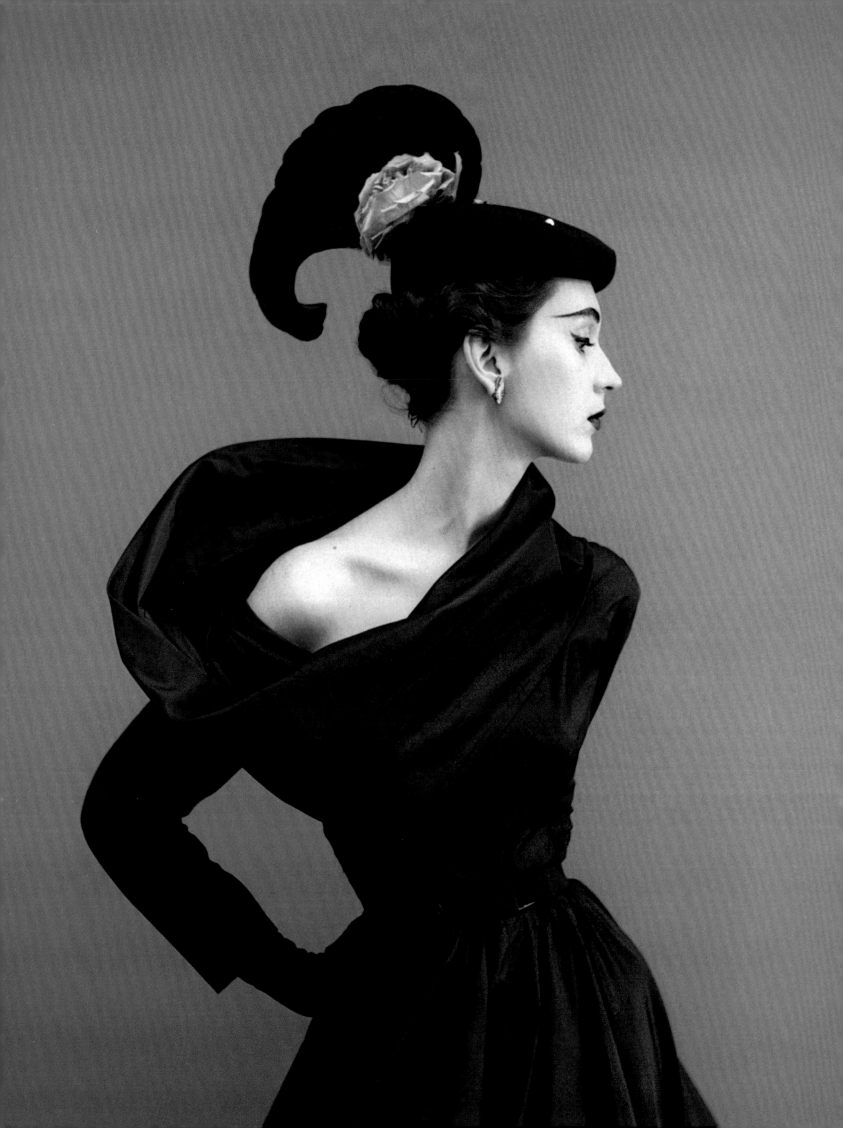

Myra Walker with Agustín M. Balenciaga

THE IMPACT OF
CRISTOBAL BALENCIAGA

Most successful designers become aware of their destiny at an early age. The young Cristóbal Balenciaga recognized his inclinations and preferred to be at the side of his mother, a talented seamstress and competent midwife in the village of Guetaria, located in the province of Guipúzcoa. The Basque community into which Balenciaga was born in 1895 was full of people who had to work every day to survive, and they did so in the primary industry of fishing. The boats often went out to sea for long stretches of time and sometimes villagers did not return. This hard reality was part of everyday life and very probably affected attendance at the main church in Guetaria, where candles would be lit and prayers offered for a loved one's safe return.[1]

Balenciaga's early years were formed in this disciplined environment which revolved around making each day's work seem as meaningful as life and death. His father, who died when Balenciaga was a young boy, was a sailor by trade who eventually made his way by operating a small pleasure boat that ferried visitors from their yachts to the shore. The Balenciaga family was of modest means, but was well respected. They lived in a small stone house, near the church in the heart of Guetaria. After Balenciaga's mother was widowed, she took in sewing and also did laundry and pressing for one of the wealthy families who had a summer house, high upon a hill that overlooked the Bay of Biscay. The Casa Torres mansion is now the site of the Balenciaga Foundation and Museum, which was established in 1997 in honor of Guetaria's native son. (The alternate spelling of Getaria is preferred by the Basque citizens.[2])

The marquesa de Casa Torres was well acquainted with the Balenciaga family and was quick to take notice of young Cristóbal's interest in fashion. It has become part of fashion lore that the marquesa provided him with the opportunity and means to copy a designer suit of hers that he admired. He passed this formidable test with flying colors, and the marquesa became his first patron, making it possible for him to become an apprentice to a tailor in nearby San Sebastián. Balenciaga absorbed all the culture that the urban world of San Sebastián offered. He took his training very seriously, and never looked back. The trajectory of his career was set in motion: his future would be in fashion.

By 1919, Balenciaga had opened his first independent studio in San Sebastián under the name of Balenciaga, in the little street calle Aldamar. For some reason, not necessarily financial, he soon shut down that studio and moved; his next address, in 1920, was avenida de Libertad, 2, under the name of Eisa (Spanish law at that time did not permit a closed company to reopen with the same name). "Eisa" was the combination of the first two letters of Eizaguirre, his second family name, and SA, which stands for "Sociedad Anónima" or incorporated society.[3]

Balenciaga's only sister, Agustina, never married and was devoted to her brother for her entire life. She lived and died in San Sebastián, in the house that Balenciaga had named Igueldo. (The house was destroyed in a fire in 1979.) Balenciaga's only brother, Juan Martin, had a daughter, who was also named Agustina but went by the nickname of "Tina." Balenciaga's favorite niece, Tina was entrusted with the management of the House of Eisa

in Madrid when it opened on the second floor of Gran Via, 9 in 1932. A Barcelona branch of Eisa set up in 1938 was managed by his nephew José, and other members of the family worked in the Madrid branch. The principal family members and designers often made the journey to Paris for the fashion shows and would stay for a time to work with Balenciaga. This arrangement was necessary to prepare for the presentation of the season's collection in Spain. Tina frequently made trips to Paris and was therefore one of the most knowledgeable in Balenciaga's immediate circle with regard to the translation of his vision to the international clientèle that came to Madrid.[4]

After these pilgrimages to the Paris shows, at which he absorbed every detail of haute couture on view, Balenciaga would dream of moving there to open his own house. That dream became a reality in 1937. The Franco regime is often cited as a reason for Balenciaga's decision, but this claim has been disputed by his grand-nephew Agustín Medina Balenciaga, who says that it has been exaggerated over the years. In fact, Balenciaga was not overtly interested in politics. It is true that many clients from the Spanish aristocracy patronized the House of Eisa, because the Madrid location was convenient for them, and even Franco's wife, Sra Carmen Polo, was a client. She had annoying habits, such as insisting on bringing along her own fabrics, and she was also very demanding about various details, such as delivery requirements. This kind of thing would not have been tolerated from another client, but, on the other hand, politics were never an issue or topic of discussion.[5] Author Lesley Miller makes the point that during the period of the Spanish Civil War, it was wise not to be overly vocal about politics just in order to survive. Such discretion would also be necessary during World War II, when Balenciaga weathered the Occupation of Paris at 10, avenue George V in order to prevent the building from being conscripted by the Germans and to keep his workers employed through the dangerous times. The stoicism and silence required while attending to a client, whoever they might be, were invaluable virtues that enabled the House of Balenciaga to remain open during the war.[6]

•

Agustín Medina Balenciaga is an attentive guardian of the Balenciaga legacy. Agustín shared with the present author many personal observations and his own perceptions about the impact of Balenciaga's life and work. He described Balenciaga as a person who devoted his entire life to his work: "Balenciaga had a deep sense of perfection and was very demanding of himself. He had such a sense of harmony, and a historical sensiblity was always present in his work."[7]

Agustín has offered the following commentary on his uncle:

Balenciaga was a perfectionist and very demanding. In my opinion, apart from the influence from various trends, a person's creative work is the result of his or her personality, soul, and vision of life. From this

perspective, Balenciaga's vision was very coherent. He possessed a clear and strict idea of the meaning of values such as honesty, effort, and rigor, and he was exigent in applying these same values to his work. Thus, there was a clear correlation between his beliefs, his values, and his creations. He was a devout Catholic who went to church often. At one point in his life he even considered the possibility of entering into a religious order. A mystical person, he loved the monastic and austere aesthetics characteristic of Catholic convents.

He also was also demanding of his staff in the different areas of his couture houses – the ateliers, the salesrooms, and the business departments. At the same time, he was to a certain extent paternalistic, and gave support and help to some of them on a level that would be difficult to conceive of today. I remember someone not connected with the Madrid atelier commenting once that it offered many employees a kind of social welfare, and they were grateful to him for giving them employment during hard times. Perhaps because of his own humble origins, Balenciaga maintained a strong sense of charity toward people in less favorable circumstances.

With his very close friends he was extremely sensitive and attentive. For example, he once heard that Mr. and Ms. Calparsoro, friends from San Sebastián, were touring in London, so he invited them to La Renerie, his weekend house close to Paris, and then secretly brought the couple's maid from San Sebastián so that they would feel more comfortable.

He was a very hard-working and disciplined person. He would start early and finish late every day, except on Sundays when he would rest. He had also a slightly pessimistic side, or rather, something like a sense of permanent dissatisfaction. He considered, for example, that success, fame, and wealth had come too late in his life.

At the beginning of his career, and during the war, he was not only designing but interacting with everyone socially as much as possible. He had a strict sense of what was right or wrong and felt betrayed if someone left him for another designer. He was dismayed when many long-time clients rushed to the House of Dior after the success of the "New Look" in 1947. From then on, he became more selective as to whom he would trust. Ultimately, he would concentrate on his work and not care about the opinions of a larger social group. He was a private man, quite secretive, as so often portrayed in the press. However, if one was fortunate enough to be included in the circle around him, one enjoyed a real intimacy with him, and his friends took pleasure in his sly sense of humor and irony.

I have tried to understand what type of person Balenciaga was, and I have tried to absorb everything good about him. I have been involved in the fashion industry, which has changed completely in recent years, and I maintain that certain standards originated with Balenciaga and other designers during the 1950s. It is important to explain what Balenciaga and his peers stood for in the history of fashion.

The success of Balenciaga, and thus, an important source of income and fame, is linked to the American clients and buyers. Private clients such as Mrs. de Osborne, Bunny Mellon, and Barbara Hutton placed huge

orders, and their wearing of his clothes generated international publicity. In Paris, after World War II, Balenciaga, along with Christian Dior and Coco Chanel, developed certain standards in the way they managed their *maisons*. By this, I mean that each was able to consolidate recognized luxury brands, and to establish the fundamentals of the luxury industry. We see for the first time – with these major designers acting in a rather intuitive way – the application of principles of brand image management. Fashion brand names reached a level of unprecedented international recognition – certainly such as had not existed before the war.

The standards they developed can be summarized as these key elements:

Continuous Innovation

For different reasons that are related to the social, economic, and cultural moment after World War II, the striving toward continuous innovation in design was markedly pronounced. Balenciaga lived through and contributed to a period in fashion history very rich in creativity and invention, especially from an aesthetic point of view. It is evident that he was a man with an enduring focus on improvement and innovation. He continually questioned his own creations and, in general, the aesthetics of things that surrounded him. This method is a common mechanism in artistic souls that often leads, after a painful research process, to a result that the artist himself considers satisfactory. In this context, Balenciaga was exceptional, because he always knew how to differentiate himself from others, and he respected his own identity.

In my opinion, these designers lived in a golden age in terms of product innovation. Today, there is less room for design or aesthetic innovation. There have been, of course, hundreds of new luxury brands arising in the market since those golden days. But everything today is judged by its image. Since the 1970s, fame has been achieved by means other than the product or garment itself. Fashion shows today do not have the novelty or character they did in the past. Like many other industries, fashion has become more banal, losing its way from its original emphasis on craftsmanship and the artistic content.

Obsession for Quality

The production of an item for the House of Balenciaga was an incredible artisanal process which was labor-intensive and in which all the steps had been laid down by Balenciaga. The result was a product of unique quality that was possible thanks only to the mastery of the haute-couture *métier* that Balenciaga practiced. Balenciaga himself was able to perform every step in the process of garment-making: pattern- and *toile*-making, cutting, sewing, and fitting. The standard he set for his couture house required great dedication. When a collection was being prepared, he was completely focused and concentrated on his work.

In addition, he emphasized quality in every detail relating to how his image was projected and how he might be perceived by clients, from boutique decoration, window display, and fashion shows, to client serv-

ice: every aspect was controlled by him to make sure that the right message was conveyed in a coherent way. For example, his boutique windows at avenue George V, decorated with the works of the sculptor Janine Janette, were highly innovative, and they worked as an element of the house brand image, transmitting a sense of the austere creativity that could be found inside.

International Fame

Balenciaga, along with Dior and Chanel, generated a level of international fame that was previously unknown for a fashion house. For the first time, luxury fashion brands crossed the Atlantic and became universal. Improvement of transatlantic travel and communications, and the information sent back to the U.S. by American journalists based in Paris contributed to the cultural encounter between Parisian couturiers and American clients. Designers from Paris would travel to New York to sell their collections; wealthy American clients would go to Paris to be dressed each season in the most expensive couture houses of the city. It is difficult to assess which portion of the volume of production these clients represented, but what is certain is that, individually, they placed the largest orders.

In my view, it is clear that Balenciaga and others were also selling the intangible aspects of Paris *raffinement*, Paris *façon de vivre*, and the French couture tradition and culture, which were tremendously attractive to American women at that time. These brands appealed to the highest and most exclusive segments of both markets, European and American, thus becoming universal.

Since then, the same logic has been applied by other famous French and Italian luxury brands that have developed their luxury-goods business. Marketing that communicates and emphasizes the tradition of well-crafted goods is being promoted again. This is the case, for example, with a company like LVMH which recognizes itself as being in the business of selling French culture and way of life, and yet ninety percent of the company sales are in Asia.

After Balenciaga retired in 1968, and with the introduction of the *prêt-a-porter* industry, the "fashion paradigma" moved down to Milan. During the 1990s, and based also on a more sophisticated use of communication strategy, the paradigm moved to New York. Fashion brands associated with that city often convey the intangible elements that represent modernity and are used for marketing.

Communication of Image

The prominence of Balenciaga coincided not only with the expansion of specialized magazines like *Vogue*, *Elle*, and *Harper's Bazaar* after World War II, but also with the greater attention paid by news journals to news related to fashion. Today there is a much larger audience as a result of global communication. Balenciaga had a mixed relationship with the press, depending on how he considered that his work was appreciated by

individual journalists. For example, he had an excellent connection with Carmel Snow [editor of *Harper's Bazaar*], who probably understood him very well. By contrast, he was unhappy with the French magazine *Elle*. On one occasion, this magazine requested that a number of his dresses be photographed with *Elle* models. Balenciaga accepted, on condition that he have final approval of the photos before they were published. When he was shown them, he saw that, ratehr radically, the heads of the models had been cut off, and he thought that this diverted attention from the dresses and displayed a lack a respect for the style he wished to portray. *Elle* did not like this type of intervention and never again asked to use Balenciaga's designs.

Extensions of the Brand: Perfumes and Accessories

Based on the heightened awareness of their brand image, Balenciaga and others were also precursors in extending their brand into new product categories, mainly perfumes and a few accessories. "Le Dix" was launched in 1947. Every detail of the perfume, from flacon and scent to packaging, was supervised personally by Balenciaga. The same could be said about the ties and foulards that were sold under the Balenciaga label. This extension and licensing was done with a certain degree of control. For example, Stanley Marcus asked Balenciaga if he could become a licensee, but Balenciaga considered it was not appropriate at the time.[8] The experience was recalled by Stanley Marcus: "On one of my first postwar trips to France, I called on Balenciaga with the idea of obtaining the exclusive representation of his perfumes for the United States. In my efforts to persuade him, I described the kind of advertising campaign we would undertake, which would assure him an important income from the sale of his perfumes in America. His listened patiently to me and replied, 'No, Mr. Marcus. All of that publicity would make my name quite common. I should not like that. I prefer to sell my perfumes in Paris.' Several years later, Balenciaga did sell his perfume franchise to an American distributor."[9]

•

Some of the artisans who worked with the House of Balenciaga emerged from a time-honored group steeped for generations in the Paris fashion tradition. The meaning of the word embroidery has a much broader context in the European tradition than it came to mean in the U.S. Embroidery as a decorative element on fabric is not limited to flat stitches and a few beads. François Lesage, whose father bought the firm of Michonet and subsequently founded the House of Lesage, explains: "From the earliest time humans wanted to adorn themselves. First, they used their bodies by directly cutting, pricking, scarring, and applying tattoos. Later, they added pigments. Clothing first began as animal skins were sewn together with bone needles. Embroidery will always be a part of the human experience. In couture, embellishment comes and goes. It is cyclical, but the mark of the hand will never disappear."[10]

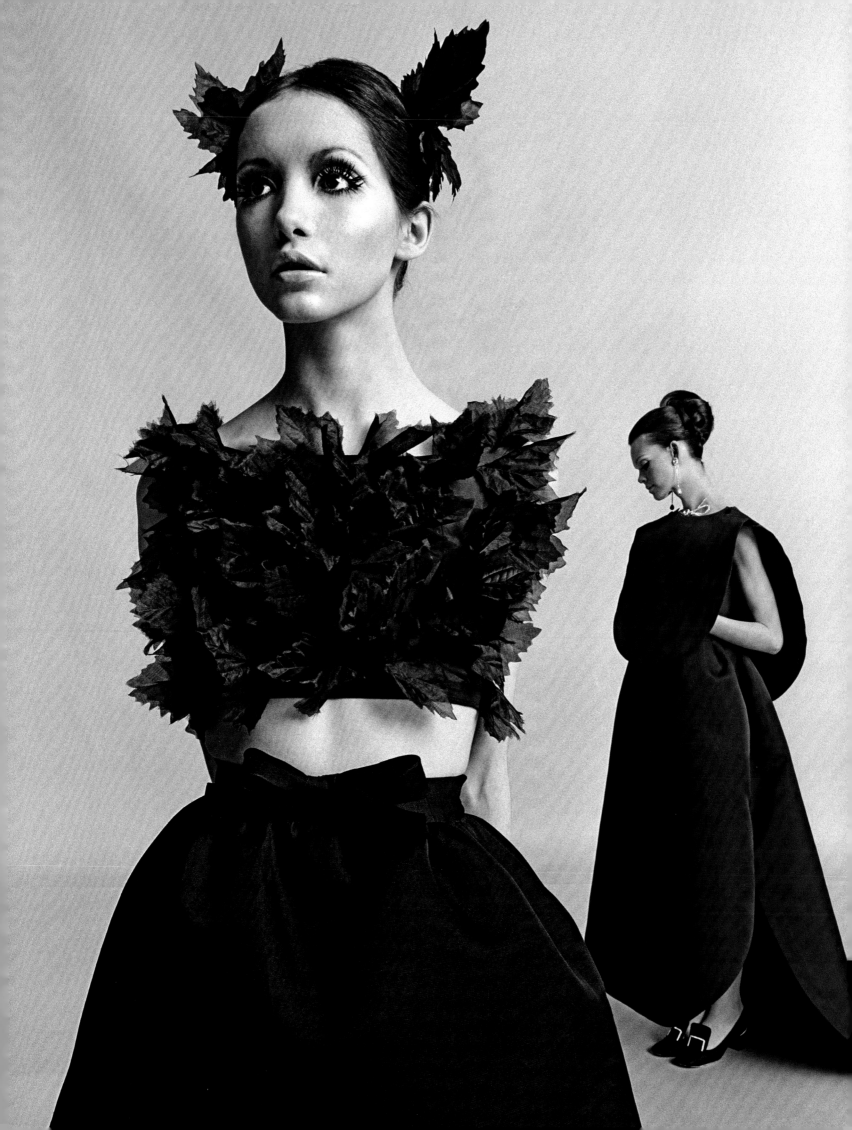

The incredible artistry of French haute-couture embroidery was developed in many private workshops and depended on embroiderers or *mainteuses*, who stitched by hand with a needle. During the nineteenth century, embroidery rose to new heights as part of the display of personal wealth among those clients who patronized the House of Worth. The conspicuous consumption of embellishment continued well into the twentieth century when the technique of traditional embroidery was improved by the introduction of a crochet hook, perfected in the small town of Lunéville in northeastern France. Using the *crochet de Lunéville* (originally a tambour hook from India), the embroiderers could rapidly execute fine embroidery and beading, working from the back of the fabric. Not only did the crochet hook shorten the work time, but delicate stitching could be done with shorter strokes on the fabric, eliminating the risk of breaking longer threads when using a conventional needle.[11]

During the twentieth century, couture embroidery houses rendered samples or models that would be shown as groups by the director to various designers. These presentations, made in January or July of each year, would be exclusive to a designer for that season. Any designs that were not chosen could then be offered to *prêt-à-porter* or private customers. The House of Lesage sold the exclusive right to use the model to Balenciaga, but Lesage remained the sole owner of the design. This arrangement represented a unique and intimate collaboration between the House of Balenciaga and the House of Lesage. Balenciaga also contracted with other embroidery artists, such as Lisbeth and Rébé.[12] These exclusive relationships have changed with the times. In fact, François Lesage struggled valiantly to keep abreast of new technology, and to incorporate new materials and techniques including "heat transfers, catalytic evaporation, holograms, metal, plastic and resin. We do things we had never done before in my parents' time, but it is important to use modernity with antique tradition and know-how."[13] Recently, the House of Lesage was purchased by designer Karl Lagerfeld in an effort to retain this important art form in France. Much embroidery is now produced in India and other Asian countries at lower prices.

Fashion historian Palmer White stated:

The striking simplicity of form, the structural modernism of Balenciaga's designs demand a subtlety from the embroiderer, whose main job is to add richness without compromising the overall purity of the concept. And yet, at the same time, the modernist innovation of Balenciaga challenges the embroiderer to be equally innovative so that both the couturier and embroiderer make ideal partners. This ideal is best expressed from the viewpoint of the perfect embroiderer by François Lesage: "The art of traditional embroidery consists of employing the same technique and the same classical materials for the various styles of drawing. The very essence of embroidery for haute couture is to associate techniques and materials that we are not used to seeing combined. That is the secret of creating. Embroidery is renewed by introducing all kinds of elements that are not predestined for embroidery. Feathers, furs, shells, leather, wool mesh, rock crystals: They can all be integrated now. What matters is creating a new and always unexpected effect and carrying it out perfectly."[14]

Balenciaga's own quest for perfection led him to work exclusively with the best craftsmen and artisans, such as the House of Lesage. The range of intangible associations that make up the essence of the Balenciaga brand includes sobriety, coherence, a sense of perfection and innovation. Based in Paris from 1937 to 1968, Balenciaga pursued his search of beauty, artistry, and exclusivity in the rarefied world of haute couture. His creative designs combined both tradition and modernity. During those three decades, Balenciaga was the most significant representative of fashion as an art for western women.[15]

1 Agustin M. Balenciaga, interview by the author, Madrid, Spain, 1 April 2005.

2 Lesley Ellis Miller, *Cristóbal Balenciaga* (New York: Holmes and Meier Publishers, 1993), p. 20.

3 Agustin M. Balenciaga, interview by the author, Madrid, Spain, 1 April 2005.

4 Ibid.

5 Ibid.

6 Miller, *Cristóbal Balenciaga*, p. 16.

7 Agustin M. Balenciaga, interview by the author, Madrid, Spain, 1 April 2005.

8 Ibid.

9 Stanley Marcus, *Minding the Store* (New York: New American Library, 1975), p. 211.

10 François Lesage, interview by Wilanna Bristow, Paris, France, 10 May 2005.

11 Ibid.

12 Ibid.

13 Jessica Kerwin, "A Stitch in Time," *W* magazine, January 2006, p. 56.

14 Palmer White, *The Master Touch of Lesage: Embroidery for French Fashion* (France: Chêne, 1987), 1988.

15 Agustin M. Balenciaga, interview by the author, Madrid, Spain, 1 April 2005.

"This short silver cloth dress, all hand embroidered in brilliants, was made for me to wear to the wedding of the daughter of the Duke of Peñrounda and to the reception after in the palace of the Duchesse of Alba. Balenciaga made me a simple pink coat to wear over it",
– Claudia de Osborne

13 (facing page) Cristóbal Balenciaga, c.1967. Tunic-style short evening dress of embroidered silver fabric by Lesage. Gift of Claudia de Osborne.

14. Cristóbal Balenciaga, c.1960. Hat of black velvet trimmed with white feathers and a jeweled pendant, attributed to Robert Goossens of Paris. Gift of Claudia de Osborne.

15 (below) Cristóbal Balenciaga, c.1960. Pillbox hat draped with a pink and black dotted silk scarf. Gift of Claudia de Osborne.

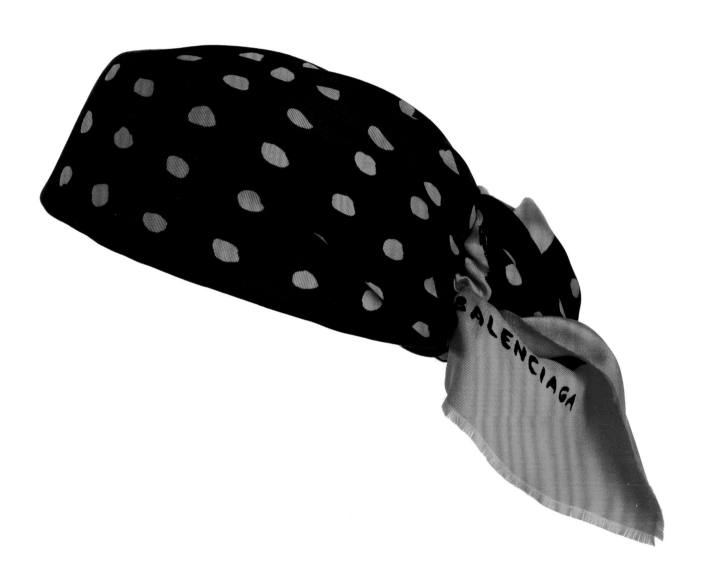

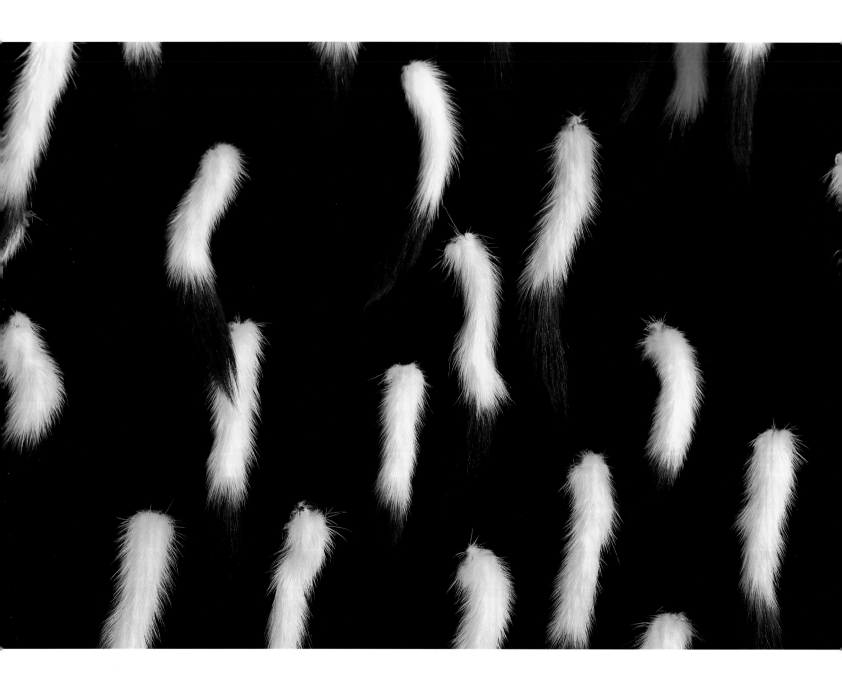

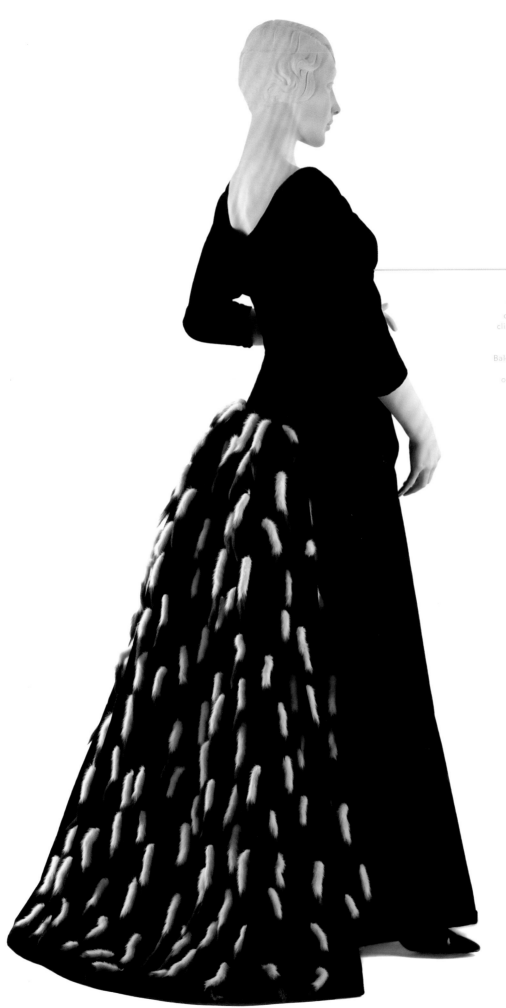

"A black Lyons velvet ball gown with a
cascade of ermine tails. The gown is to
cling to the body in front, which is why it
is not lined. All fullness is in the back
with a semi-bustle and a slight train.
Balenciaga made this especially for me to
wear to a big ball in Paris. No one has
one like it. I also took it to America and
wore it to a huge party given by
Al Meadows. The dress was
a sensation in Paris and Dallas."
– Claudia de Osborne

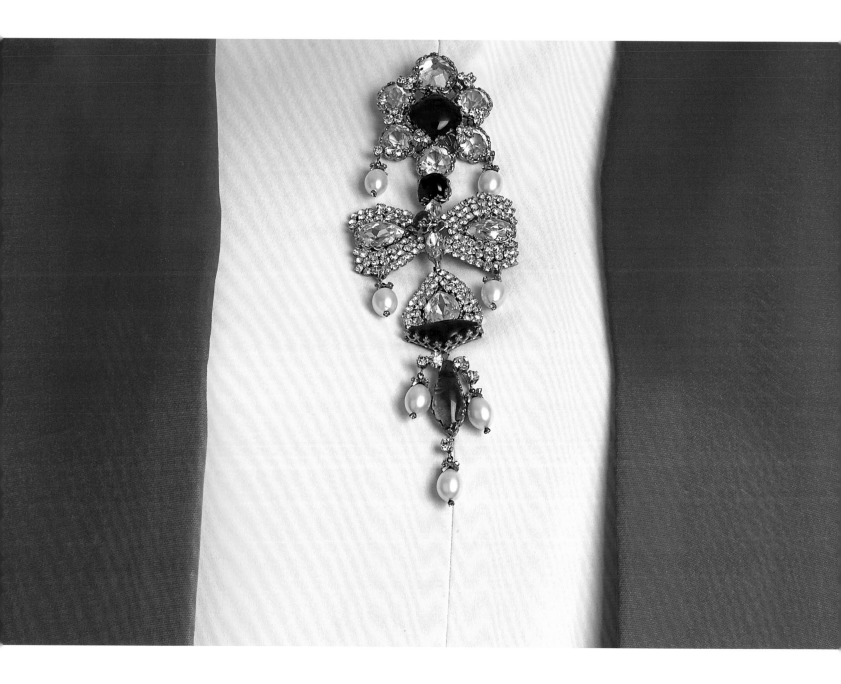

17 (facing page and below)
Cristobal Balenciaga, 1967
Evening gown of white silk with
a sleeveless coat of red silk gazar and
jeweled brooch,
by Robert Goossens of Paris.
Gift of Claudia de Osborne.

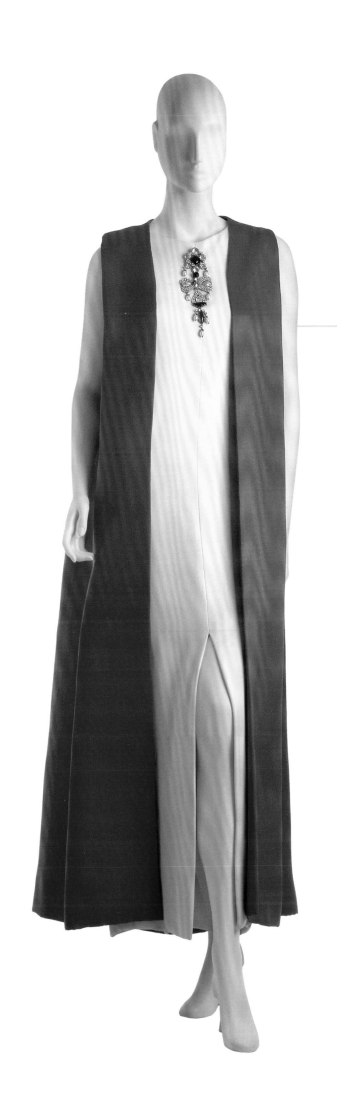

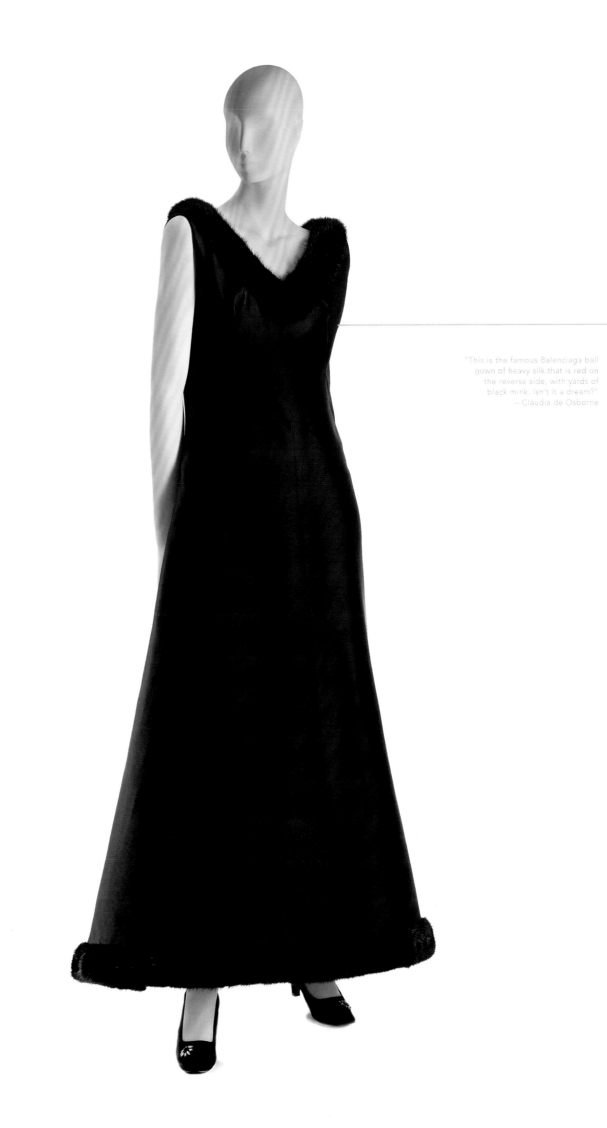

"This is the famous Balenciaga ball gown of heavy silk that is red on the reverse side, with yards of black mink. Isn't it a dream?"
– Claudia de Osborne

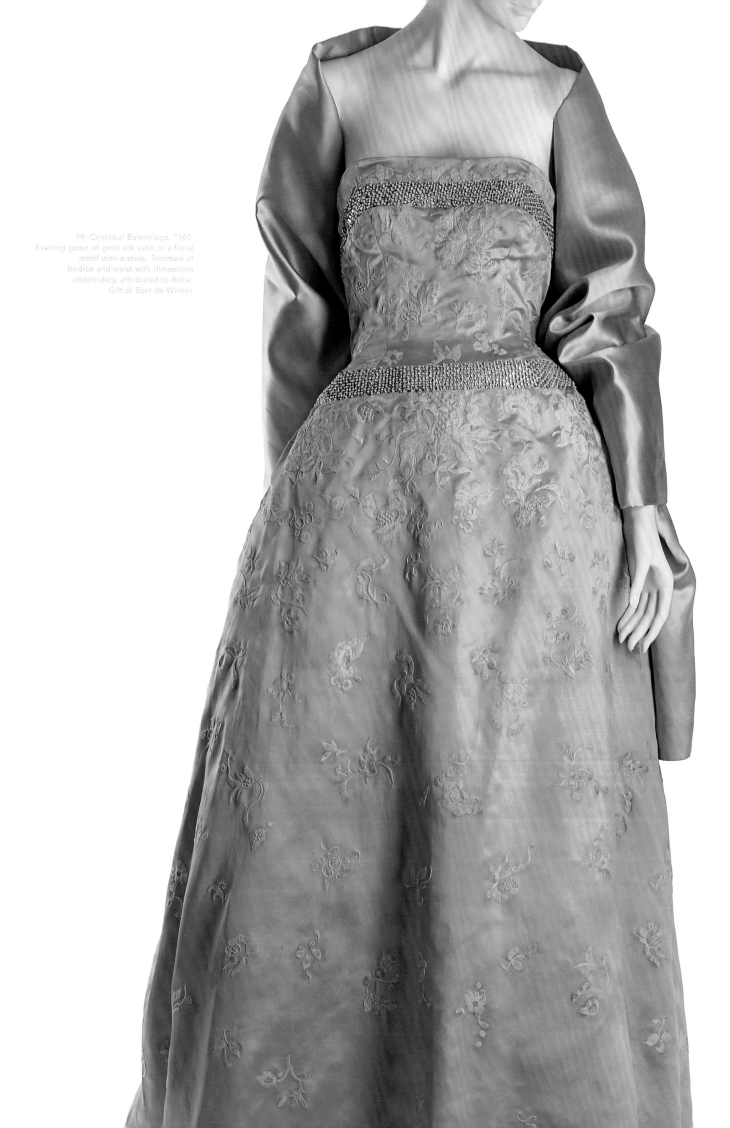

19 Cristóbal Balenciaga, 1960.
Evening gown of gold silk satin in a floral
motif with a stole. Trimmed at
bodice and waist with rhinestone
embroidery, attributed to Rébé.
Gift of Bert de Winter.

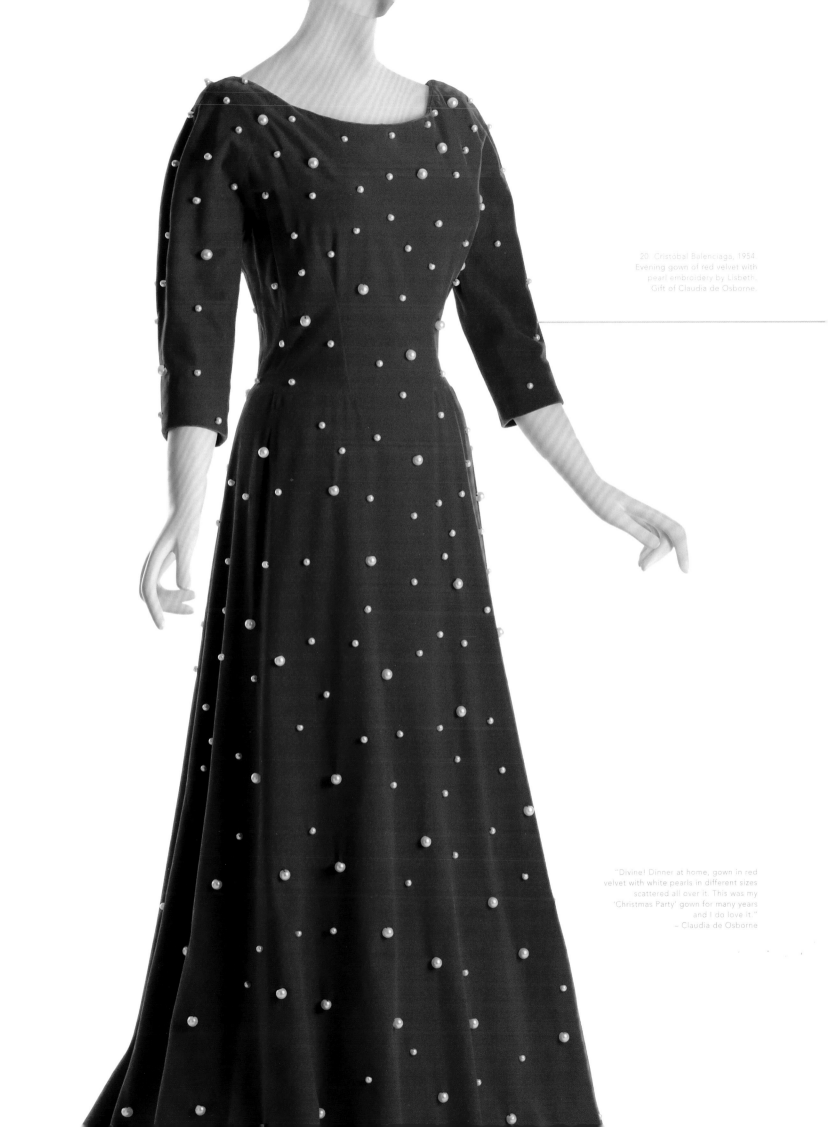

20. Cristóbal Balenciaga, 1954
Evening gown of red velvet with
pearl embroidery by Lisbeth.
Gift of Claudia de Osborne.

"Divine! Dinner at home, gown in red
velvet with white pearls in different sizes
scattered all over it. This was my
'Christmas Party' gown for many years
and I do love it."
– Claudia de Osborne

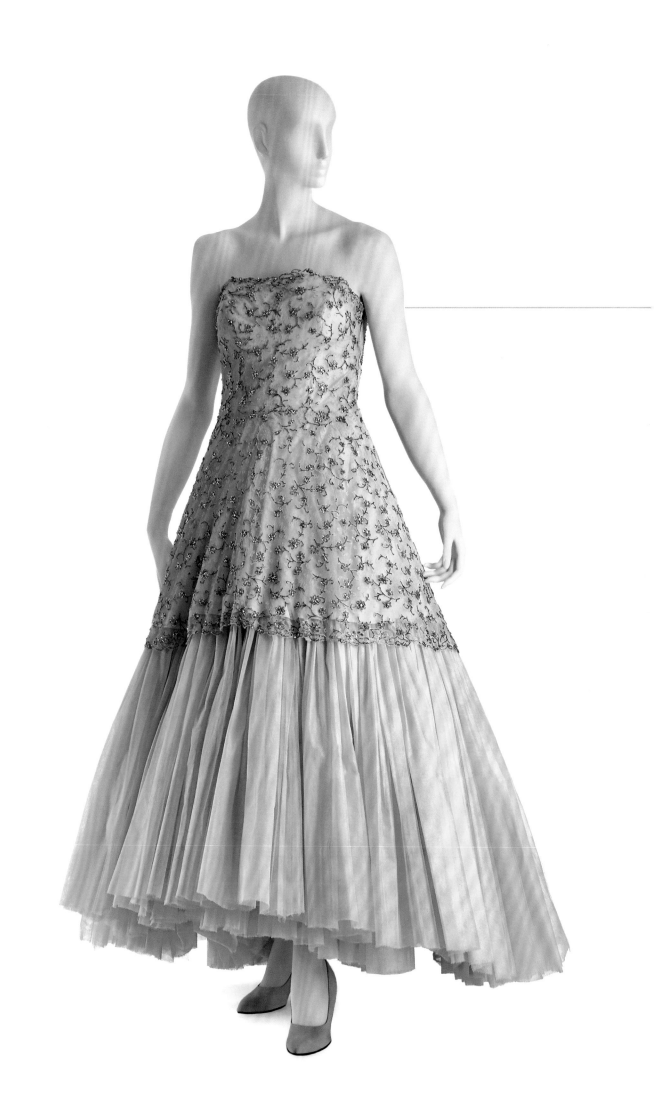

22 (facing page and below)
Cristóbal Balenciaga, 1967.
Evening gown of black velvet with beaded
embroidery attributed to Lisbeth.
Gift of Claudia de Osborne.

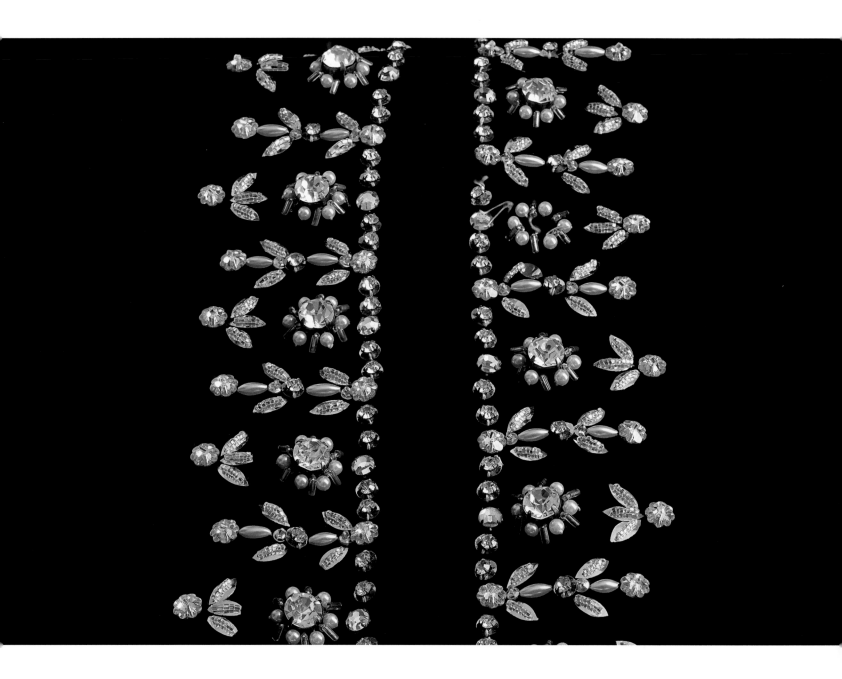

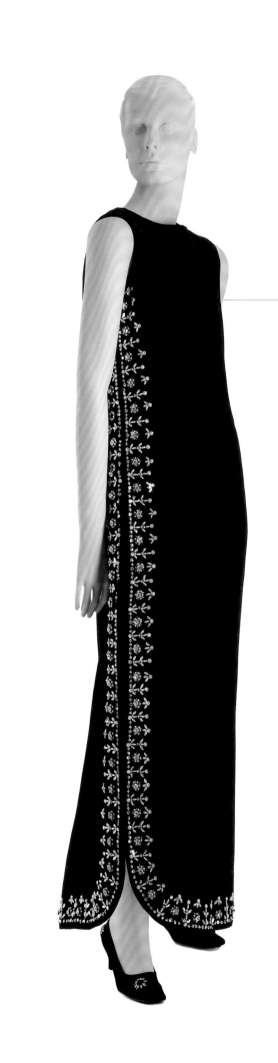

"Balenciaga had a priest's "casulla" in
mind when he cut this. He said, 'A very
sexy priest.' The side slashes showed all
of one's leg when walking or dancing.
It was the hit of the collection and
it was one of the last dresses
he made for me."
– Claudia de Osborne

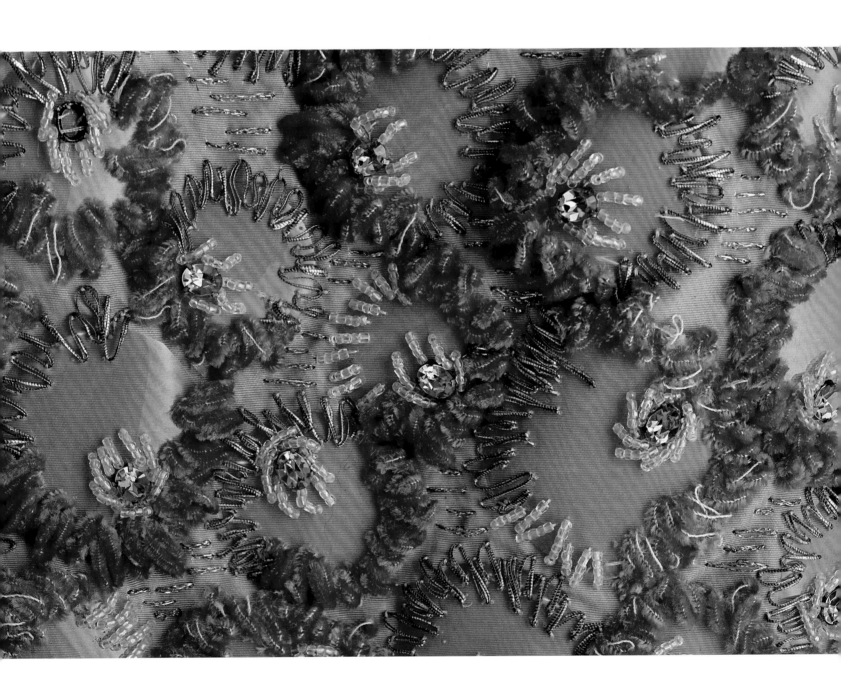

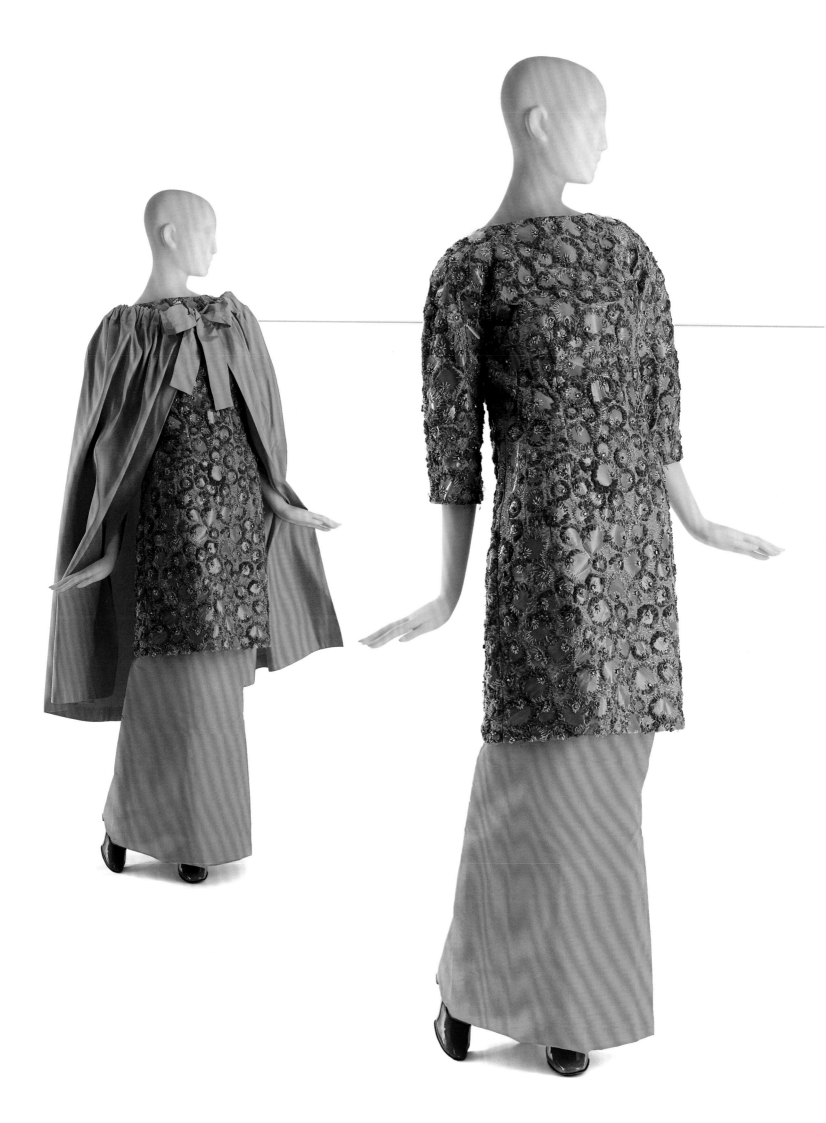

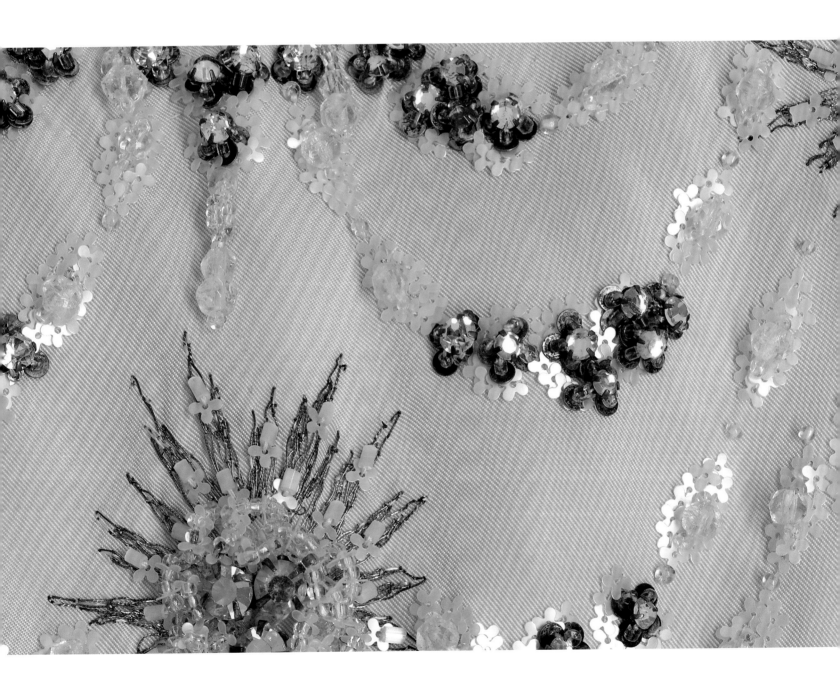

24 (facing page and below)
Cristóbal Balenciaga, c.1960.
Evening gown of black and white silk taffeta
with embroidery, attributed to Rébé.
Gift of Claudia de Osborne.

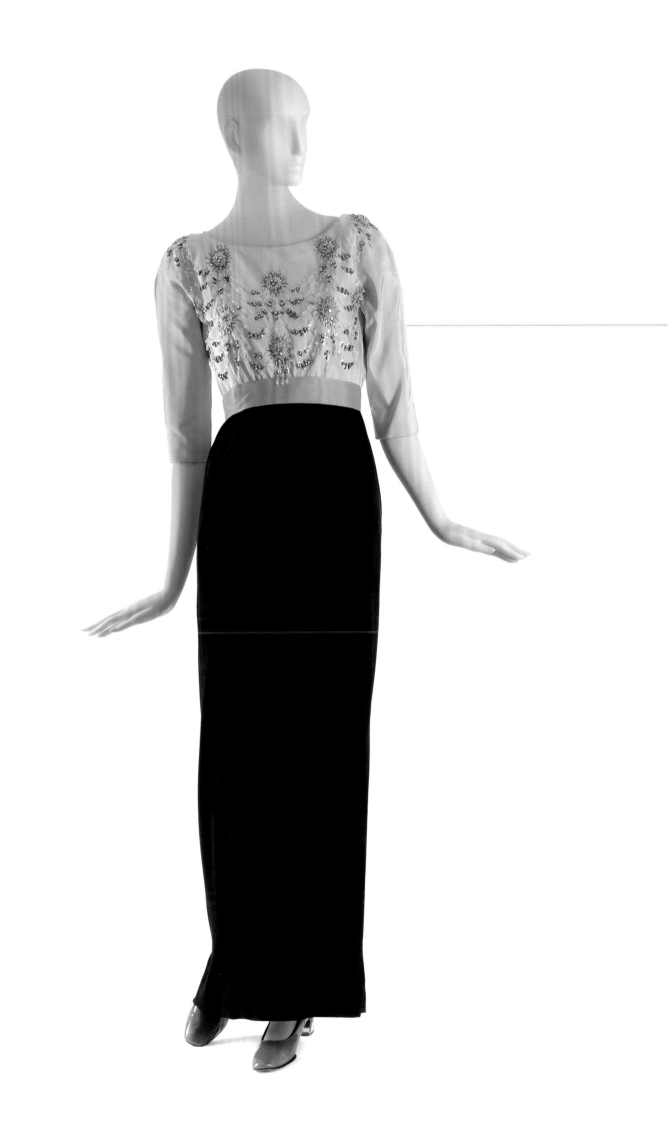

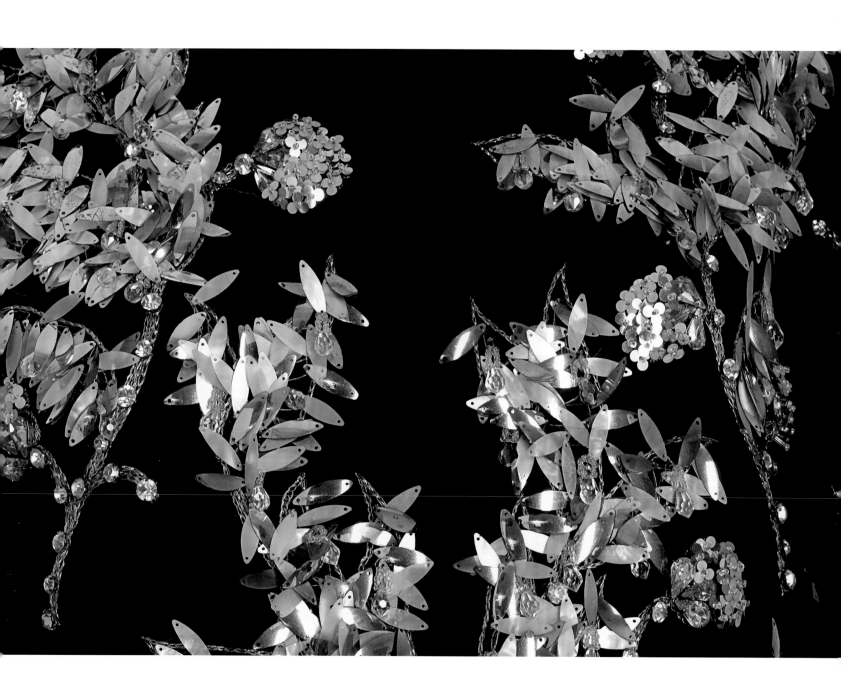

25 (facing page and below)
Cristóbal Balenciaga, c.1964
Evening dress of black silk crepe
with silver embroidery, attributed to Rébé.
Gift of Claudia de Osborne.

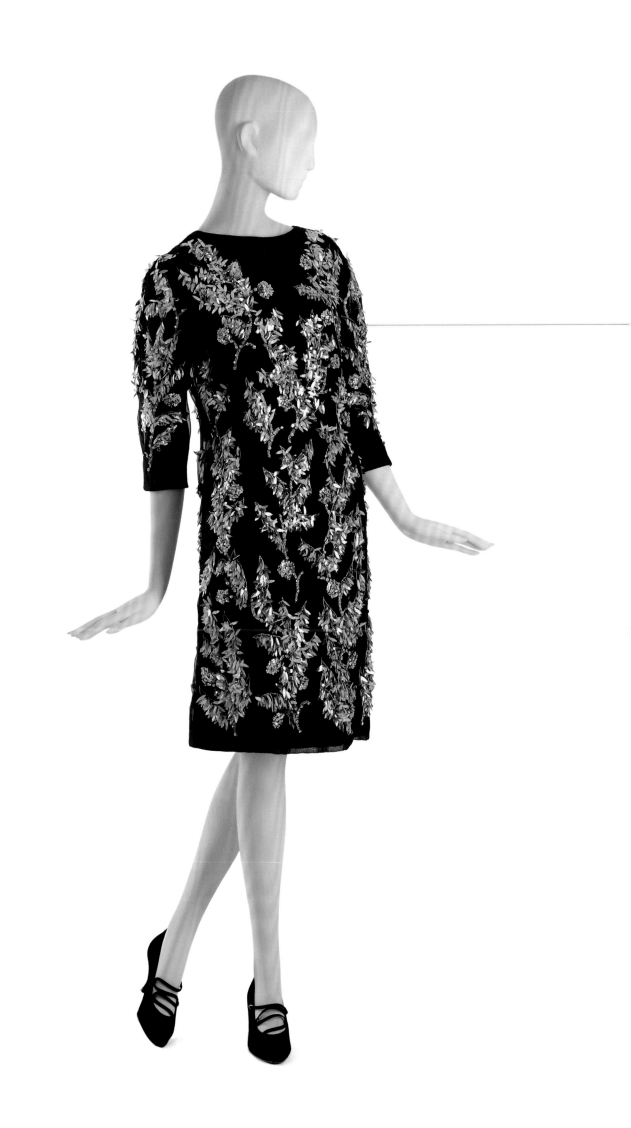

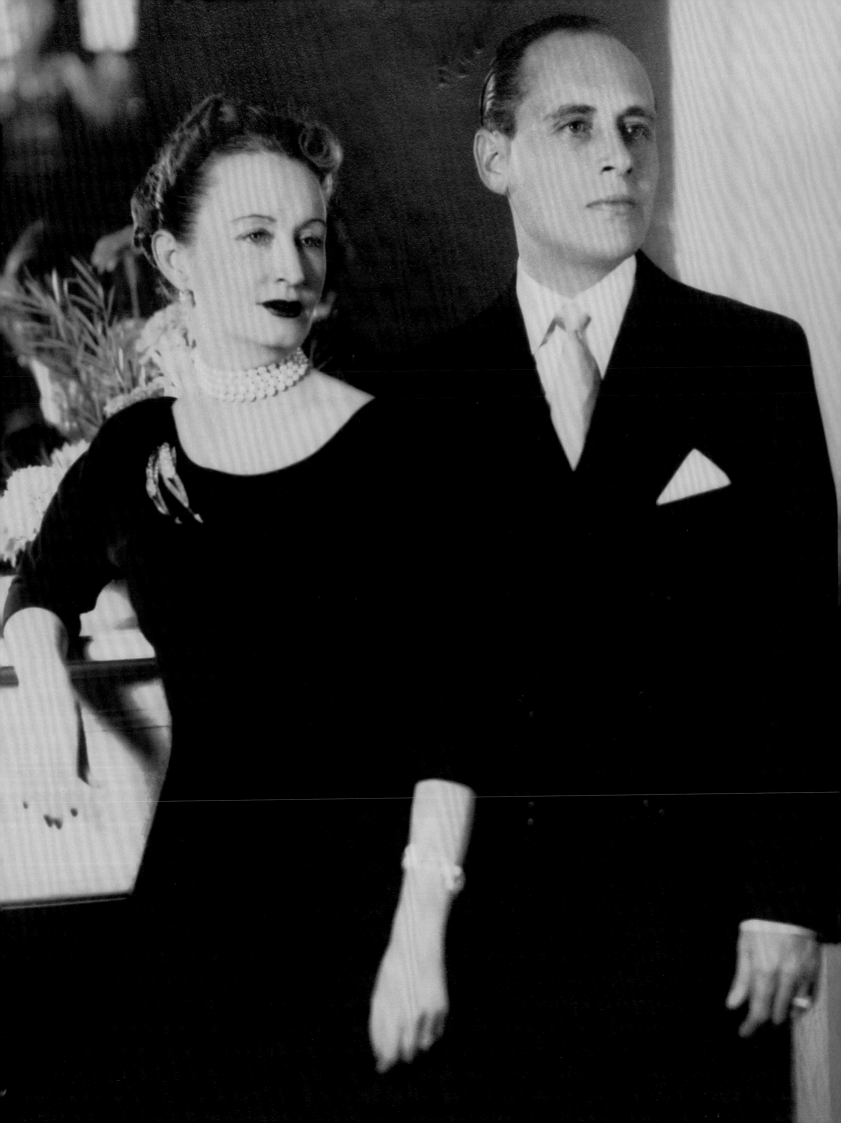

Myra Walker

DIARY OF A COLLECTOR
Claudia Heard de Osborne

Claudia Heard was born in Corpus Christi, Texas, but lived the majority of her adult life outside the United States where she made a dynamic impact in the rarefied social world of European society. Her passion and zest for all of the best that life had to offer is evident in the numerous stories recounted by those who knew her best. Claudia and her beloved husband, Rafael de Osborne, enjoyed the opera in Paris and Milan, went skiing in the Swiss Alps, were popular guests at lavish weddings and private parties, and competed in high-stakes backgammon tournaments at Gstaad. They maintained a home in Spain but also kept apartments at the Ritz Hotels in Paris and in Madrid. Claudia had many interests, but the activity that gave her the greatest pleasure was buying and wearing the beautiful clothes of Cristóbal Balenciaga.

While she did not keep a formal diary or journal, Claudia was a prodigious writer of personal letters to a few family members and to her close friend Edward Marcus of the Neiman Marcus department store in Dallas. In 1976, his secretary, Midge Cutler, carefully compiled excerpts from Claudia's correspondence with him. These letters read like diary entries, as she breathlessly recounts to "Eddie" the details of her life in Europe. Her younger cousin, Frances Heard Billups of San Antonio, did not save Claudia's letters but remembers their being always full of little notes and sketches, along with tales about her almost daily custom fittings for her couture wardrobe. Edward Wicker, a nephew who spent one year during World War II living with Claudia in Mexico City and remained in touch with her until her death in 1988, recalled that while he was there, dutifully attending classes, Claudia was out most nights until dawn and often did not rise until late in the afternoon.[1]

Claudia's early life was spent as an ordinary child growing up in Corpus Christi. Her mother ran a boarding house, and her father worked as a county-court clerk. Things changed when her father, Claude, in partnership with Estill Heyser, struck it rich during the Texas oil boom. New wealth propelled the family into a wealthier lifestyle, but Claudia was probably more affected by her parents' divorce when she was only eleven. It is speculated that this event may have been at the root of her rebellious attitude toward society's norms and what was expected of a young woman at that time.[2]

Claudia made her debut in Dallas in the early 1930s, while briefly attending Southern Methodist University. She also attended the University of Texas at Austin, which was where she met Edward Marcus. While Claudia always behaved like a "lady," she was absolutely fearless in her approach to life. A real beauty, she dated the actor Tyrone Power while he was stationed as a soldier in Texas. Following the failure of an early marriage, she took up residence in Mexico City. Spanish Generalísimo Francisco Franco had suggested that many of Spain's elite move to Mexico City to recover from the Spanish Civil War, and again later, to wait out World War II in safety. As fate would have it, Señor Rafael de Osborne, a member of the revered Osborne family, who had produced sherry for more than 300 years, was in Mexico City on extended business. Rafael, who had never been married, was completely taken with Claudia, and they were married in Refugio, Texas, in 1948.

26 Photographer unknown.
Claudia Heard de Osborne with
her husband, Rafael, c.1953.
Courtesy of Edward and Jane Wicker.

There is no confirmation of precisely when Claudia became enthralled with Balenciaga's clothes or how they met. It is presumed that she was familiar with his work before the war, since her father's fortune had made it possible for her to travel abroad as a young woman. While American *Vogue* and *Harper's Bazaar* both recognized "the Spaniard" soon after Balenciaga opened his atelier in Paris in 1937, there was little information about French fashion in the United States during the war. Anxious to regain its position of authority in the world of fashion, Paris promoted Balenciaga, and his reputation soared. In 1947, and again in 1948, he suffered two major setbacks. First, Christian Dior's post-war corelle line, dubbed by the American fashion press the "New Look," stole the spotlight, and many of Balenciaga's clients deserted him for Dior at that point. Balenciaga was offended by this mass defection and decided to cease all personal interaction with his clients. When his partner and close friend Vladzio d'Attainville died soon after this fiasco, Balenciaga became further disillusioned. It is commendable that one of the people to encourage him not to give up was Christian Dior himself. It was nevertheless during this difficult period that Claudia Heard de Osborne managed to make a favorable impression on Balenciaga, and, in addition to becoming a lifelong friend and confidante, she became completely and exclusively devoted to Balenciaga as a couturier.[3]

When Claudia became pregnant with her only child, Marcarena, she promptly ordered a maternity ensemble of black silk taffeta, which was custom made for her at Balenciaga in 1949. She wore her couture maternity dress to attend the debut of Frances Heard in 1950 and stayed on to gave birth to her daughter in Texas, because she felt more comfortable in American hospitals. During the early 1950s, Frances made several trips to France and Spain at the invitation of Claudia and Rafael, before her marriage to James Billups in 1956, and through Claudia she met Balenciaga. She has since recalled that Claudia socialized with the designer regularly in both Paris and Madrid: "Claudia would go back and forth to Paris, mainly because she was constantly buying clothes. Her life was all about clothes and she wore them magnificently. Claudia had a wonderful style and her taste was very classic. She wore Balenciaga's dresses like no one else."[4]

The primary couture experience for Frances Heard took place in Madrid at Balenciaga's atelier, where she ultimately purchased more than fifty ensembles. The red lace evening gown (fig. 99) sparked a vivid memory for her, as she recalled being slightly intimidated by dealing with a vendeuse named Adela:

> Everybody was terrified of her but she knew what she was doing. Adela would come in and inspect you and knew exactly how everything should be, how a dress should fit, and how you were supposed to look wearing it. Adela wanted each Balenciaga to be a work of art. Maybe Balenciaga had trained her, or she just possessed an innate knowledge. Whatever the case, Adela turned everybody out of the salon looking letter-perfect.[5]

It was great fun for Frances to attend fashion shows in Madrid while staying with Claudia. They would stay at the Ritz (where Claudia kept several rooms just for her clothes) and go to and from Porta Santa Maria, the villa where

Rafael and Claudia lived when they were not traveling. Claudia did not spend a great deal of her time at Eisa, preferring to see the Balenciaga's new collections at the first showing with the buyers in Paris, where she would place her orders. While in Madrid, Claudia's principal business activities and her frequent private fittings took place at her apartments at the Ritz. When Agustín Balenciaga asked his elderly aunts, Tina and Marie, who had managed Eisa, if they remembered Claudia, they replied, "Claudia de Osborne had a very spontaneous personality. As a major client, she was pleasant to deal with and always paid on time." They also fondly recalled Claudia joking that her clothing bill "had just dried up another one of her father's oil wells."[6]

Claudia's fashion sense was shaped by her early years spent shopping at Neiman Marcus. There she dealt directly with Carrie Marcus Neiman, who both showed her what to buy and imparted sage advice. It is this important early connection with "Aunt Carrie," forged during her formative years, that later influenced her desire to donate more than three hundred Balenciaga and Givenchy designs from her personal wardrobe to the Texas Fashion Collection. Edward Marcus encouraged her to do so in honor of Carrie Marcus Neiman, who died in 1953.

One of her earliest letters to Edward Marcus that mentions Balenciaga reads:

The visit with Cristóbal was delightful. I was so nervous, as he is so exacting about hair, clothes, make-up, etc. So I wore no make-up and after all, the clothes are his. Even so, he later sent to the hotel and picked up everything I wore that I'd had made in Paris. He insisted that the collar was wrong on one suit, the belt on a coat, etc. He's marvelous and a darling! Oh, he's so terribly sad and depressed over his sister's death and as I told you, of his little dog. At least though, he went out with me. We did the antique show and the Orangerie art exhibition, ate a lot and talked. He may be better now that he's starting a new collection and is keeping busy.[7]

Neither Balenciaga nor his clients were able to accept completely the new emphasis on youth and the changes that were on the horizon by the mid-1960s. There exists an interesting letter in which Claudia laments missing the Fall 1967 presentation of Balenciaga's collection in Paris:

I am sick now that I did not take the leopard printed shorts, blouse, and bolero but I didn't know where I'd wear it. After seeing the new fashion magazines, I guess anywhere your knees could stand the cold. This is the first year I didn't go to Paris for collections as I was busy. As soon as I got to Madrid, Balenciaga sent over 200 photographs of his Paris collection. They never show these photos as they are not for the public to see, but I am used to them and I can always tell about the dress from the photos.

I think I will go to see Balenciaga's collection in Paris, since it will not open in Madrid until October. Frankly, all this "mini" business is a mess, even on 15 year-olds. Maybe in Paris things will look better to me. Balenciaga wants me to buy his black evening dress in velvet embroidered in brilliants [fig. 22].[8]

Balenciaga announced his surprising decision to retire in 1968. This came as devastating news to Claudia, who told Edward Marcus that she had nothing to do since Balenciaga's closure.

> I found your note when I arrived in Madrid yesterday. I've been in Paris to see my dear Cristóbal, as I knew he was sad and I wanted to be with him. His work was his whole life and I worry for him, as he will be very much alone now. I'll meet him in the north of Spain in the middle of this month. He has promised to go to the bulls with me. I've been trying to get him to do anything to distract him. I am really fed up with Madrid, as it has changed so. With Balenciaga finished, I've no work here, as I am usually fitted almost daily.[9]

After Balenciaga closed, Claudia reluctantly took her business to the House of Givenchy at the urging of Balenciaga himself. She was not happy about this at first, but over time grew to like Givenchy's designs. At the House of Balenciaga in Paris, Margot was the *vendeuse* who dealt exclusively with the Countess Mona von Bismarck and with Claudia de Osborne, but unfortunately none of the sales records relating to Margot survives in the archives. Mme Odette Sourdel, who had worked for more than twenty years for Balenciaga, moved to the House of Givenchy and began working as Claudia's *vendeuse* in 1968. Mme Florette Chelot, who had worked with Balenciaga since he opened in 1937, also began working at Givenchy but stayed only three years.

Mme Sourdel, who became close to Claudia at the House of Givenchy, described her great affection for Balenciaga as a platonic friendship that was very deep and unshakable. Claudia fretted more than once that she would be more distressed over the death of Balenciaga than she would be at losing her own husband.

In a letter of 1969, Claudia described her experience with Hubert de Givenchy (she was still seeing Balenciaga socially when she could). This letter demonstrates how much Givenchy wished to please her, and she would finally come to terms with the reality that she had to move on:

> I flew to Paris to see Givenchy's collection. Unfortunately, I came down with the flu and a high fever and didn't leave my rooms in the Ritz for a week. Givenchy sent all the clothes I was interested in to the hotel so that I could study them more and decide. I ordered quite a few, of course, but they are NOT like what my Cristóbal made, but better than other places, I think.
>
> Cristóbal came every evening to the Ritz and dined with me. He looks good and is the same wonderful person. He and I always cry though, before the evening is over. Mostly about, "Remember this dress or that?" He is sad not to be working and said maybe he could have gone on for a few years more. He thinks current fashion is awful, but he also realizes it is best that he retired and so do I.[10]

Later in 1969, Claudia wrote, "I do miss my Cristóbal, but Hubert de Givenchy is charming and does hand springs to please me, so I don't go to any other house."

A few months after the death of Balenciaga in 1972, Claudia wrote: "I'll be going to Paris any day to order my winter clothes. I always went in August but since Cristóbal died, I am not so clothes mad. I loved to dress for

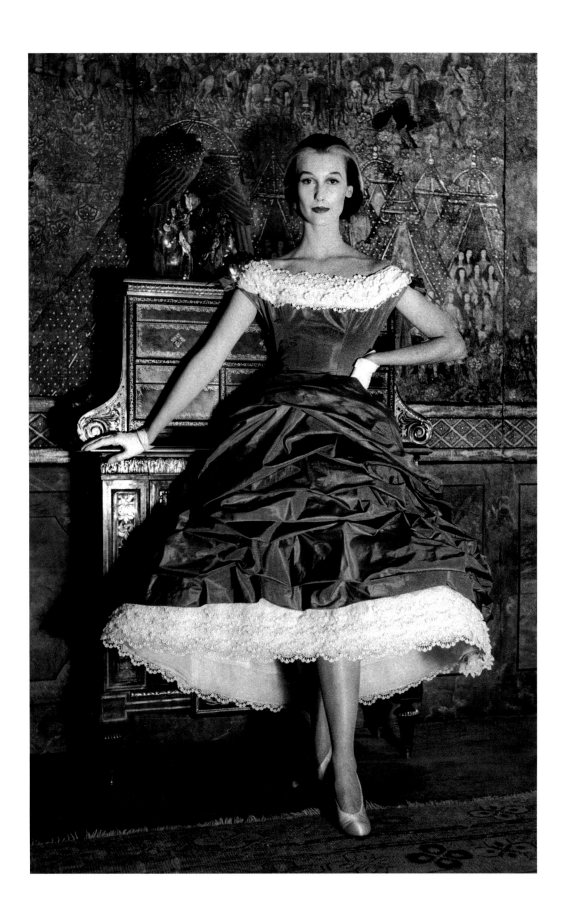

him and loved his telling me what to buy. Paris is lonely without him. I hope in time I grow used to not having him, but I doubt it."[11] Soon after this letter, Claudia was cheered up by a call from Diana Vreeland at the Costume Institute in New York. In 1973, the Metropolitan Museum of Art hosted the first major exhibition in honor of Balenciaga's contribution to fashion. Claudia was overjoyed that they wanted to borrow many of her Balenciaga clothes. She recalled that Rafael came in to find her crying over Macarena's baptismal dress, which Balenciaga had made specially for her. She loaned many items for the exhibition and subsequently donated the christening gown to the Costume Institute, but could not bring herself to give away more. The attachment to her Balenciagas was still too deep.

Claudia loved to gossip in her letters about the famous people that she met while out on the town: "One night at Maxim's I had Aristotle Onassis on my left (at the next table) sans Jacqueline. He had four of the most divine looking young girls with him, all dressed extremely well. His son was there too but Papa had all the attention."[12]

In the fall of 1973, Claudia recounted a dreadful story about lost luggage:

Macarena returned to Madrid with me when I went to Paris for the collections. At the airport, she had to take a taxi as all of our luggage would not fit in the car. Porters had put a huge suitcase of hers with me, so we had to take one of my big Louis Vuitton cases out. I told her to make sure that it was strapped on the top well. But when she arrived at my apartment, Macarena told me that a car passed and told the driver they had lost a piece of luggage on the auto route from the airport. They returned and searched, but of course they never found it. Inside were all my summer clothes, all by Givenchy, five outfits that were never worn once! I was sick, as I love my clothes, you know.

She recovered to continue in the next paragraph:

Ramon Esparza, who worked as Cristóbal's right hand for more than twenty years (he didn't cut or sew, he was more like a manager or confidant) designed a collection this summer for Chanel's Fall collection. Ramon was anxious for me to attend so I felt I should out of my love for Cristóbal. I had the seat of honor and after-wards acted as his hostess at a very chi-chi cocktail party and dinner at Maxim's. Most of us were Balenciaga's old friends. I do hope he has success.

Givenchy's collection is the best one of his I've ever seen, no nonsense with sheer elegance, workmanship and good fabrics. I always have the honor seat there. This time Rose Kennedy was on my left. When I commented that a certain black dress was nice, she said "Not for me, I've been in mourning so often that I only want red orange and bright things."[13]

There is one long letter that paints a vivid picture of the kind of lifestyle led by Rafael and Claudia, when they attended the wedding of an Austrian princess later that same year:

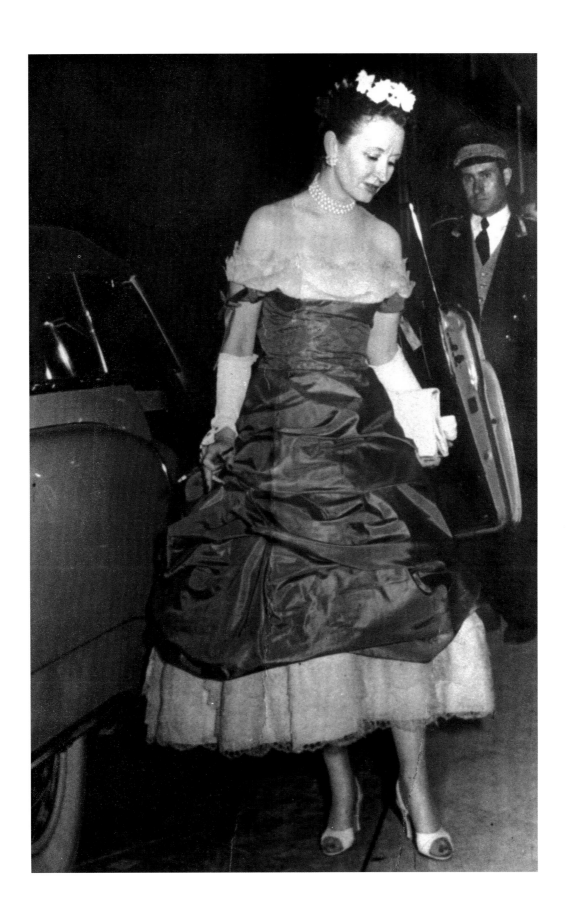

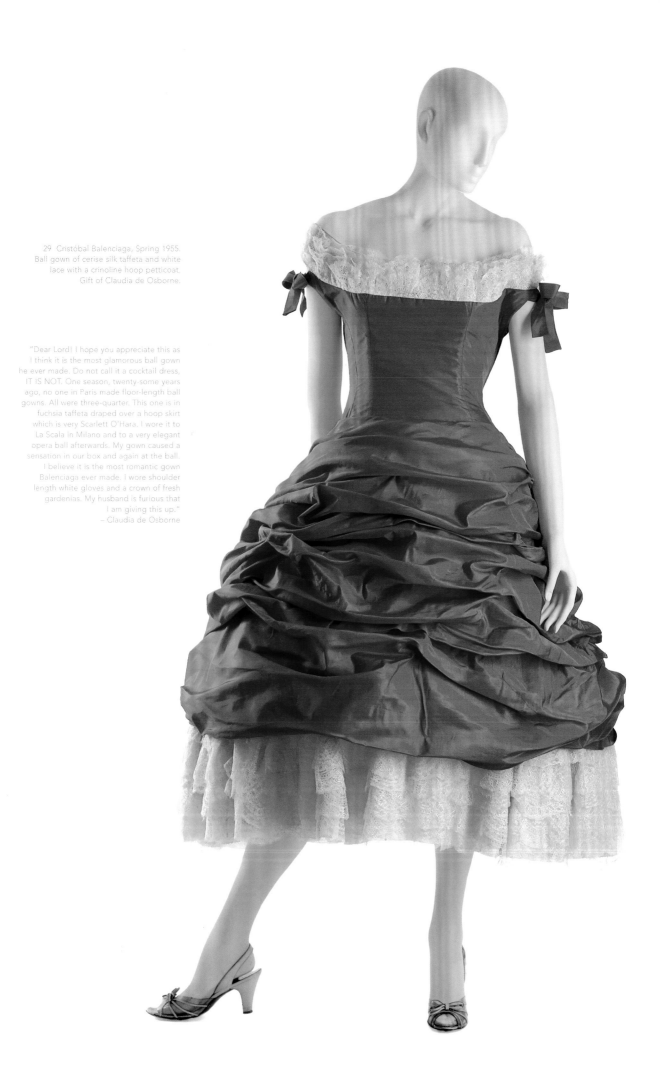

29 Cristóbal Balenciaga, Spring 1955.
Ball gown of cerise silk taffeta and white
lace with a crinoline hoop petticoat.
Gift of Claudia de Osborne.

"Dear Lord! I hope you appreciate this as
I think it is the most glamorous ball gown
he ever made. Do not call it a cocktail dress,
IT IS NOT. One season, twenty-some years
ago, no one in Paris made floor-length ball
gowns. All were three-quarter. This one is in
fuchsia taffeta draped over a hoop skirt
which is very Scarlett O'Hara. I wore it to
La Scala in Milano and to a very elegant
opera ball afterwards. My gown caused a
sensation in our box and again at the ball.
I believe it is the most romantic gown
Balenciaga ever made. I wore shoulder
length white gloves and a crown of fresh
gardenias. My husband is furious that
I am giving this up."
– Claudia de Osborne

The wedding was quite a big thing. It took place in Salzburg, and all the Spanish guests went on a chartered plane: Carmencita Franco (Marquessa de Villaneuve) and her husband, her darling daughter HRH Princess of Bourbon, and Dutchess of Cadiz; the Duquesa de Alba, Princess Haelanae, Louis Miguel Dominguin (the great matador) and all assorted titles of Spain.

As we descended the plane in Salzburg, the Spanish ambassador (a cousin of Rafael's) was there to greet us and of course there were no customs. We were put into two fancy autobuses and driven through Salzburg to a castle. As the two buses arrived, an Austrian band all in typical costume began to play and a cannon shot off twenty salvos. (I guess that was for the rank of Carmen, Princess of Bourbon and la Alba.) The bride's family was there to welcome us and they also wore Austrian dress. They had six hairdressers for us. That evening there was a seated dinner at tables of six and eight in the castle. All the nobles of Europe were there. I had the heir to the throne of Hungary at my table and Rafael was seated with the Princess of Lichtenstein, who was so darling chic, and elegant. Also, there was Mrs. Harrison Williams, the Countess of Bismarck. She is now plain Signora Martini, but as Bismarck was related to the family of the bride, she used her late husband's title. Mona is about 80 years old now, but a great friend of mine as we were both favorites of Balenciaga.

Also there was my old chum Ava Gardner, and Audrey Hepburn. The Americans were Sonny Whitney and his wife, who is a dear. You have never seen more tiaras and crowns in emeralds, diamonds, and rubies. Our Princess Carmen wore the most exquisite one, the crown she wore in her wedding to Prince Alfonso. After dinner we went downstairs to the ballroom for a ball that went on until dawn. The Austrians are the most gay and charming people I have ever known. The Spaniards were agape at the easy friendliness of them. Macarena was also invited and had a wonderful time. The next morning we were taken into Salzburg for the wedding, which was all terribly colorful and chi-chi. There was a reception and seated lunch with a place card for each guest that went on so late we had to go to dinner in our wedding clothes.[14]

In all there were four days of parties, then Rafael and Claudia went to a hotel in Salzburg to rest. This was just one of many of the special occasions for which Claudia loved to dress, and she was always prepared to make an entrance. They accepted invitations to lavish house parties, replete with marathon backgammon tournaments as entertainment. After playing until dawn, or even later, they would have dinners at which the women were expected to wear evening gowns and the men donned dinner jackets. Between such events or attending *corridos* (bull fights), Claudia still took time to go to Paris to order clothes and would return later for a month of fittings. She continued to be dressed by Givenchy throughout the 1970s.

In 1974 Claudia had to face the reality of a taxi strike in Paris, while being fitted at Givenchy. She therefore rented rooms just across the street from the atelier. She wanted to be close, so that Givenchy could easily come

over if she had a problem with the fittings. She complained to Edward in another letter that she did not like the hotel at all because the service was bad and "one must dial one's own numbers on the telephone." At other hotels she only had to pick up the receiver and say "Givenchy's" or "Get my husband in Spain."[15]

In 1975, after the death of Generalísimo Franco, the life that Claudia and Rafael de Osborne had known was altered by the arrival of a new government in Spain. As she contemplated the changes, Claudia decided to give away her beloved Balenciaga dresses, suits, and evening gowns. She noted in a letter of 25 December 1975 that she had packed two more wooden boxes of Balenciaga clothes to ship to Texas:

> The Spanish government does not want any of Balenciaga's clothes to leave Spain or to be sold. I tried to cut out all labels. But as the hours of packing got longer and longer, I finally gave up and left many labels in the garments. As I have an American passport and the clothes are mine, I should be able to do with them as I see fit. As you know, the clothes made by Señor Balenciaga in Spain, are those marked with the label EISA. When I had suits made here (in Madrid) he sent his top tailor from Paris. That tailor today is the famous Ungaro. While I do not like his collections, he does know who to cut and fit suits and coats. He should!
>
> If you see any little drops of water on the dresses, they are my tears. I cried as I packed, as I loved each and every dress, coat, and cape. I hope you'll find everything I sent as beautiful as I think they are.[16]

Just as Claudia Heard had defiantly left Texas to embark on a new life in Spain, she would defy the wishes of the Spanish government and send her beloved designer clothing back to Texas, where she stated that the collection should be known as the "Claudia de Osborne Collection of Balenciaga," and added a personal note: "I hope that Aunt Carrie would be pleased."[17]

In that same letter, in which Claudia wrote many paragraphs explaining how she had worn various garments, she made a poignant declaration:

> And sooner or later I'll give all my things of Balenciaga to the university. I have held back my favorite ones, one that I think is the most beautiful dress and coat he ever made. It is pink satin embroidered in crystal tear drops and rhinestones with matching shoes. I have told Rafael that I want to be buried in it so if my Cristóbal is waiting for me wherever we go when we die, he'll be so pleased to see me in his dress and coat.

The world had changed, and Claudia was not that pleased with the turn of events. She did not like mini-skirts, and she was against "women's lib," saying, "I do not want my freedom as I can do as I please without it."

After her multiple gifts to the then North Texas State University in Denton, the chairman of the art department, Edward Mattil, and his wife, Betty Marzan, were eager to have Claudia come to Dallas so that they could give a big party in her honor. She finally returned to Texas for a grand celebration in 1983. Shelby Marcus remembers Claudia as a very striking person, who arrived at her home for a cocktail party wearing a big showy hat. One

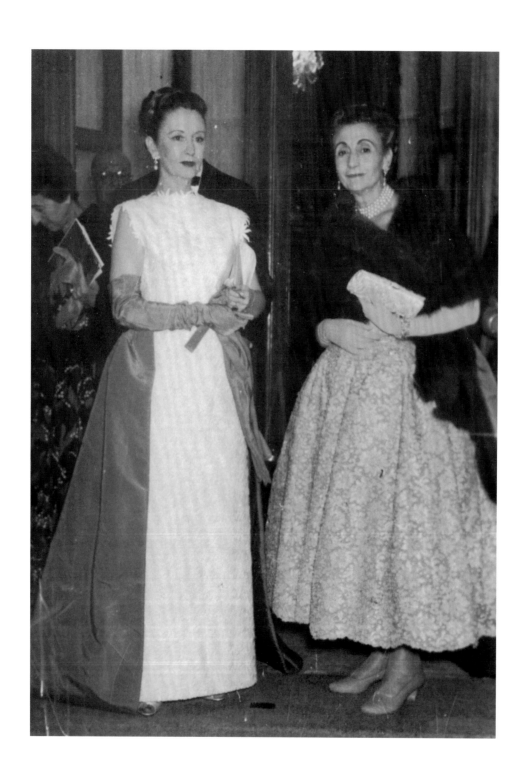

reason behind the multiple donations was that Claudia simply could not part with too many of her Balenciagas at any one time. She also began to include gifts of her Givenchy designs, resulting in a stunning, comprehensive collection of the work of Hubert de Givenchy in Texas. In total, Claudia de Osborne eventually donated 371 ensembles to the Texas Fashion Collection, including many rare hats and accessories by Cristóbal Balenciaga and Hubert de Givenchy.

Rafael de Osborne died in 1985. Claudia continued to buy clothes at the Paris collections throughout the 1980s, but her passion had dimmed as she sampled different designers, such as Yves Saint Laurent and Christian La Croix. After her death, on 18 March 1988, her estate took a long time to be settled. Ultimately, her wardrobe, which still included many Balenciagas, was auctioned off and dispersed to private collectors and museums across Europe and the United States.

On 7 March 1976, she wrote to Dr. Mattil:

Mr. Marcus can tell you how I love clothes. It is sort of a religion with me. Also, Cristóbal Balenciaga was one of the closest friends I ever had. I spent many happy days with him at his chateau near Orleans. He was such a man of exquisite taste, in houses as well as clothes. So, you see how I loved each and every dress of his. I cried as I packed them, as each reminded me of him and of the occasions that he made them for. I am terribly happy that these things are in the hands of people who appreciate them.

With most kind regards I remain very truly yours,
Claudia de Osborne

1 Edward and Jane Wicker, phone interview by the author, 11 March 2006.

2 Ibid.

3 Mme Florette Chelot, interview by the author, Paris, France, 7 March 2005.

4 Frances Heard Billups, interview by the author, San Antonio, Texas, May 2005.

5 Ibid.

6 Tina Balenciaga and Marie Balenciaga, interview by Agustín M. Balenciaga, Madrid, Spain, January 2006.

7 Letter from Claudia de Osborne to Edward Marcus, date unknown.

8 Letter from Claudia de Osborne to Edward Marcus, September 1967.

9 Letter from Claudia de Osborne to Edward Marcus, July 1968.

10 Letter from Claudia de Osborne to Edward Marcus, September 1969.

11 Letter from Claudia de Osborne to Edward Marcus, September 1972.

12 Letter from Claudia de Osborne to Edward Marcus, 1972.

13 Letter from Claudia de Osborne to Edward Marcus, Fall 1973.

14 Letter from Claudia de Osborne to Edward Marcus, 1973.

15 Letter from Claudia de Osborne to Edward Marcus, 1974.

16 Letter from Claudia de Osborne to Edward Mattil, 1975.

17 Letter from Claudia de Osborne to Edward Marcus, 1975.

All of the above letters are from the archives of the Texas Fashion Collection, University of North Texas

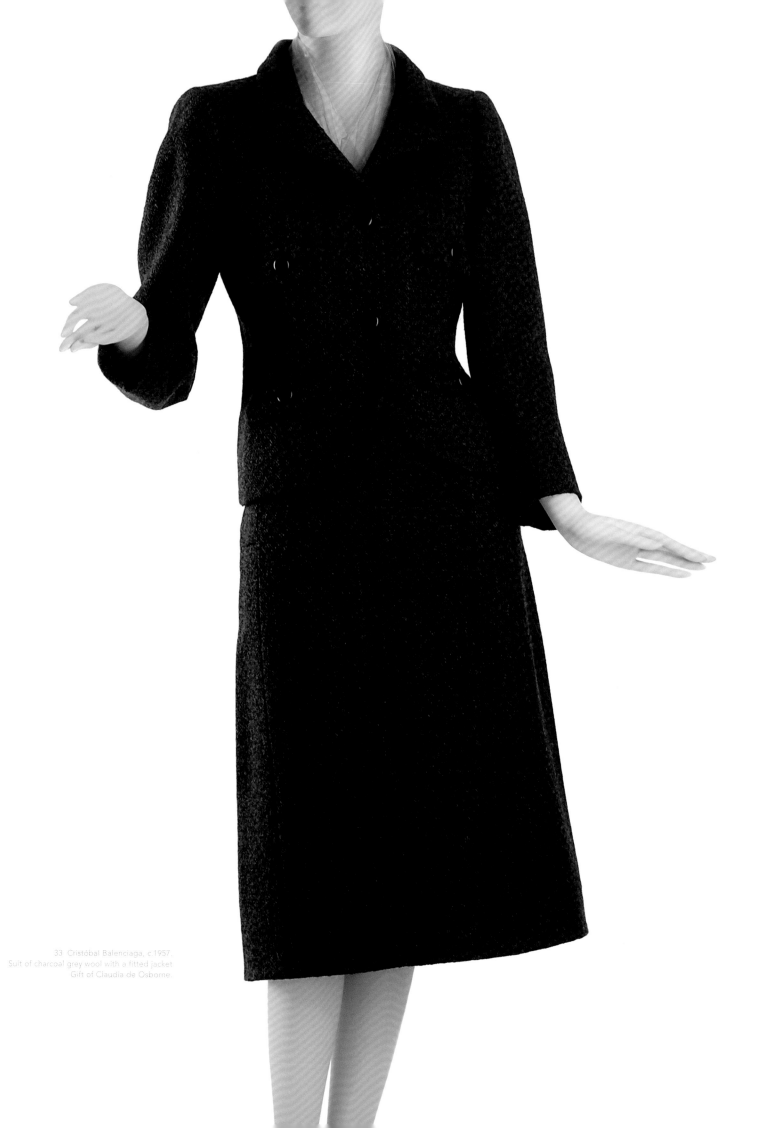

33 Cristóbal Balenciaga, c.1957.
Suit of charcoal grey wool with a fitted jacket.
Gift of Claudia de Osborne.

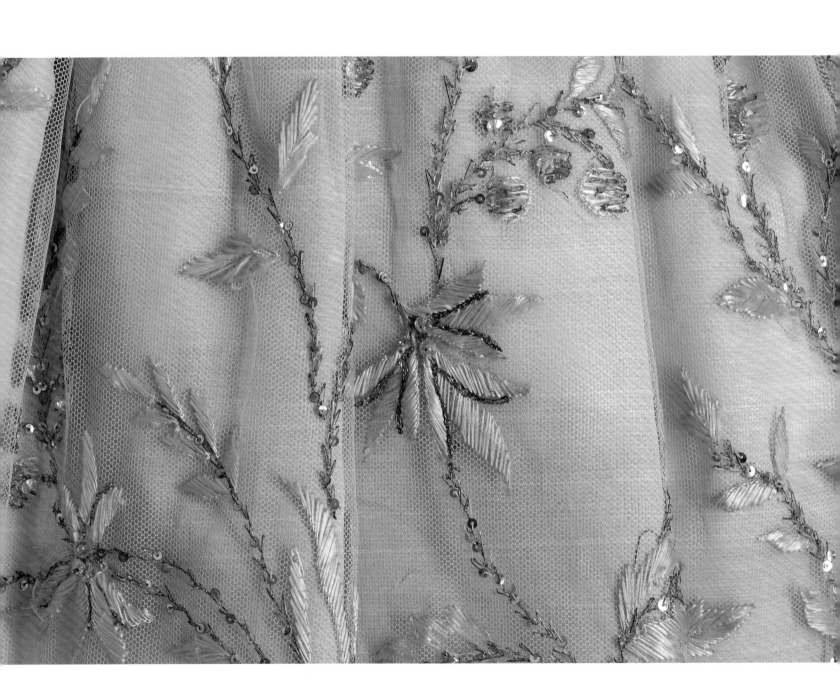

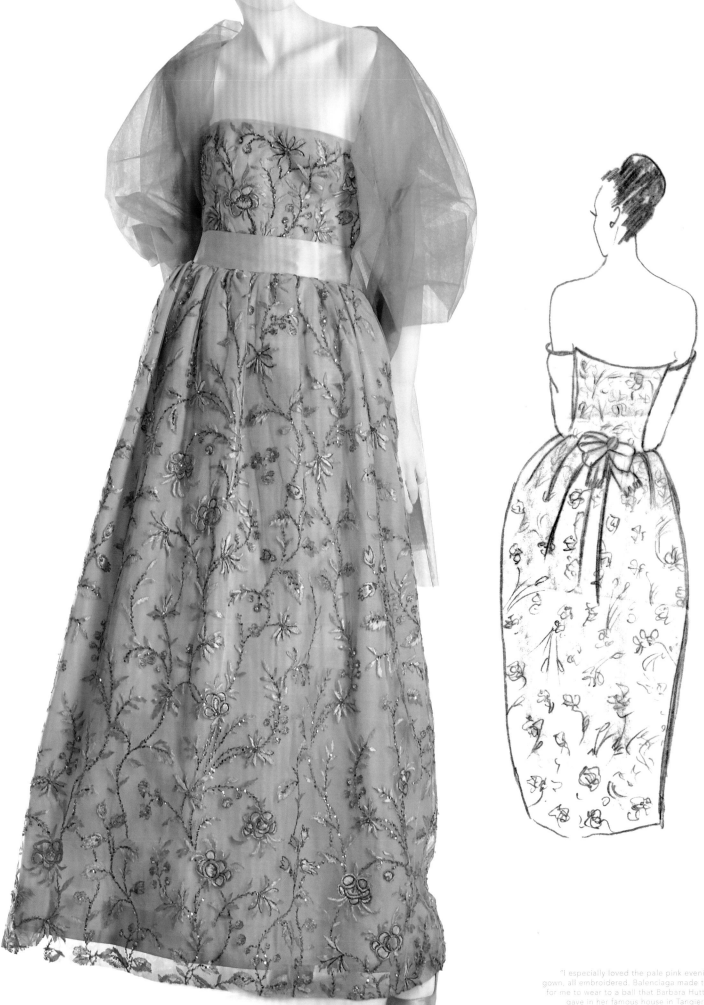

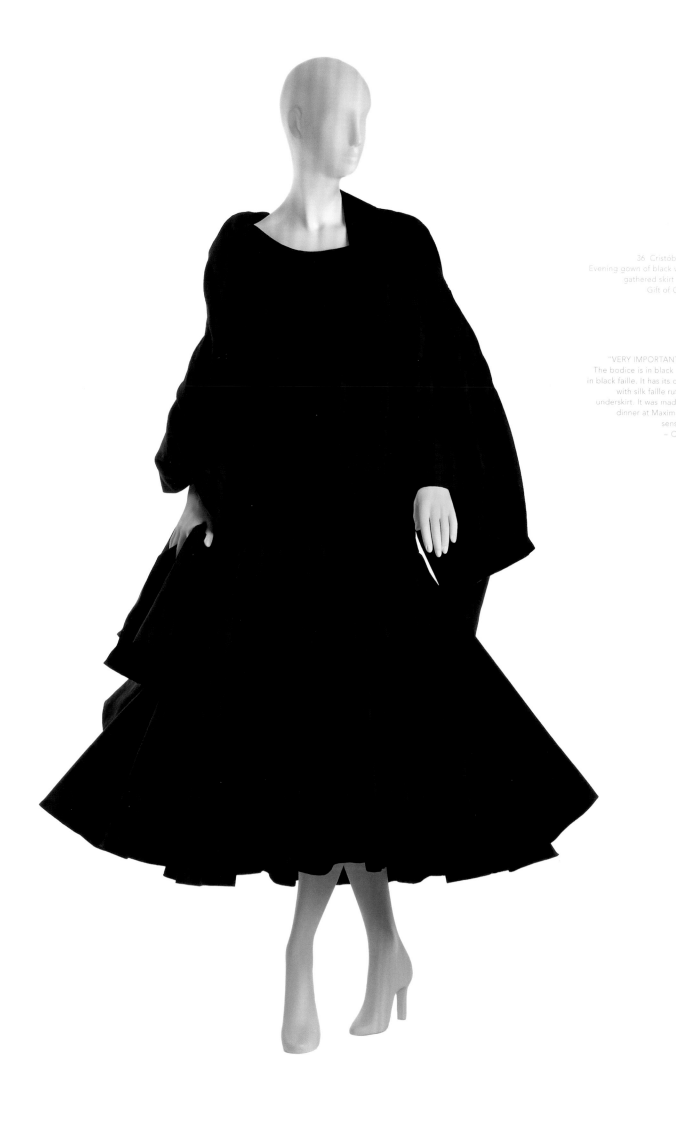

36 Cristóbal Balenciaga, 1953.
Evening gown of black wool with silk taffeta
gathered skirt and matching stole.
Gift of Claudia de Osborne.

"VERY IMPORTANT long dinner gown.
The bodice is in black wool with a full skirt
in black faille. It has its own black wool scarf
with silk faille ruffles and its own silk
underskirt. It was made for a large private
dinner at Maxim's and also caused a
sensation in New York."
– Claudia de Osborne

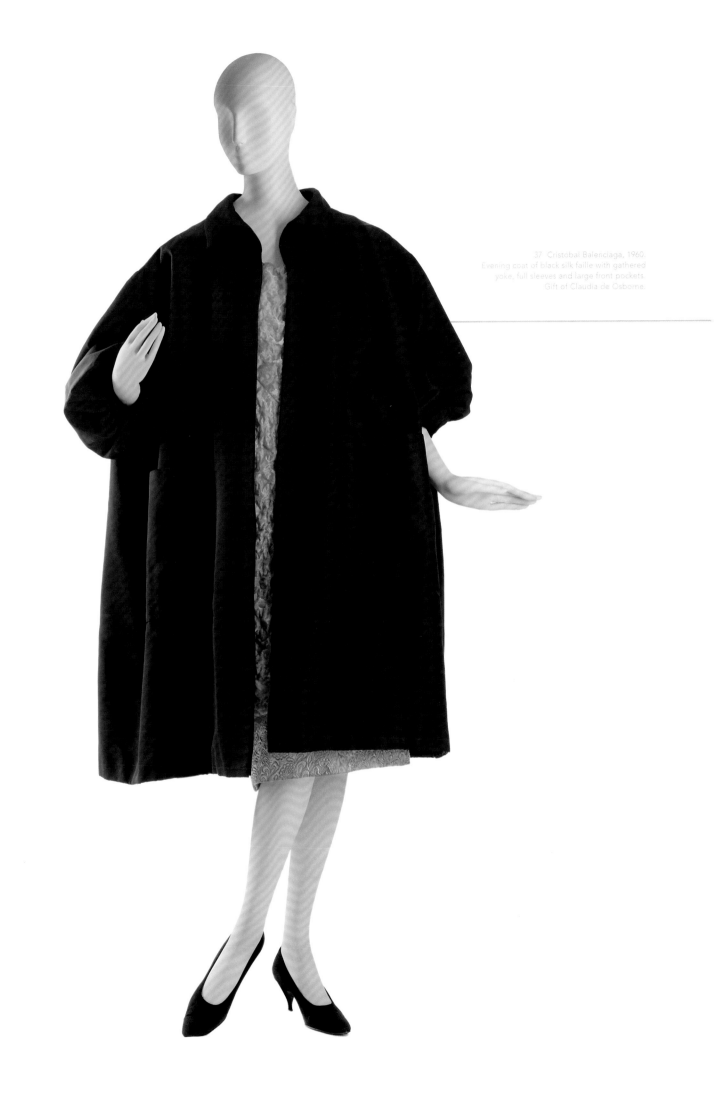

37 Cristobal Balenciaga, 1960.
Evening coat of black silk faille with gathered
yoke, full sleeves and large front pockets.
Gift of Claudia de Osborne.

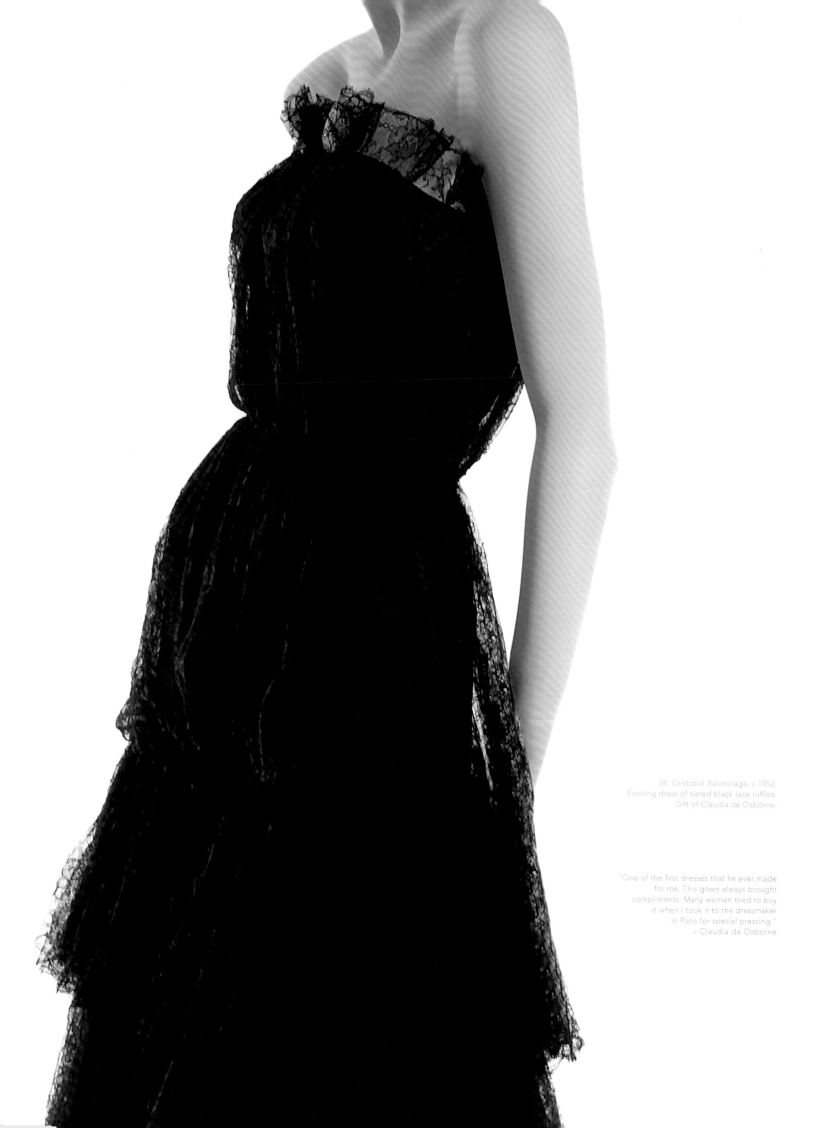

38 Cristóbal Balenciaga, c.1952.
Evening dress of tiered black lace ruffles.
Gift of Claudia de Osborne.

"One of the first dresses that he ever made
for me. This gown always brought
compliments. Many women tried to buy
it when I took it to the dressmaker
in Paris for special pressing."
– Claudia de Osborne

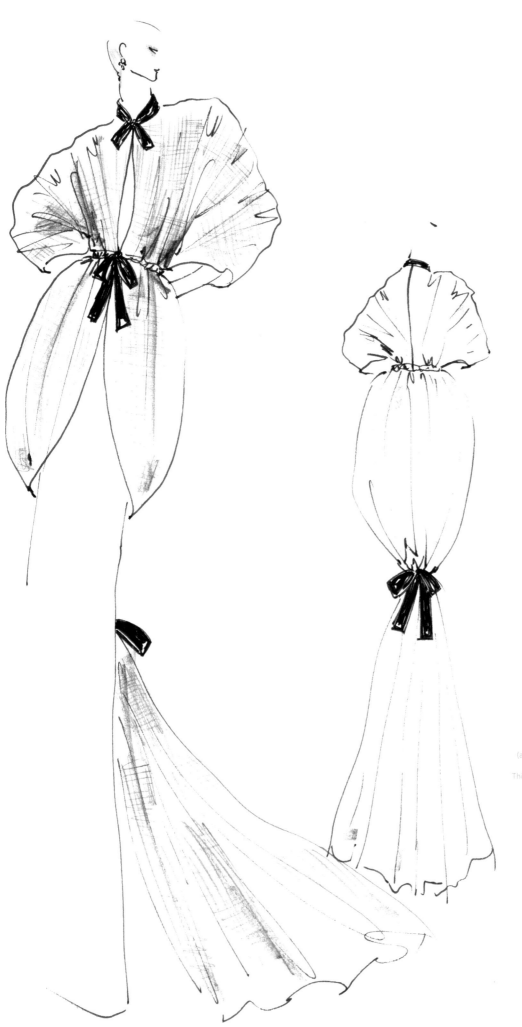

39 House of Balenciaga, c.1954
(artist unknown). Sketch of evening cape of
black silk net with silk ribbon ties.
This was another sketch provided to Claudia
for her personal use.
Gift of Claudia de Osborne.

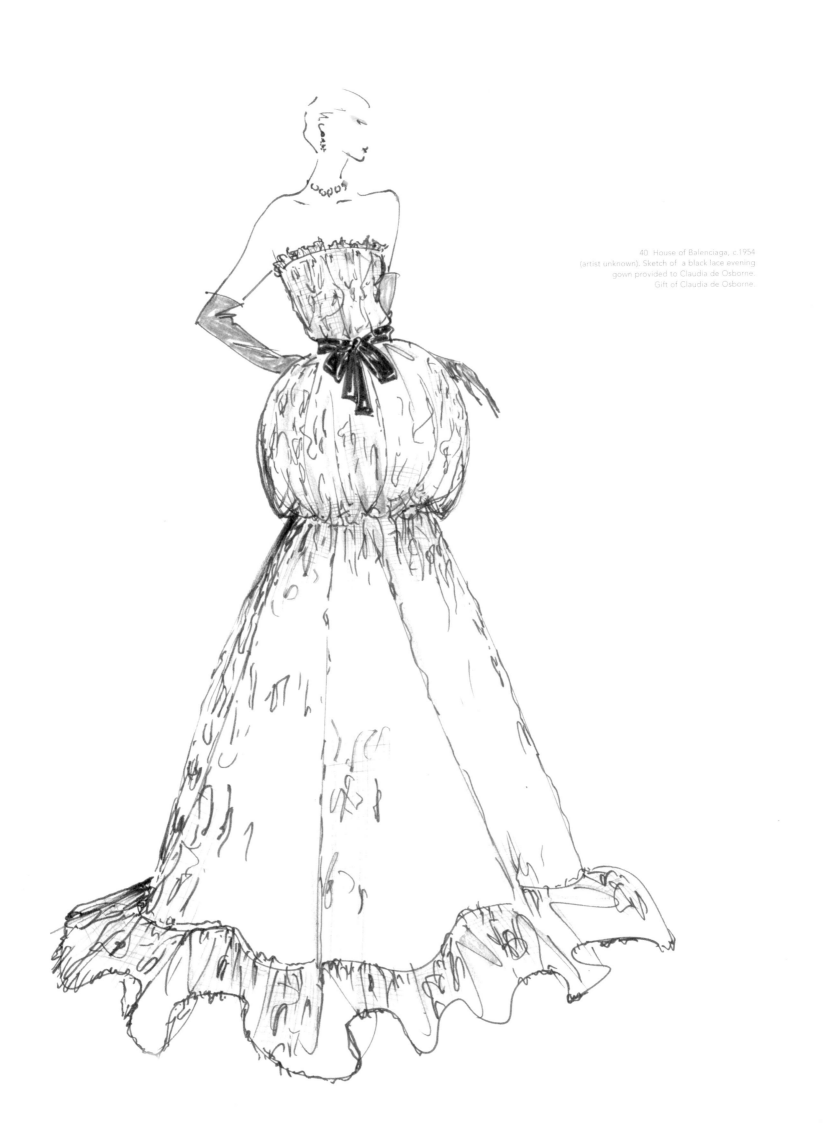

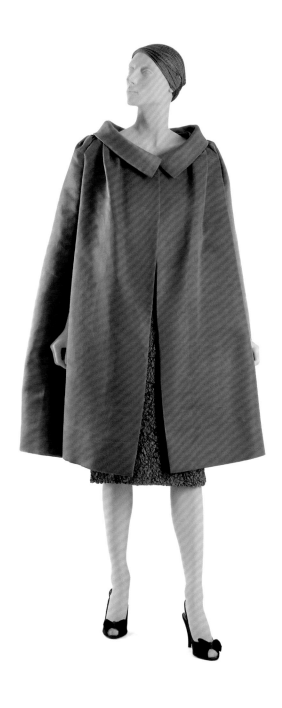

41. Cristóbal Balenciaga, c.1953.
Evening ensemble of cocktail dress of brown
ribbon lace and a tobacco silk cape.
Gift of Claudia de Osborne.

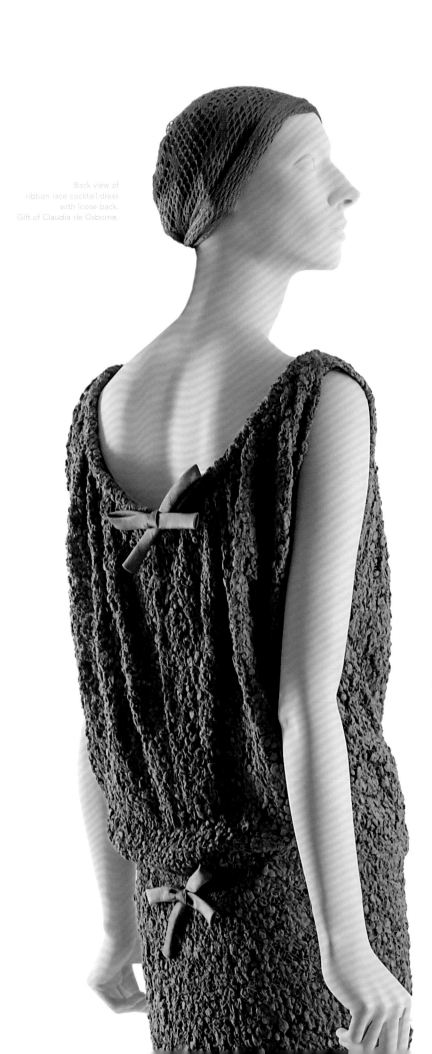

Back view of
ribbon lace cocktail dress
with loose back.
Gift of Claudia de Osborne.

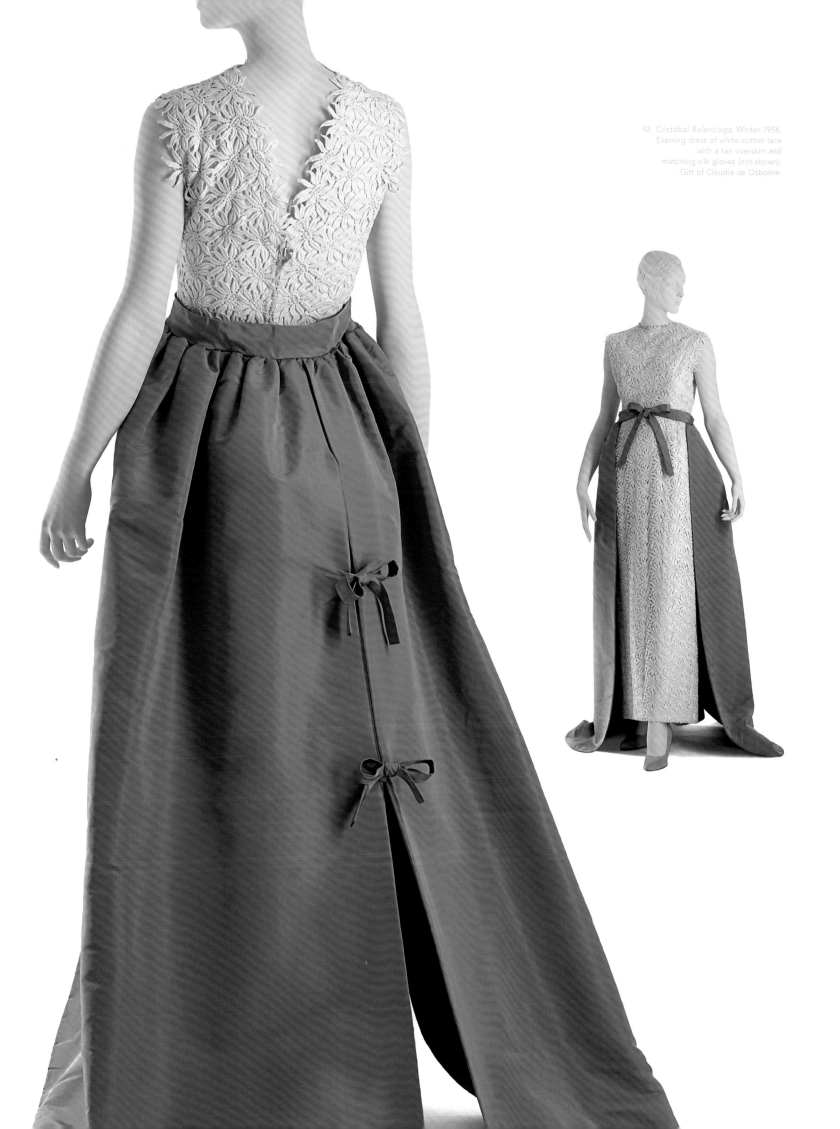

42 Cristóbal Balenciaga, Winter 1956.
Evening dress of white cotton lace
with a tan overskirt and
matching silk gloves (not shown).
Gift of Claudia de Osborne

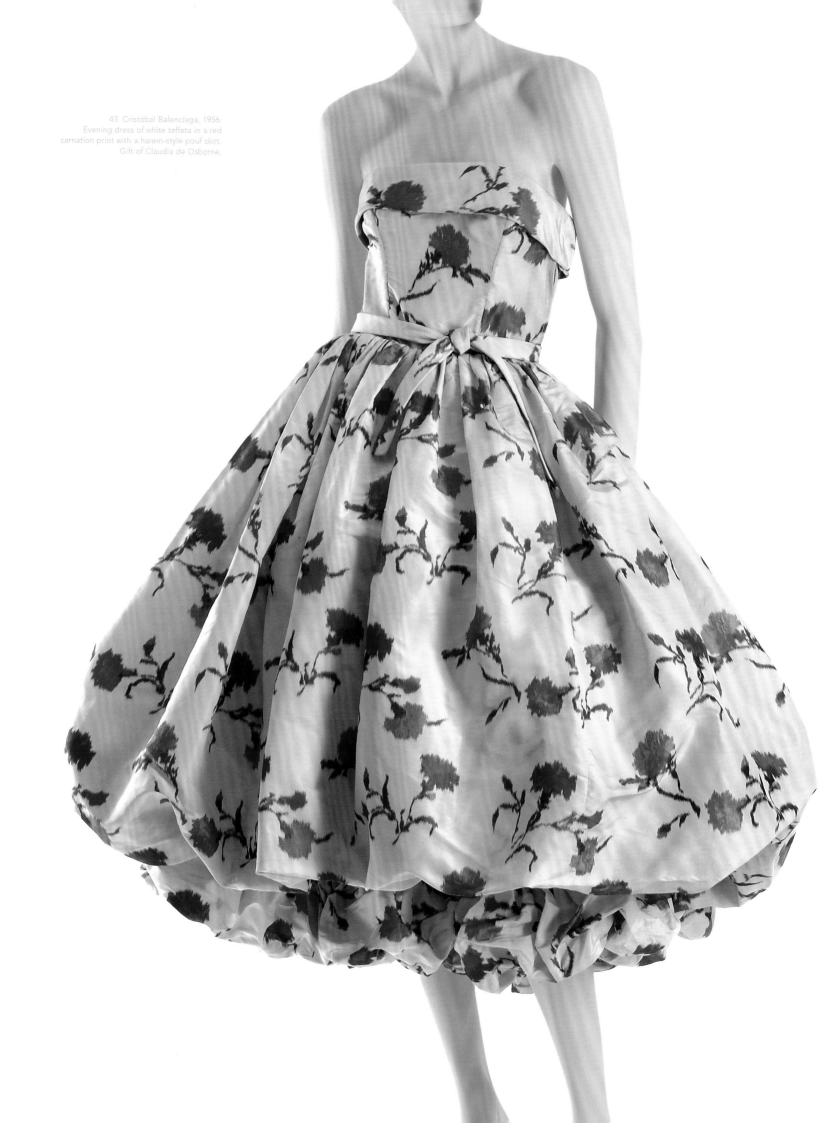

43 Cristóbal Balenciaga, 1956.
Evening dress of white taffeta in a red
carnation print with a harem-style pouf skirt.
Gift of Claudia de Osborne.

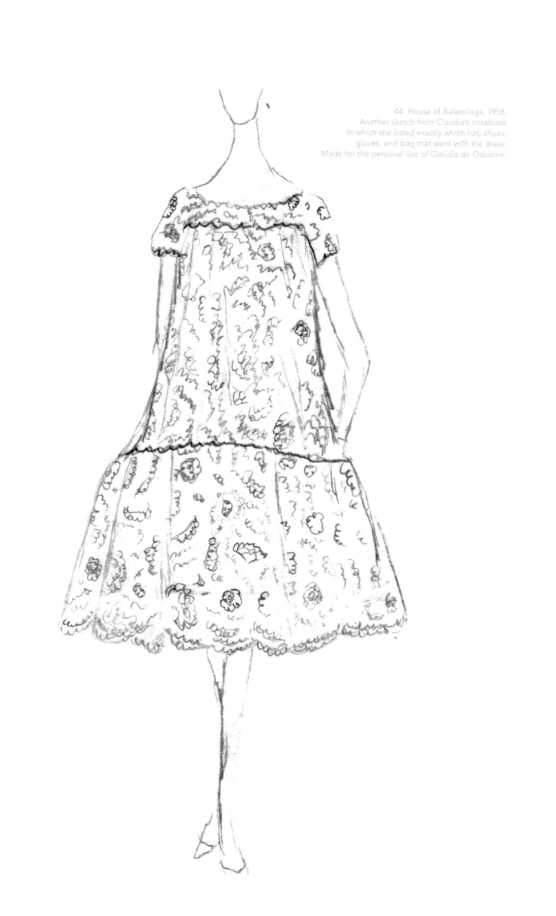

44 House of Balenciaga, 1958.
Another sketch from Claudia's notebook
in which she listed exactly which hat, shoes,
gloves, and bag that went with the dress.
Made for the personal use of Claudia de Osborne.

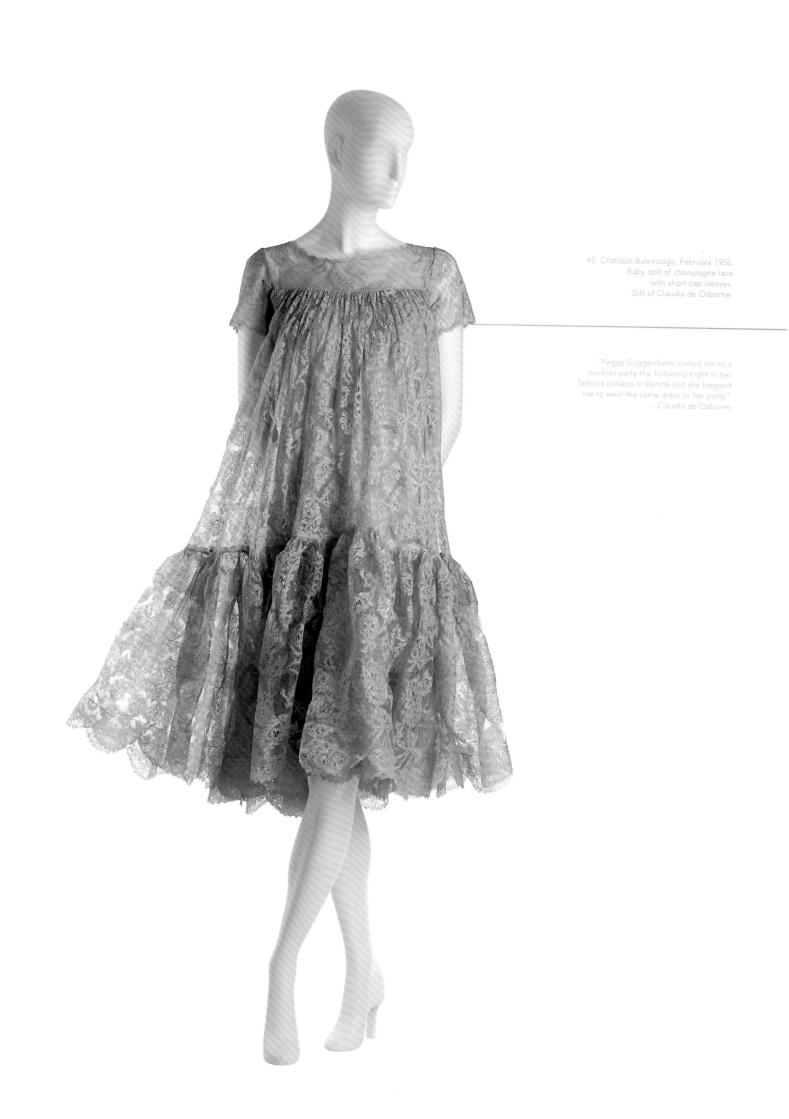

45 Cristóbal Balenciaga, February 1958.
Baby doll of champagne lace
with short cap sleeves.
Gift of Claudia de Osborne.

"Peggy Guggenheim invited me to a
cocktail party the following night in her
famous palazzo in Venice and she begged
me to wear the same dress to her party."
– Claudia de Osborne

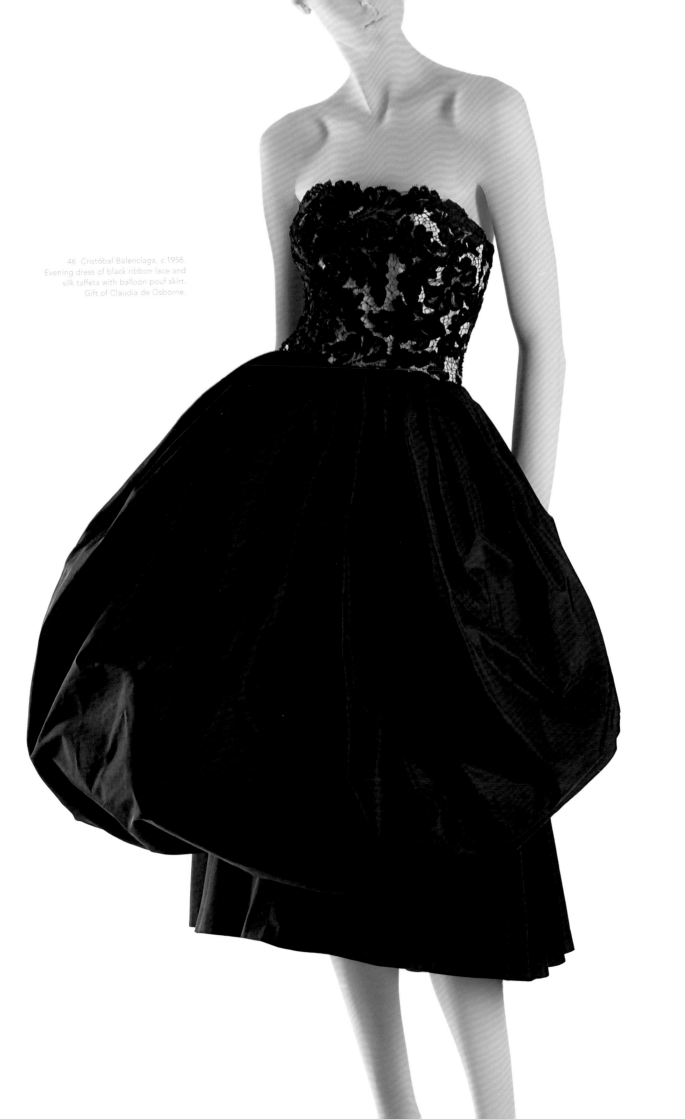

46 Cristóbal Balenciaga, c.1956.
Evening dress of black ribbon lace and
silk taffeta with balloon pouf skirt.
Gift of Claudia de Osborne.

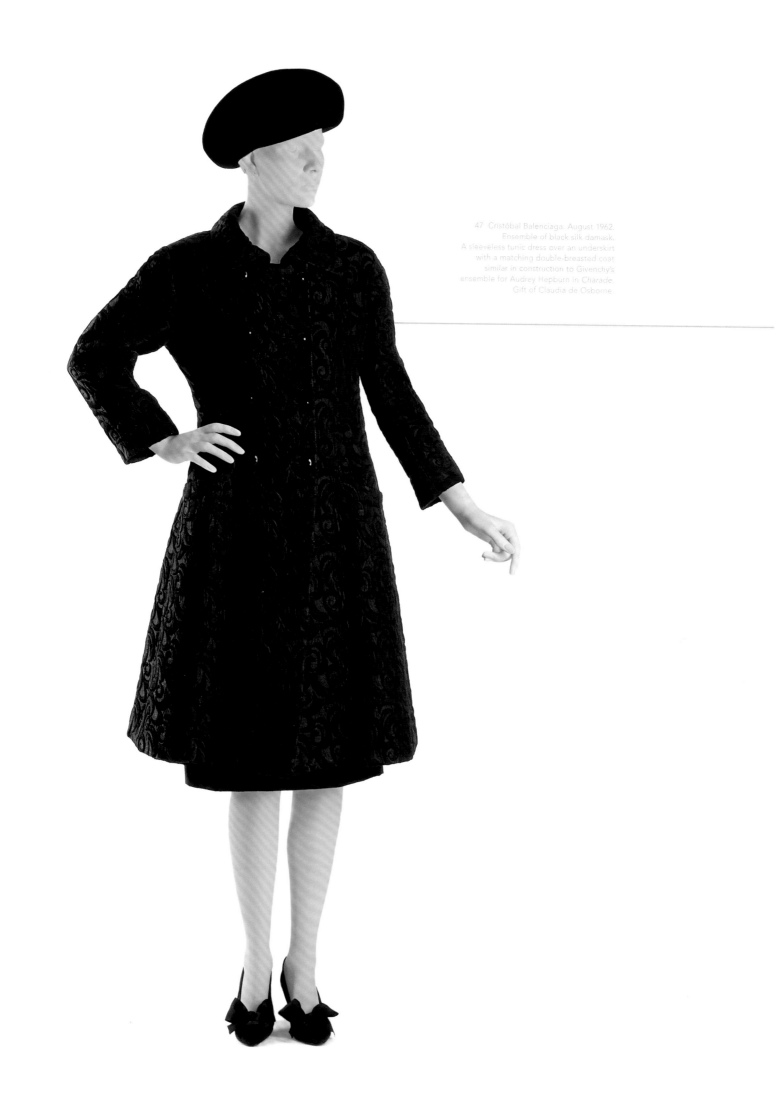

47 Cristóbal Balenciaga. August 1962.
Ensemble of black silk damask.
A sleeveless tunic dress over an underskirt
with a matching double-breasted coat
similar in construction to Givenchy's
ensemble for Audrey Hepburn in *Charade*.
Gift of Claudia de Osborne.

48 (facing page and below)
Cristóbal Balenciaga, c.1965.
Ensemble of dress and matching coat of
green and black in a textured motif.
Fabric attributed to Abraham.
Gift of Claudia de Osborne.

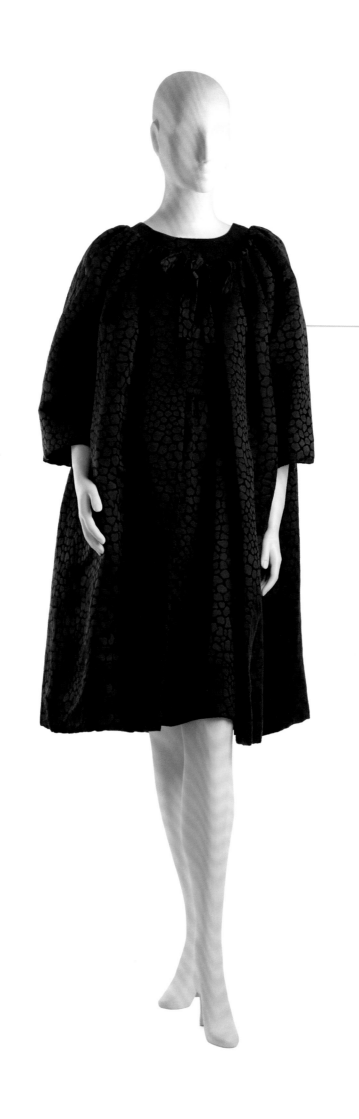

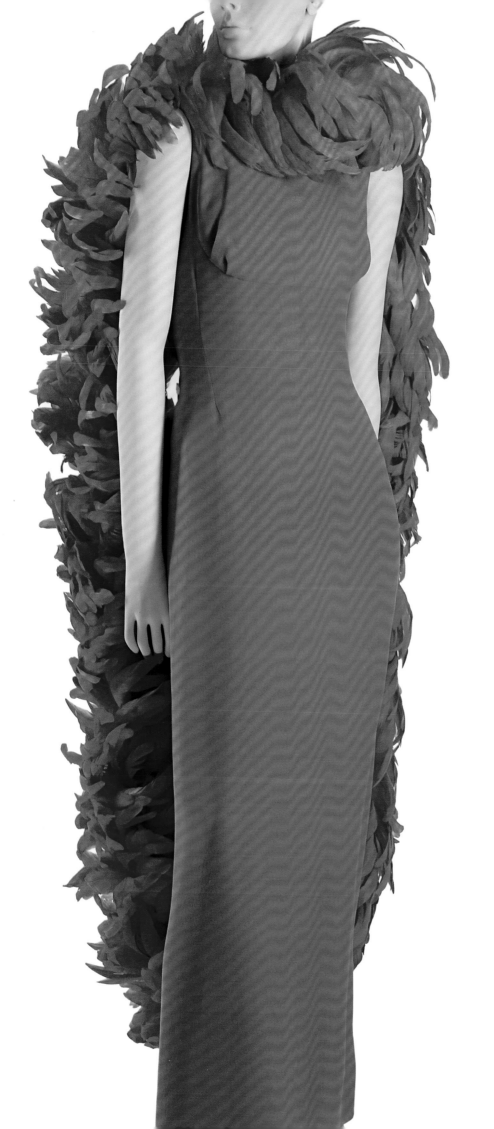

49 Cristóbal Balenciaga, Winter 1965.
Evening dress of fuchsia silk crepe
and feather boa. Claudia had matching
shoes custom made by Roger Vivier to wear
with this dress (not shown).
Gift of Claudia de Osborne.

50. Cristóbal Balenciaga, Winter 1967.
Pantsuit of a silver metallic coat with black
wool pants. The "Bird of paradise hat" was
worn by Claudia with this ensemble.
Gift of Claudia de Osborne.

51 Cristóbal Balenciaga, c.1967.
Ski suit of a tan and cream striped wool
jacket with brown faux-fur pants.
Gift of Claudia de Osborne.

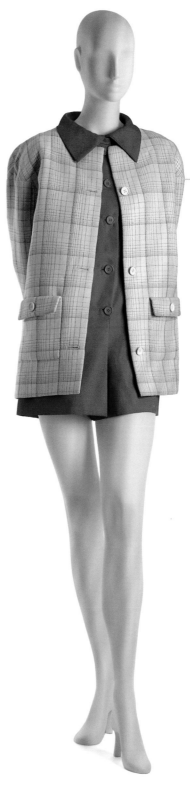

52 Cristóbal Balenciaga, 1967.
Suit of black and cream windowpane
plaid wool. Fabric by Staron.
Gift of Claudia de Osborne.

53 Cristóbal Balenciaga, 1968.
Short pantsuit with red and cream plaid
wool jacket over red cotton jumpsuit.
Gift of Claudia de Osborne.

55 Cristóbal Balenciaga, c.1962.
Hat of black satin trimmed with black
feathers and a fabric bow.
Gift of Claudia de Osborne.

56 Cristóbal Balenciaga, c.1960.
Hat of black satin trimmed with black coq
feathers and black satin ribbon.
Gift of Claudia de Osborne.

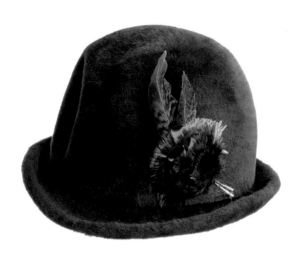

57 Cristóbal Balenciaga, c.1960.
Derby of green velvet trimmed
with mixed feathers.
Gift of Claudia de Osborne.

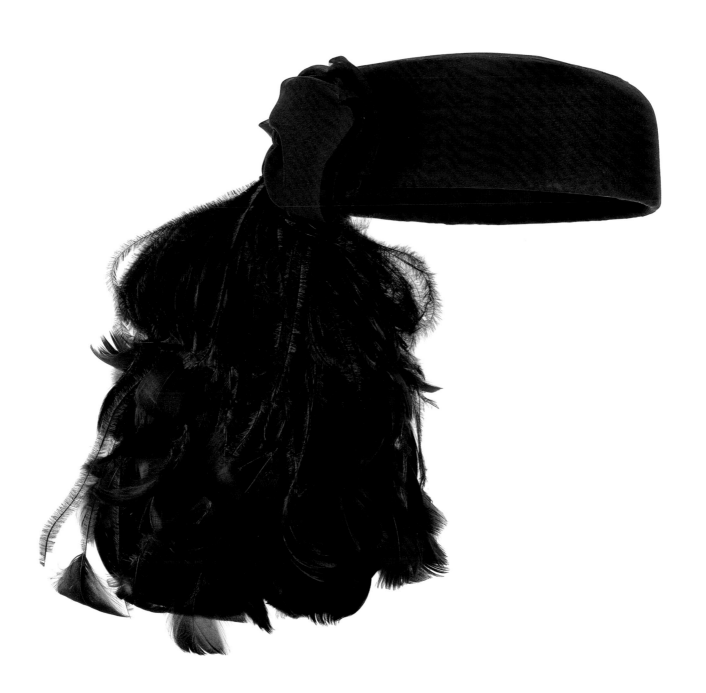

59 Cristóbal Balenciaga, c.1960.
Hat of black velvet with a jeweled brooch
attributed to Robert Goossens of Paris.
Gift of Claudia de Osborne.

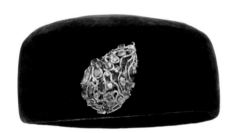

60 Cristóbal Balenciaga, c.1960.
Hat of brown velvet with gold jeweled
brooch by Robert Goossens of Paris.
Gift of Claudia de Osborne.

61 Cristóbal Balenciaga, c.1963.
Hat of green satin covered with
green feathers with a jeweled brooch.
Hat of pink satin covered with
pink feathers and a rhinestone brooch.
Gift of Claudia de Osborne.

62 Cristobal Balenciaga, c.1955.
Hat of black "Bird of Paradise"
feathers and silk net.
Gift of Claudia de Osborne.

63 Cristóbal Balenciaga, c.1960.
Pillbox hat covered in magenta silk flowers.
Gift of Claudia de Osborne.

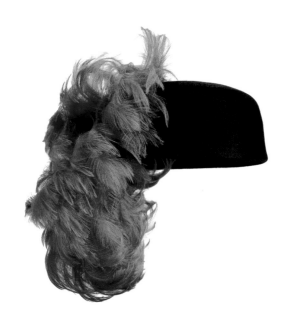

64 Cristóbal Balenciaga, c.1955.
Black satin pillbox hat
trimmed with green feathers.
Gift of Claudia de Osborne.

65 Cristóbal Balenciaga, c.1960.
Hat of leopard fur with a curved brim
and black leather hatband.
Gift of Claudia de Osborne.

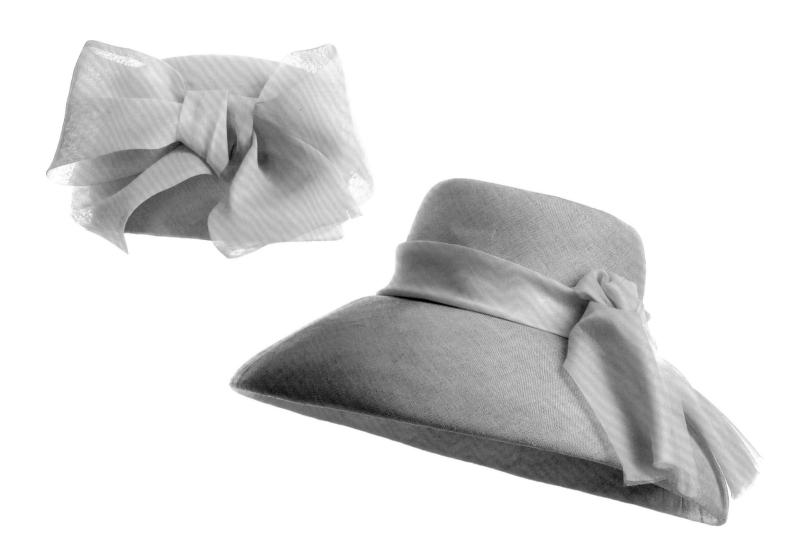

66 Cristóbal Balenciaga, c.1960.
(left) Pillbox hat of white organdy
trimmed with a large fabric bow.
Gift of Claudia de Osborne

(right) Cristóbal Balenciaga, c.1965.
Large brimmed hat of natural straw trimmed
with white organza sash at crown.
Gift of Claudia de Osborne.

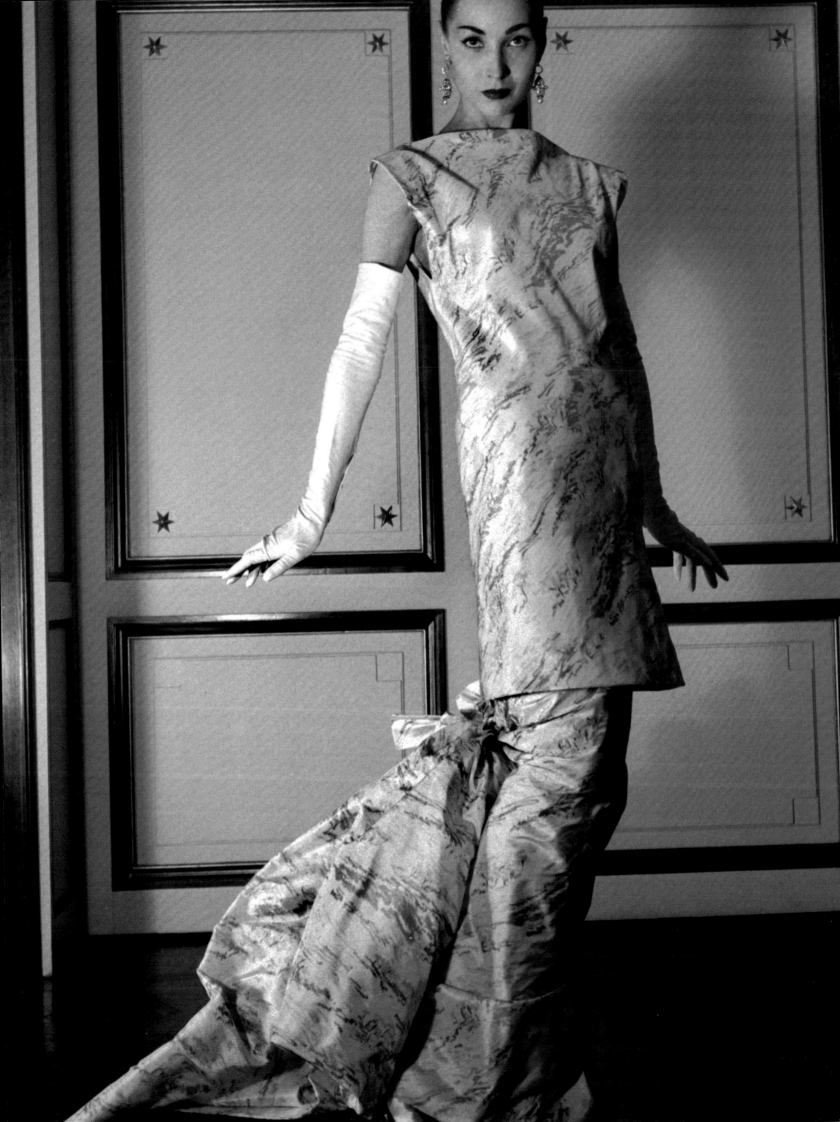

Myra Walker with Lawrence Marcus

NEIMAN MARCUS
A Fashion Capital

It has been said, that in order for the transmission of culture to occur, there must be a place for it to happen. Neiman Marcus became the touchstone of taste and style from the very beginning, when it opened its doors for business on 10 September 1907. A large newspaper advertisement the day before declared, "Quality – A Specialty Store." At Neiman Marcus, a woman could buy "tailored suits, evening gowns and wraps, furs, demi-costume, coats, dresses, modish waists, dress and walking skirts, petticoats, and millinery." Dallas had never before seen such apparel as this, imported directly from New York and Paris. Women came in by the score, then the hundreds, and they shopped voraciously. A discriminating clientèle was established, and it developed a sophisticated eye for fashion.[1]

Neiman Marcus was founded by Herbert Marcus, his sister, Carrie Marcus Neiman, and her husband at the time, A. L. Neiman (also known as "A. L."). Together, they created a flourishing emporium and were never discouraged. On 1 January 1913, the *Dallas Morning News* featured a story with a photo of Herbert, and A. L. Neiman, extolling their success and business savvy. Throughout World War I, and despite a devastating fire that caused them to move to the store's present location at 1618 Main Street, they continued to thrive. Stanley Marcus, Herbert's eldest son entered the business in 1926. A year later (the twentieth anniversary), the owners doubled the size of the store. Around that time, Carrie and A. L. were divorced, and A. L. subsequently sold his interest in the store. Another Marcus son, Edward, an accountant, joined the family business in 1928. The store recognized that customer service took many forms, and Neiman Marcus was the first department store to install air-conditioning for the comfort of their customers – a significant event in light of the Texas climate.[2]

During these formative years, Herbert Marcus and Carrie Marcus Neiman traveled frequently to Europe. The styles they saw at Paris fashion shows were often translated into garments in the burgeoning manufacturing district in Manhattan. At this time, it was Ms. Neiman who handled the selection and buying of women's fashions for the store. Moira Cullen, who joined Neiman Marcus in 1918, was trained under the watchful eye of Ms. Neiman as a fashion buyer and merchandise manager.[3]

This magic mixture of personalities and commerce culminated in the store's creating its own international Neiman Marcus Fashion Awards in 1937, which were given to individuals or companies noted for "Distinguished Service in the Field of Fashion." The first awards were announced in 1938, and at various times subsequently the awards were referred to as the "Oscars" of the fashion industry. They were given not only to fashion designers; often a movie star or other fashionable celebrity was singled out for an award on account of personal style. During World War II, Americans made up the roster of nominees, but as soon as the war ended, the Neiman Marcus buyers returned to Paris, along with many other buyers and members of the press. All were anxious to see the latest in post-war fashion. Neiman Marcus was keen to acknowledge Christian Dior for the creation of the "New Look," and M. Dior accepted in person his Neiman Marcus Fashion Award in 1947, together with fellow recipients Irene of Hollywood and Italian shoe designer Salvatore Ferragamo (the British designer Norman Hartnell was also given an award that year but was unable to travel to Dallas for the event).[4]

The presentation of the Fashion Awards was timed to coincide with the establishment of the Neiman Marcus Fashion Exposition. It was a brilliant marketing strategy, since Stanley Marcus invited every significant American manufacturer to the awards ceremony, a prestigious event to which an invitation was much sought after. Neiman Marcus always understood the importance of cultivating and sustaining business relationships. The ceremony was held on the first Saturday evening after Labor Day. The big night featured a fashion show that had been weeks in the planning. Haute-couture designs from Paris were paraded on stage, mixed in with American designs already carried by Neiman Marcus. Although haute couture was not usually sold in the store, Neiman Marcus, on this occasion only, would invest in haute-couture selections as a marketing device and deftly sold the idea of French fashion through the presentation of its fashion shows.[5]

In the first instance, the Fashion Exposition was presented to an elite crowd of award winners, their guests, and invited industry guests. Neiman Marcus shrewdly included all of its most important suppliers, not just those associated with the fashion industry. This decision made everyone with whom the store did business feel specially involved with the Neiman Marcus "inner circle." All attendees were entertained in style on Saturday evening, followed by a brunch on the Sunday morning. On Sunday evening, an even more coveted invitation was issued to a VIP list, for a cocktail party hosted by Stanley and Billie Marcus at their home on Nonesuch Place in Dallas.[6]

Neiman Marcus did not forget the customer in all this revelry. On Monday night, the public was invited to attend a command performance of the fashion show. The entire first floor of the store was cleared out and transformed into a runway. Customers would come from all over the region to enjoy this unique spectacle. Its popularity grew to a peak in the mid-1950s, with the audience reaching 500 on Monday evenings. Later, a Tuesday night presentation was added after more than 1,200 customers clamored for tickets.[7]

The Fashion Exposition was a great example of the credo of Neiman Marcus. They entertained and educated their customer to desire what they offered – which was the height of good taste and great style. Stanley Marcus brilliantly presented fashion to the store's clientèle via French haute couture and succeeded in making the customer feel a part of the excitement. Later in the season, after the shows, many of these original Paris fashions were sold at a reduced rate to Neiman Marcus customers, who were tipped off by knowing salespersons eager to please. This backroom sales activity is corroborated by Alexandra Palmer in her book, *Couture and Commerce: The Transatlantic Fashion Trade in the 1950s*: "Couture was seen by stores, and especially by department stores, as cultural capital. The value of featuring couture in fashion shows and having it worn by leading socialites who patronized the store went beyond dollars and cents. Having these clothes available demonstrated a merchant's link to European design."[8]

The careful selection of high fashion to stimulate interest and sales was the purview of a select few. Stanley Marcus and Carrie Marcus Neiman traveled through much of Europe, as part of their "quest for the best," both

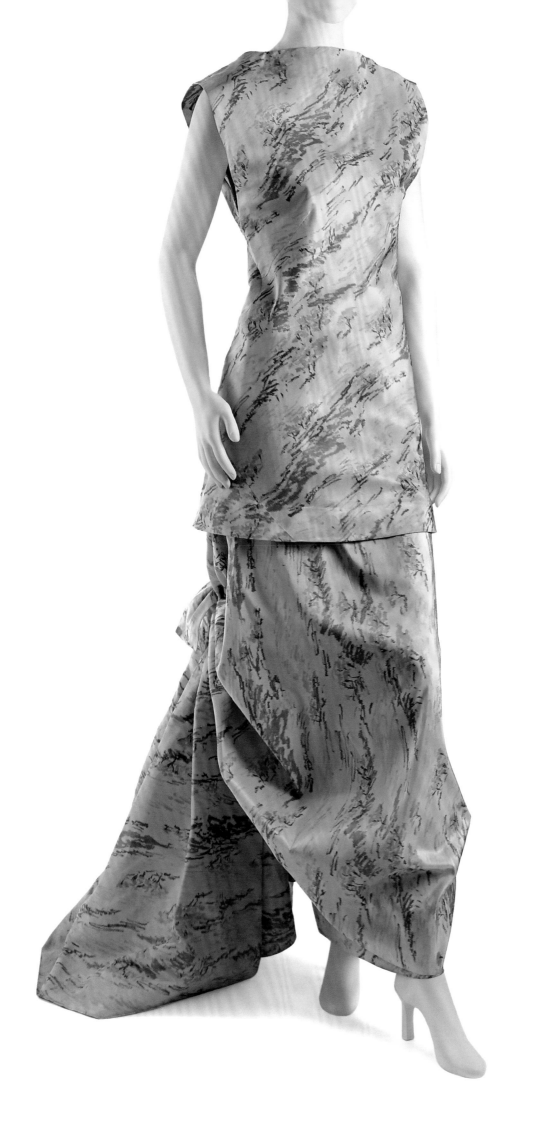

before and after World War II. These trips included attending Paris fashion shows, which was arranged by the store's Paris office. Moira Cullen, second in influence only to Ms. Neiman, lived in New York in order to work closely with the manufacturers on the final product for the store, although the manufacturers were not always pleased to have the meticulous and detail-minded Cullen looking over their shoulders. She also spent several months each year in Dallas, in order to acquaint herself with the requirements of Neiman Marcus customers. This immersion meant that, back in New York, she was able to oversee such steps as the implementation of Neiman Marcus's demand for changes in fabrics to make them more suitable for the Texas climate, or the push for a better fit. When a young Lawrence Marcus returned from serving in World War II, he was sent to New York to be tutored in the fashion business by Cullen. As Stanley and Edward became more absorbed in the daily details of management, it was Lawrence who was to be sent out into the world to discover and develop new ideas for fashion marketing. Mr. Marcus has recorded that Cullen imparted an invaluable wealth of knowledge and insight to him during his time with her in Paris, before her retirement in 1946.[9]

Another intriguing personality in the Neiman Marcus stable was Bert de Winter, whose career and life revolved around fashion at the store. Her wardrobe consisted of more than seventy-five Balenciaga haute-couture ensembles, which she wore to work at the store, generating a great deal of fashion envy among the other buyers and, most likely, in some of her own clients, too. Her unfettered personality is indicative, however, of the way that Neiman Marcus gave free reign to someone who showed genuine flair and good business sense. Throughout the late 1950s and the 1960s, several of Bert de Winter's ensembles migrated from her personal wardrobe into the Texas Fashion Collection – after she had made the most of wearing the latest styles. Upon her death in 1972 the bulk of her wardrobe was received by Edward and Betty Mattil, who made a mad dash to Dallas the night before the estate sale in order to have first choice of de Winter's collection. Ms. de Winter championed many other designers, especially after the retirement of Balenciaga in 1968, but her avowed preference was always for Balenciaga.[10]

Bert de Winter was by all accounts a remarkable woman who held a unique and somewhat unassailable position within Neiman Marcus. Her early personal history is largely unknown prior to her arrival at Neiman Marcus in the early 1950s. Former Neiman Marcus display designer Allen Shaffer recalls her as a fascinating woman who maintained an air of privacy with hints of an aristocratic past. At times, she was referred to as the "Countess Bert de Winter." Everyone at the store was in awe of her impeccable style. The photographer Cecil Beaton, who was a keen observer of fashion and visited Balenciaga in Paris, wrote that one of Balenciaga's tenets was that "No dressmaker can make a woman chic, if she is not chic herself."[11] There is little doubt that, from all accounts of Bert de Winter, she was exceptionally chic.

Apart from the beauty salon, which was run by an outside company, the only other space that Neiman Marcus ever leased to another vendor was the millinery boutique owned by the Neveleff brothers and their partner,

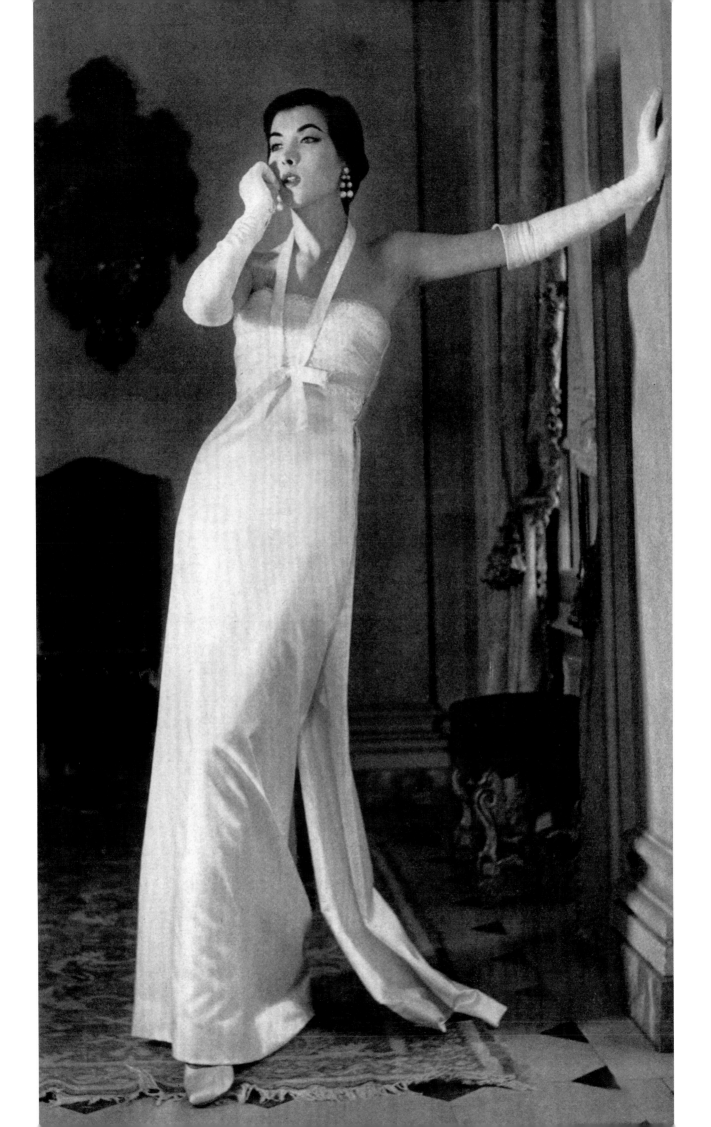

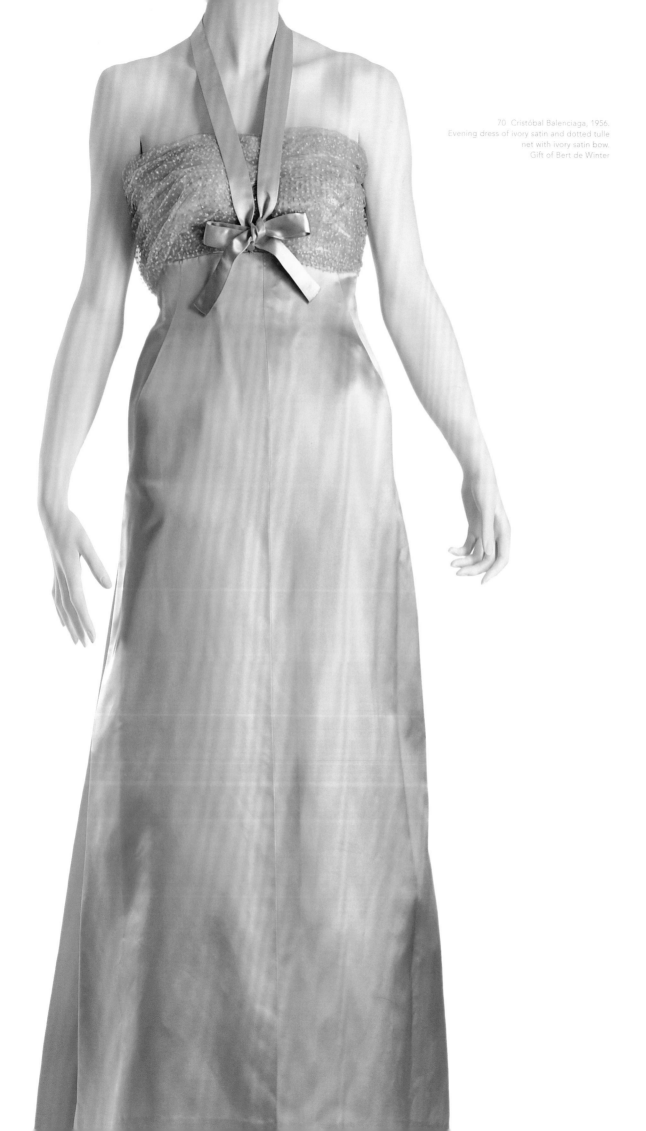

70 Cristóbal Balenciaga, 1956.
Evening dress of ivory satin and dotted tulle
net with ivory satin bow.
Gift of Bert de Winter

J. Lechin, who were based in New York. However, their chief buyer and resident expert on fashion trends was Bert de Winter. Armed with an expense account from the Neveleffs, de Winter traveled to Paris for the fashion shows, along with the other Neiman Marcus buyers. (By the 1950s, there were three women's fashion buyers: Laura Goldman, who had been a protégé of Moira Cullen; Evelyn Berger; and Emma Sadler, who has been described as a crisp businesswoman who appeared quite reserved in her Irene suits, but who, according to Lawrence Marcus, once abruptly left him stranded in New York in the middle of work, to marry her sweetheart.[12]) It is evident that the Neveleff brothers supported their fashion muse in high style. She always stayed at the Ritz Hotel on her twice-yearly trips to Paris, where she commanded a personal limousine with the same driver every time. Lawrence Marcus mentioned that this treatment was another example of how she set herself apart from the other buyers for Neiman Marcus, who were certainly not housed at the Ritz.

In Paris, de Winter would buy hats and millinery, attending as many shows of the season as possible, where she absorbed ideas like a sponge. Almost certainly, her favorite thing to do in the city during the 1950s would have been to shop for herself. Because of her association with Neiman Marcus, she was graciously received and treated well: Mme Florette Chelot, her *vendeuse* at the House of Balenciaga, recalls being assigned to her exclusively. De Winter alternated from selecting the latest fashion-forward Balenciaga couture ensembles to shopping for Balenciagas offered at a discount from the prior season. This kind of entrée was allowed only to very special customers. The sales books of Mme Chelot contain her handwritten records of all de Winter's purchases, including notations about new season purchases and also those she bought on sale. These records are an invaluable source for dating many of de Winter's purchases at the House of Balenciaga. Mme Chelot has also verified that de Winter selected and paid for the garments under her own name and had them fitted while she was in Paris. Special treatment was extended to her because of her connection with Neiman Marcus, but she patronized the House of Balenciaga because of her personal preference for his designs.[13]

The millinery salon at Neiman Marcus was located on the first floor. As business increased, Bert de Winter, in partnership with the Neveleff brothers, leased an additional boutique space, which was ideally located exactly where customers got off the second floor escalator. Her office was just behind this boutique, separate from the other fashion buyers. Neiman Marcus gave her *carte blanche* as to what was sold in this small cubicle of fashion heaven. She was allowed to purchase anything from a vendor and sell it, as long as the other Neiman Marcus buyers were given first choice for larger orders. Able to buy just one or two items from a designer or vendor, she was quite selective and branched out into buying anything that she felt would be a success, creating an air of competition for sales inside Neiman Marcus. The store continued its unconventional business arrangement with the Neveleffs and De Winter throughout the 1950s and 1960s. Customers considered Bert de Winter's fashion sense and expertise as an essential part of their fashion experience.

Until now, the exact nature of the Balenciaga garments once belonging to Bert de Winter and now housed in the Texas Fashion Collection, has been unclear. Only a few of the suits and dresses bear a Neiman Marcus label in addition to the Balenciaga couture label. Research has confirmed that the bulk of de Winter's wardrobe was purchased for her personal consumption, and she proudly wore her Balenciaga suits in her professional capacity at Neiman Marcus. There are also numerous lavish cocktail and evening gowns by Balenciaga that she no doubt wore with great pleasure. It is important to note that the few suits in the Texas Fashion Collection that did not belong to de Winter were donated directly by Neiman Marcus. The only other Balenciaga designs that were donated, besides those belonging to Claudia Heard de Osborne's extensive collection, are three beautiful bias-draped evening gowns that were owned by the American designer Adele Simpson. Simpson too, always made the twice-yearly pilgrimage to Paris to view the collections.

The Texas Fashion Collection contains very few Balenciaga ensembles or evening gowns that belonged to other Dallas women. Such items include a lovely dress purchased by Mrs. Malcolm Wilson at Eisa (fig. 95) while she was visiting Mr. and Mrs. Algur Meadows when they lived in Madrid, and a beige wool bodice, worn by Mrs. Stanley Marcus. The larger point is that Bert de Winter appears to be the only person in Dallas who amassed such a comprehensive Balenciaga wardrobe straight from Paris. This fact does not mean that other women did not find their way to the House of Balenciaga, but it does support the earlier statements that Neiman Marcus conducted business in the way that was most profitable. "Couture" was procured in the traditional way, with the store's buyers making selections they deemed viable for their Texas clientèle. Garments were ordered from the various fashion shows, and couture items were eventually sent directly to the store. However, the original couture examples seem to have been used only for the marketing of French fashion, via the Neiman Marcus Fashion Exposition and the frequent fashion shows presented at the in-store restaurant, the Zodiac Room. Alexandra Palmer explains: "European couture design was promoted by country of origin through the fashion press and by the local retailer."[14]

The relationship among the press, department stores and the fashion industry was critical to each of them. *Vogue* and *Harper's Bazaar* heralded the latest trends; fashion periodicals functioned as the main conduit for the transmission of important fashion images directly to the customer. For example, Carmel Snow, editor of *Harper's Bazaar*, took an early interest in the career of photographer Richard Avedon. Snow first took Avedon to Paris on the sly, even though another photographer had been given the assignment. She then ran a three-page spread with Avedon's photos instead. Avedon recalled:

When Carmel took me on, I didn't know a thing about fashion. I didn't know anything about *le monde* – you know, "the world." When she took me to Paris she introduced me to people I'd never heard of – Colette, Cocteau, Bérard. In New York, she'd say, "I want you to come to dinner with such-and such," always creative people. She was always telling me about a book I should read, an artist whose work I should look at – never

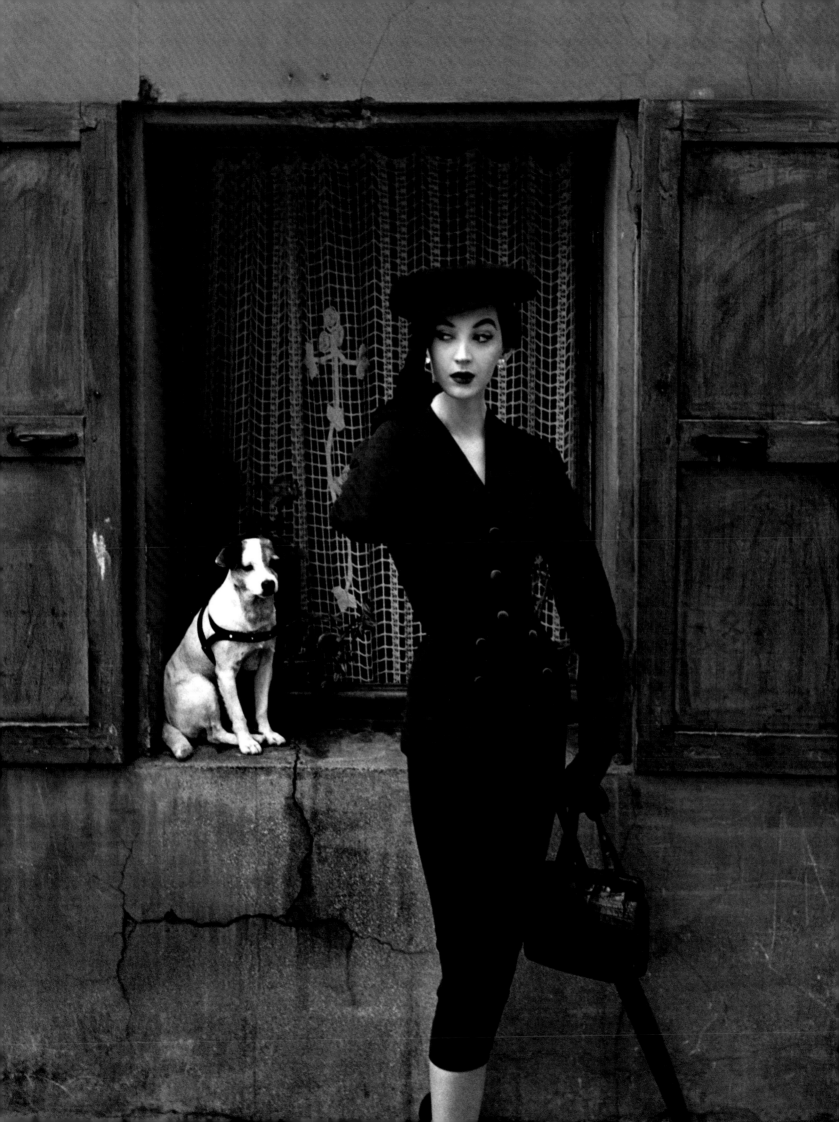

another photographer. She was enlarging my world. Brodovitch had brought out my quality as a photographer, and because Carmel immediately recognized it, she said, "Publish his work exactly as it is." But what she taught me about fashion! After that first "secret" trip, I always sat beside Carmel at the collections I photographed. She took me into a world I couldn't have understood without her. Some of it was the world of her imagination ("In the old days, there was a mystery in every buttonhole"), but she got across to me what I was then able to get into my pictures.

When we looked at my pictures together, she went straight to the human quality: "There's a look in this eye . . .". She showed me what was good and what was bad in my pictures and the fashions. She's the only editor whose judgment I could ever rely on.[15]

Snow was also a loyal champion of Balenciaga's vision and never wavered in her coverage of his work in *Harper's Bazaar*.

Neiman Marcus consistently took out advertisements in major fashion magazines. There was clearly a symbiotic relationship, based on the common agreement that Paris fashion reflected the epitome of taste and style. However, Paris styles were retooled for ease of manufacturing and the better to suit the American market.

Lawrence Marcus has confirmed that Paris fashion was the benchmark for all retailers and manufacturers during the 1950s but especially for Neiman Marcus. Mr. Marcus recounts how many visitors came to the store to study the clothes:

It was always interesting during my years to see the designers who really had intellectual curiosity. They would come down for shows and would ask the buyers if they could visit our stockrooms, so that they could examine in detail how their competitors or leaders might make the article. Neiman Marcus educated other designers. I always had a great deal of respect for them. They were not there to copy but to learn some of the hidden skills that are buried inside well-designed and well-made pieces of clothing.[16]

Neiman Marcus put its reputation on the line, especially when it came to fashion. Executives, including Stanley and Edward Marcus and, later, Lawrence Marcus, regularly traveled the world. They nurtured talented employees like Bert de Winter and held her opinion in high regard. The store promoted women in a professional capacity, long before the campaign for women's liberation. It invested in the fashion industry by sending its most trusted representatives to the Paris collections, ultimately in service of the customer. Recognizing Paris as a cultural summit, the fashion arbiters of Neiman Marcus staked their claim and returned to Texas to offer the rewards of haute couture, establishing the store's reputation as an American fashion capital.

1 MA 82.5, Neiman Marcus Archives Collection, Texas/Dallas History and Archives Division, Dallas Public Library Archives.

2 Ibid.

3 Lawrence Marcus, interview by the author, 1 March 2006.

4 Dallas Public Library Archives, Dallas, Texas.

5 Ibid.

6 Ibid.

7 Ibid.

8 Alexandra Palmer, *Couture & Commerce: The Transatlantic Fashion Trade in the 1950s* (Vancouver, BC: The University of British Columbia Press in association with the Royal Ontario Museum, 2001), 71.

9 Lawrence Marcus, interview by the author, 1 March 2006.

10 Ibid.

11 Cecil Walter Hardy Beaton, *Glass of Fashion* (Garden City, N.Y., Doubleday, 1954), 310.

12 Lawrence Marcus, interview by the author, 1 March 2006.

13 Mme Marie Andree-Jouve, Mme Florette, interview by the author, Paris, France, 5, 7, and 9 March 2005.

14 Palmer, *Couture & Commerce*, 116.

15 Carmel Snow, *The World of Carmel Snow* (New York: McGraw-Hill Book Company, Inc., 1962).

16 Lawrence Marcus, interview by the author, 1 March 2006.

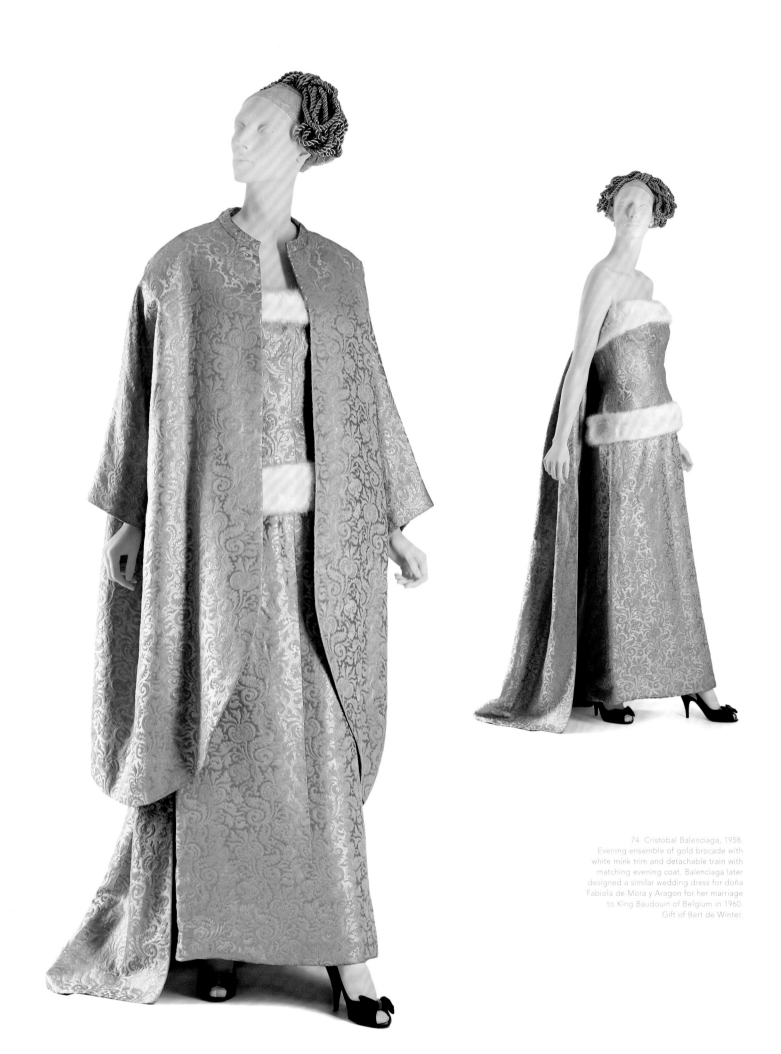

74 Cristóbal Balenciaga, 1958.
Evening ensemble of gold brocade with
white mink trim and detachable train with
matching evening coat. Balenciaga later
designed a similar wedding dress for doña
Fabiola de Mora y Aragon for her marriage
to King Baudouin of Belgium in 1960.
Gift of Bert de Winter.

75 Cristóbal Balenciaga, c.1960.
Bowler hat of pink stitched wool
trimmed with a small black bow.
Gift of Mrs. Lee Hudson

76 (below) Cristóbal Balenciaga, 1956.
Toque hat of magenta silk leaves and net.
Gift of Adele Simpson

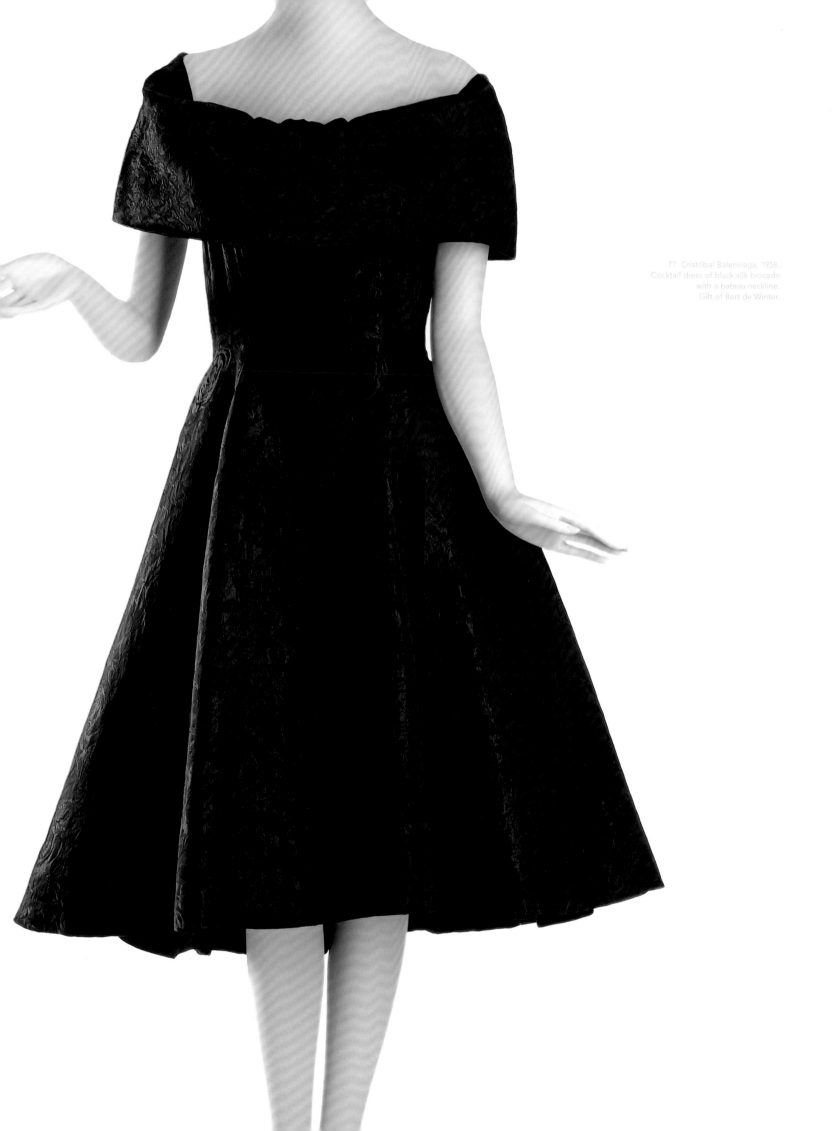

77 Cristóbal Balenciaga, 1958.
Cocktail dress of black silk brocade
with a bateau neckline.
Gift of Bert de Winter.

78 Cristóbal Balenciaga, 1959
Cocktail dress of fuchsia pink silk brocade
with a draped bustle.
Gift of Bert de Winter

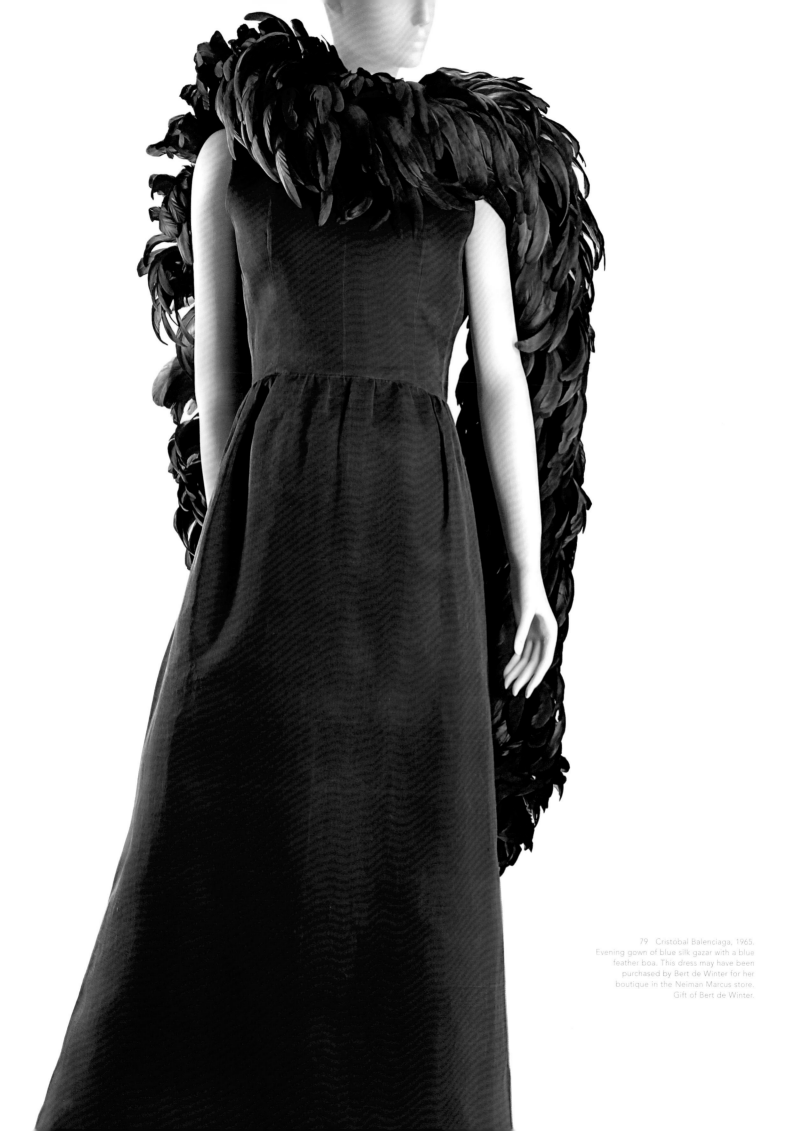

79 Cristóbal Balenciaga, 1965.
Evening gown of blue silk gazar with a blue
feather boa. This dress may have been
purchased by Bert de Winter for her
boutique in the Neiman Marcus store.
Gift of Bert de Winter.

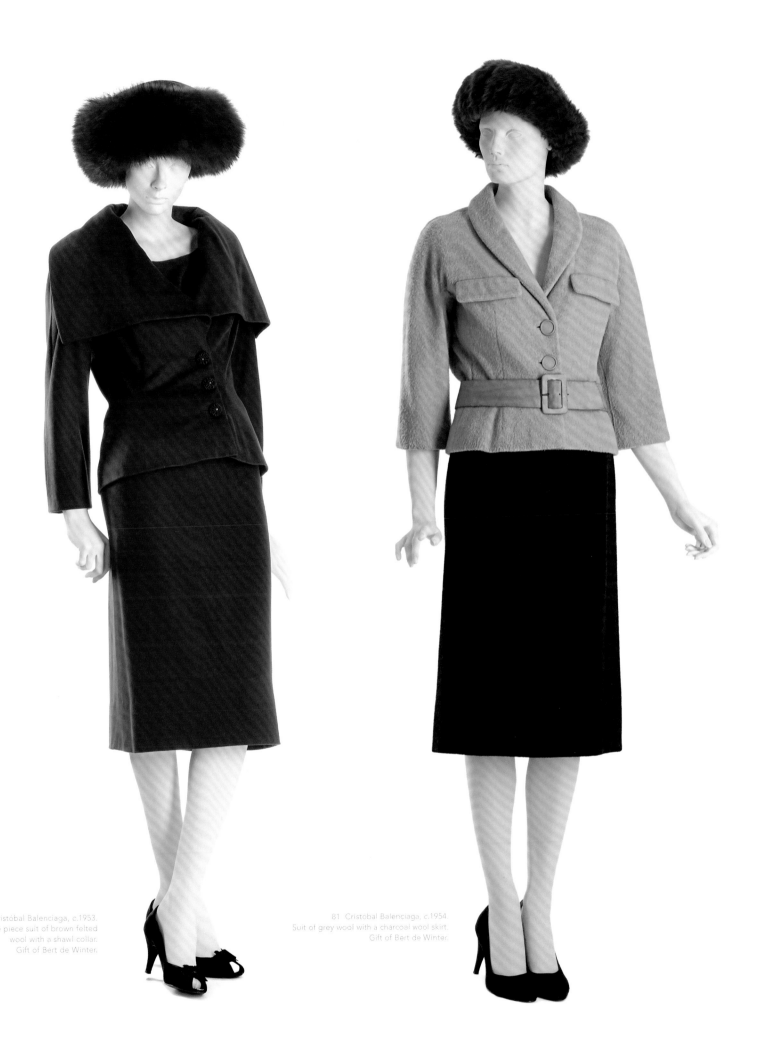

80 Cristóbal Balenciaga, c.1953.
Three piece suit of brown felted
wool with a shawl collar.
Gift of Bert de Winter.

81 Cristóbal Balenciaga, c.1954.
Suit of grey wool with a charcoal wool skirt.
Gift of Bert de Winter.

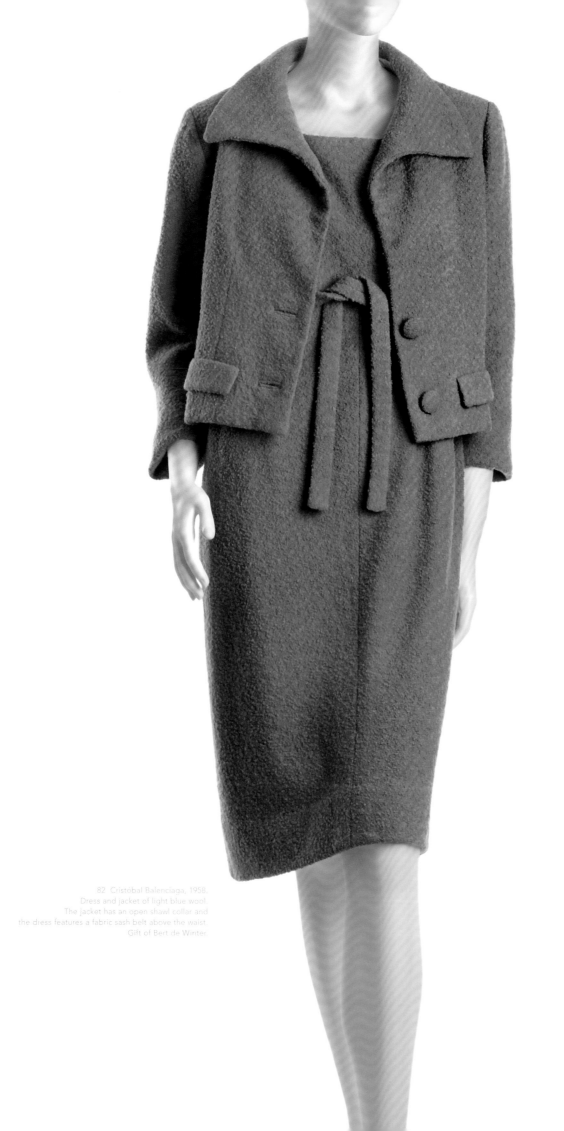

82 Cristóbal Balenciaga, 1958.
Dress and jacket of light blue wool.
The jacket has an open shawl collar and
the dress features a fabric sash belt above the waist.
Gift of Bert de Winter.

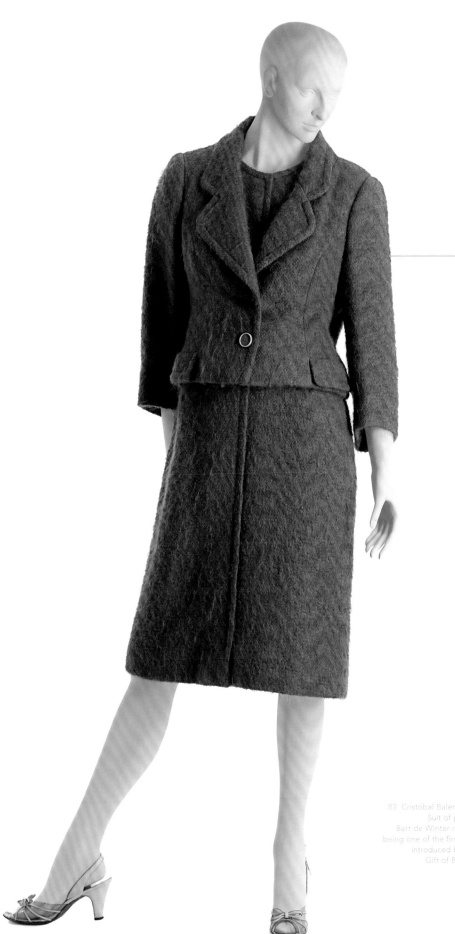

83 Cristóbal Balenciaga, c 1957.
Suit of purple mohair.
Bert de Winter recalled this as
being one of the first mohair suits
introduced by Balenciaga.
Gift of Bert de Winter.

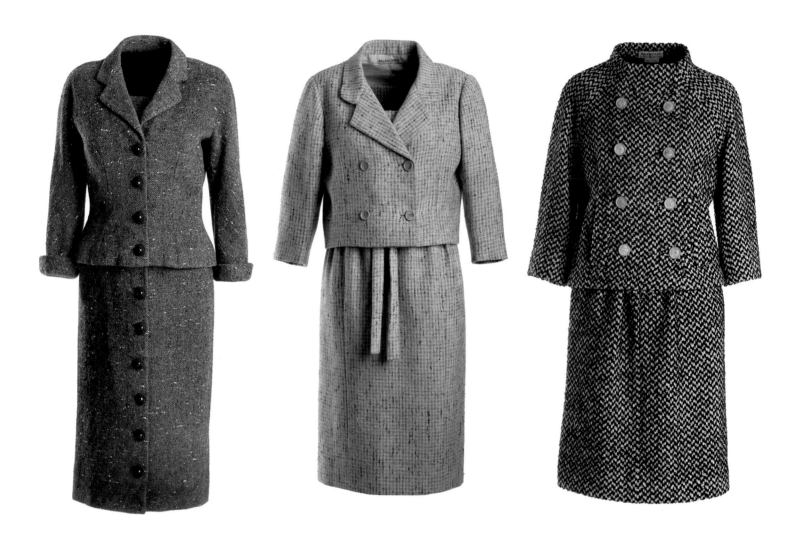

84 Cristóbal Balenciaga, c.1954.
Suit of brown wool tweed trimmed with
matching buttons on jacket and skirt.
Gift of Neiman Marcus.

85 Cristóbal Balenciaga, 1957.
Dress and jacket of oatmeal wool tweed
with a fabric sash belt at waist.
Gift of Bert de Winter.

86 Cristóbal Balenciaga, 1959.
Suit of black and beige herringbone tweed.
The jacket has a standing collar and is
trimmed with a double row of bone buttons.
Gift of Bert de Winter.

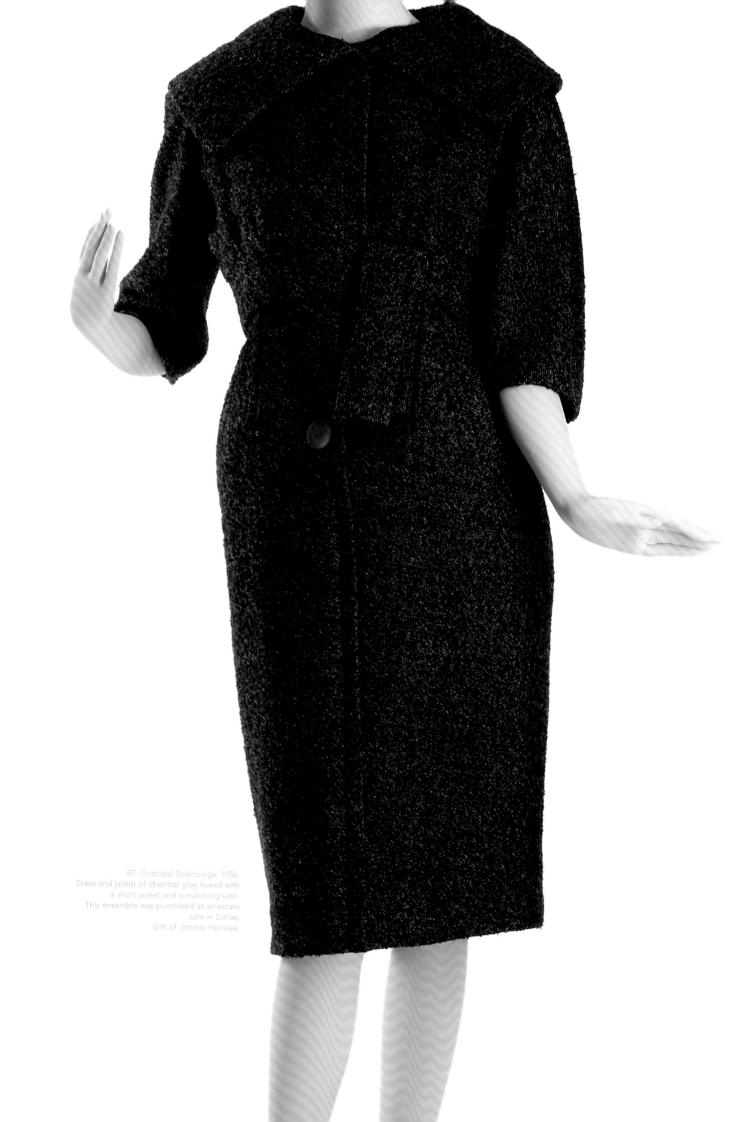

87 Cristóbal Balenciaga, 1956.
Dress and jacket of charcoal gray tweed with
a short jacket and a matching sash.
This ensemble was purchased at an estate
sale in Dallas.
Gift of Jimmie Henslee.

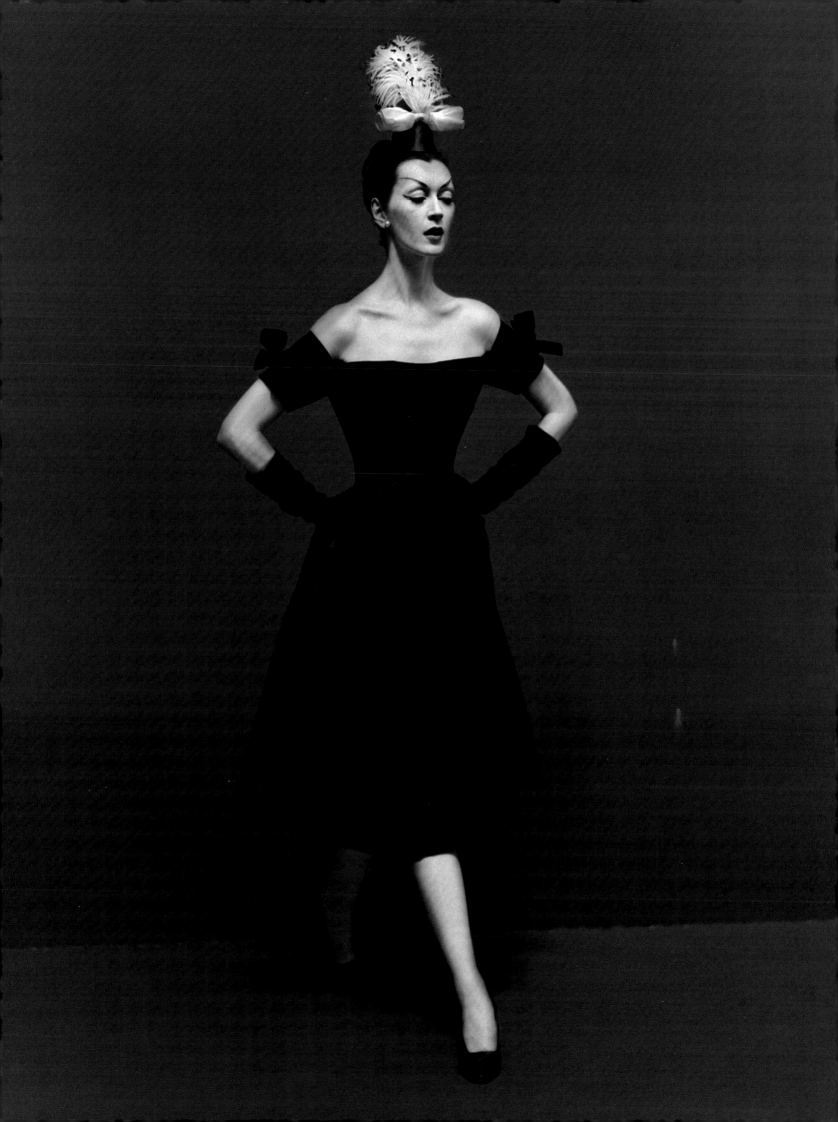

Myra Walker

INSIDE THE HOUSE
OF BALENCIAGA IN PARIS

"The best part of my life was working at the House of
Balenciaga for 31 years. That is a long time."
– Mme Florette Chelot

Fashion is both a vital part of French history and an integral cultural component. In Paris, the topic of fashion typically is reported in the news and discussed in cafés. Designers are casually mentioned by first names. Even the way in which a designer's place of business is referred to – the House of Balenciaga – implies a level of familiarity. However, gaining entry to a famous house was not such a casual process, and Balenciaga was no exception: one had first to negotiate with the head gatekeeper, Mlle Renée d'Esting, the Directrice, who might evaluate one's status with a withering glance before allowing admittance – or not.

One of the first employees to be hired by Balenciaga when he opened at 10, avenue George V was Mme Florette Chelot. Mme Chelot clearly recalls the setting of the interview: a room in which Balenciaga sat at a white table, armed with a pencil and pad of notepaper; there was no extra chair for her, for which M. Balenciaga immediately offered an apology. Mme Chelot was promptly hired as the designer's first *vendeuse* or salesperson. The role of the haute-couture *vendeuse*, the literal "face of the company," has been under-represented in the history of fashion.

Balenciaga made intelligent hiring decisions in terms of the skills required of the employees who interacted with international clientèle. They needed to have poise and a certain chic about them. A *vendeuse* was expected to maintain a very demanding schedule, satisfy the demands of important private clients, work with buyers and vendors, handle members of the press, and, sometimes, placate irate husbands. One of the key qualifications of a *vendeuse* was to be able to speak English so that American clients could be graciously accommodated. Mme Chelot's personal history serves as an illuminating case study. She began to work in the fashion industry in 1926. When Henri Bendel opened an office in Paris, he recruited a young man, who worked with fabrics. This man introduced Mme Chelot to M. Bendel, who subsequently offered her a position as a buyer in New York. At this time, she was very young, and she felt her English was not strong enough to enable her to accept the offer. But it inspired her to improve her English. She eventually married and continued to work in Paris. She fondly remembers Henri Bendel as a very nice man. Later, at the House of Balenciaga, she conducted business with M. Bendel. He was very proud of her and remarked, "Florette, you did not want to come with me, but maybe you made a better choice."

Another *vendeuse* at the House of Balenciaga was Mme Odette Sourdel. As a young girl, just out of high school, she and a friend embarked on a "grand tour" of the United States, just after World War II had ended. They visited New York, Chicago, Denver, San Diego, Santa Fe, and New Orleans, traveling for three months. Her

89 Photograph by Henry Clarke.
Model wearing Balenciaga's black silk taffeta
dress with a purple velvet coat
for *Vogue*, October 1951.
Courtesy of *Vogue*:
© 1951 Condé Nast Publications, Inc.

interest in learning English also provided Odette with a future opportunity. She was hired as a *vendeuse* at the House of Balenciaga in 1948 and stayed until 1968. Both Florette and Odette enjoyed their contact with Americans and had long successful careers, dealing with important English-speaking clients. The personal *vendeuse* of Señora Claudia de Osborne, Margot, also worked with Countess Mona von Bismarck at Balenciaga. Odette Sourdel also became well acquainted with Claudia de Osborne when, after the retirement of Balenciaga, Mme Sourdel went to work for Hubert de Givenchy. There she assisted Claudia de Osborne for fifteen years. During her tenure at the House of Balenciaga, Mme Sourdel served a long list of distinguished clients which included the Duchess of Windsor, Her Serene Highness Princess Grace of Monaco, and Mrs. C. Z. Guest. She has many fond memories of these dynamic personalities.

Numerous other famous individuals flocked to the House of Balenciaga. Clients were admitted only with the express permission of Mlle Renée d'Esling, the Directrice. However, it was the *vendeuses* who handled all aspects of business from that point on. The "Who's Who" list of clients included Mrs. William Randolph Hearst, Ingrid Bergman, Sophia Loren, Anita Loos, Claire Booth Luce, Princess Lee Radziwill, Doris Duke, Mrs. Thomas Biddle, Barbara Hutton, and Pauline de Rothschild, to name but a few. Countless meetings and private fittings were part of the *vendeuse*'s job. Just as importantly, a lot of charm and finesse were required in order to satisfy the particular demands of each customer.

The six-month cycle of a collection began with the presentation of fabric samples, which were closely examined by Balenciaga. While small runs of the exclusive fabrics that he had chosen were being produced, the designer traveled to Spain for two months, to design his new collection and to check on the business in San Sebastián, Madrid, and Barcelona. When Balenciaga returned to Paris, many of his ideas were translated into working sketches by Martinez, a trusted Spaniard on Balenciaga's staff. These sketches would be dispatched to various ateliers within the House.

Each of the ateliers was rigorously operated by a talented and loyal staff: Mme Claude, active from 1937 to 1968, worked on dresses; Denis, active from 1937 to 1958, worked on suits; Emanuel Ungaro handled suits from 1960 to 1964; Mme Felissa, active from 1937 to 1968, managed the only workshop to make both suits and dresses; Mme Ginette, active from 1937 to 1968, worked on dresses; Mme Jaqueline, active from 1955 to 1968, also worked on dresses; Madame Lucia, active 1947 to 1968, likewise; Marcel, suits and coats; Paul, suits and coats; Mme Suzy, 1937 to 1968; Salvador, 1948 to 1968. Salvador's group included André Courrèges and Emanuel Ungaro, who each later left Balenciaga and became famous in his own right. This roster is impressive because it charts the longevity of Balenciaga's highly competent and dedicated staff. They understood how the master thought and were able skillfully to execute his vision.

The House of Balenciaga also sustained a thriving millinery business. From 1937 to 1940, the hats were made by the Paris milliner Mme Legroux. After 1940, Balenciaga made the decision to open his own millinery shops

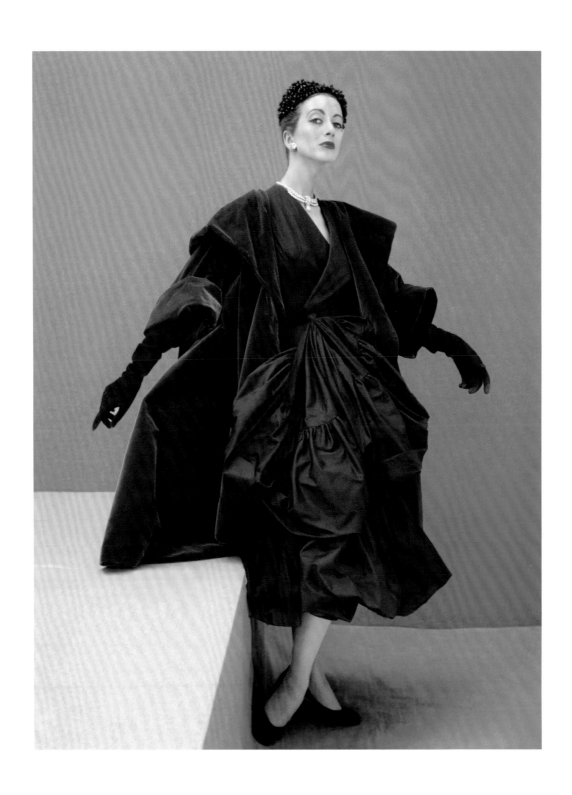

90 Photograph by Richard Rutledge
for Glamour, 1 October 1950, p.152.
Courtesy of Glamour.
© 1950 Condé Nast Publications, Inc.

on the premises, and imaginative, sculptural hats were made by Mme Janine, active from 1941 to 1968; Madame Helene, active from 1941 to 1960, and Madame Ginette, active from 1960 to 1968. Hat-making also required the decorative trimmings that have always been an essential part of French haute-couture tradition. Balenciaga dealt with only the highest-quality sources: Judith Barbier, established in Paris in 1860, provided hand-made silk flowers and sumptuous feathers; Lemarie, established in 1901 supplied exotic feathers. Former model Michelle Hanjian explained, "When it was time to present the collection, Balenciaga personally saw that the correct hat was put with each ensemble, just as he had envisioned it from the beginning." Balenciaga, who worked closely with the millinery designers to convey his ideas and select materials, was adamant that a hat must be "just right" in order to finish off the ensemble.

Each working day, Balenciaga supervised the activities in the various workshops, relying on his key people to create a precise pattern. He could speak French, but he preferred to converse in his native Spanish with employees inside his workrooms. A thorough understanding of his vision and the translation of his ideas to sketches, patterns, muslin *toiles* (patterns), and finishing were made possible only through clear communication. Balenciaga personally continued to work with each *toile* to correct proportions. According to Salvador, after the garment was made with the chosen fabric, Balenciaga would check the workmanship of each design up to four times. It is in keeping with this work ethic that Michelle Handjian, who worked as a fit model in the studio, offers the observation that Balenciaga was "all business," and Mme Florette confirms that everyone who worked there addressed him respectfully as "Monsieur Balenciaga."

The production process lasted about two months. After the last phase of checking, final selections were made for the season's showing. When Balenciaga was satisfied with his collection, accessories, including hats and jewelry, were chosen for the models. Michelle Handjian confirms that the jewelry for each ensemble was chosen after the hats, just before the show. The jewelry had been designed in advance, often by couture jeweler Robert Goossens, who conferred with Balenciaga throughout each season. Goossens's well-crafted work was characterized by somber medieval overtones, combined with a sense of luxury and playfulness, that appealed to Balenciaga.

When a fashion show began at the House of Balenciaga, reverence was expected. It was a serious parade of models with no music, and talking was forbidden. The first showing was held for buyers, although some privileged clients, like Claudia de Osborne, would be allowed to attend as well. Clients would make a note of the numbers carried by each model. If Mrs. de Osborne was taken with a dress, she would tell a man employed by Balenciaga to go into the workroom to put a hold on the fabric for her order. She wanted to buy dresses made only in exactly the fabric Balenciaga presented in the collection, and she also wanted the hat and the other accessories that went with it. Most of her shoes were custom-made at Mancini or Roger Vivier. Later, when she patronized the House of Givenchy, she was just as particular and demanding. Givenchy once suggested to her

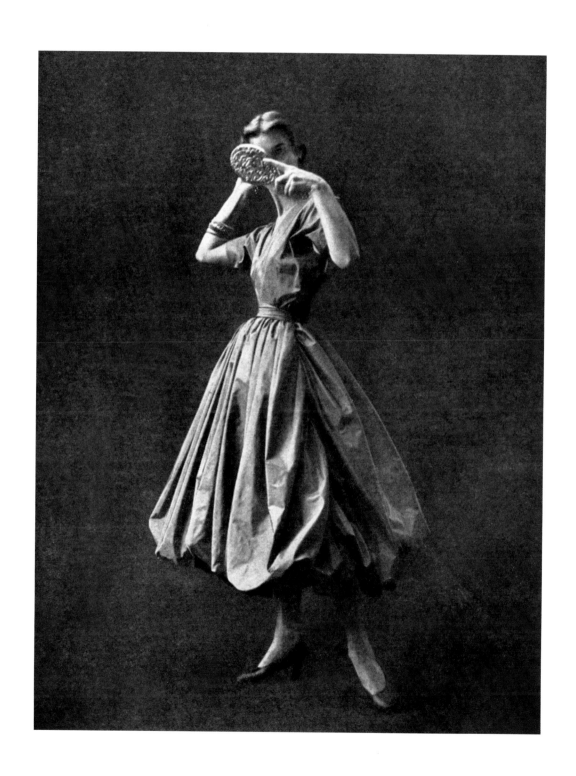

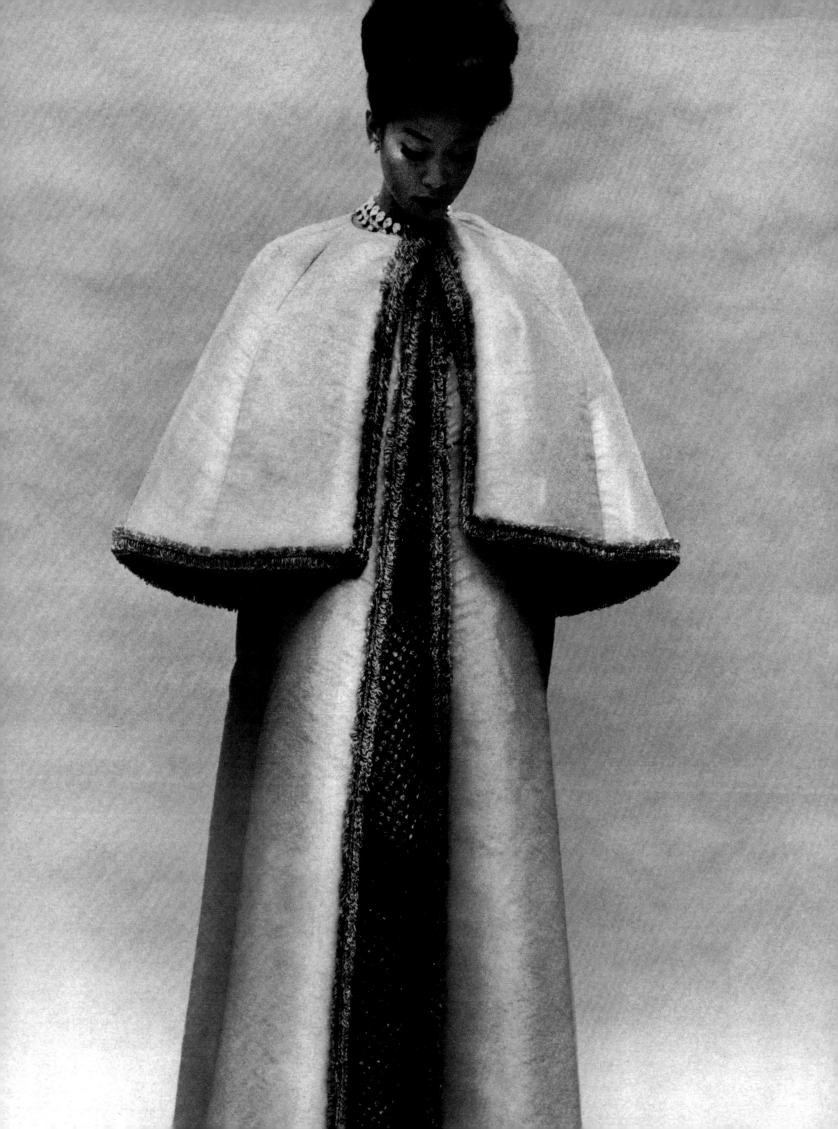

that she may not want to dress exactly like the model, because it may be too "showy," but Claudia insisted that she did.

During a fashion show, the entire staff kept a watchful eye on the audience. Mme Florette recalls that she would snatch paper out of someone's hand if she suspected they were sketching Balenciaga's designs. The atmosphere was charged with excitement about the new collection, combined with the tension of being on guard against piracy. American buyers for well-known department stores, such as Neiman Marcus, Lord & Taylor, and Bonwit Teller, were on hand at the first viewing to see the latest masterpieces by Balenciaga, for which privilege their stores paid a high admission fee, known as a "caution," that was roughly equivalent to two couture orders. In return for access to the collection, the store representative was expected to order two or more styles on each occasion, and the caution would be deducted from the final invoice amount.

In the early years, the fashion press was carefully screened before attending, and the writers were expected to observe certain unwritten rules. However, by 1956, Balenciaga was fed up with his ideas being leaked by the press, ahead of the department stores' receiving their exclusive deliveries, and from then on, he, followed by Givenchy, banned the press from the critical first showing and allowed them to view the collection only a month later.

At the end of a show, Balenciaga would never come out to take a bow or greet the audience. This was consistent with the way he wanted it to be: only about the work.

The debut presentation of a new collection was a major event. However, once it was over, shows continued to be held at the House of Balenciaga throughout the season. These smaller presentations occurred every day at 3:00 p.m. At this time, clients would assemble to examine their selections more closely. Each client that came to the salon expected personal attention from her *vendeuse*. Mme Florette described the atmosphere as extremely hectic. She would have to attend to each customer as she tried on garments and also offer her opinions. This process often involved running from one dressing room to another. A *vendeuse* worked strictly on commission from sales. If one found herself busy with too many clients, she would hire extra assistants. These assistants were employed by the *vendeuse* and were paid out of her commission.

The work schedule of a *vendeuse* was precise, and expectations were high. They reported to work each day at 9:00 a.m. and worked into the evening. They also worked part of the day on Saturday. A vacation period coincided with a two- to three-week period when the House closed so that orders could be made up by the workrooms for delivery. As a major client would have a custom dress form in her own measurements at the House, this practice worked for the early stages of making the pattern. When an order was placed by a client, the duties of a *vendeuse* expanded from writing it up and taking a deposit (or full payment) to tracking the order during every stage of production. In effect, the *vendeuse* had to cater to the client at every point in the process.

After a garment was first made up precisely to a client's measurements, there was a series of three fittings. This important aspect of the couture process was intimate and required discretion on the part of the *vendeuse*.

92 Photograph by William Klein
for *Vogue*, April 1967, p.72.
Courtesy of *Vogue*:
© 1967 Condé Nast Publications, Inc.

Many clients returned to the House of Balenciaga for their fittings. But a major client, such as Barbara Hutton or Claudia de Osborne, would rarely return to the salon, preferring that the *vendeuse* come to her apartment at the Ritz Hotel or to her private home. Mrs. de Osborne liked to order complete Balenciaga ensembles and carefully listed the accessories for each dress to be packed by her maid for traveling. Barbara Hutton did the opposite: according to Mme. Florette, Hutton would order two or three of the same dress so that she could have one on hand at her various homes throughout the world. Not having to pack was the ultimate luxury.

The *vendeuse* would be accompanied to each fitting by a tailor, whose job it was to ensure the proper fit. The garment had been made in the chosen fabric but did not have the lining yet, so that seams could be taken in and marked to fit the body. Emanuel Ungaro was the tailor sent by Balenciaga to Claudia de Osbourne. These sessions could go on for hours. The relationship between a *vendeuse* and her client often became a life-long friendship. Both Mesdames Florette and Odette speak of Christmas cards, family photographs, gifts, and overall high regard bestowed on them by wealthy clients. They were women together, sharing a unique personal experience. In many cases, these friendships endured, even after the House of Balenciaga was closed.

Friendship could be draining at times. Mme Florette says that Barbara Hutton often called her at home, saying that she was lonely and wanted her to come over late at night. Clients were not easy to accommodate, owing to their personal travel schedules and busy lives. Many American clients came for the fashion show, placed their orders, and then left before there was time for a first fitting. They might go on a cruise or vacation and then return to Paris. A *vendeuse* had to be on call, in case an important client was ready for her fitting or behind schedule. Clients could be not only draining but also unpleasant. Mme. Florette tells the story of one woman (discreetly unidentified) who made her so angry that she dismissed her from the House of Balenciaga: "She was a good client but so difficult, and she was never pleased. One day I was so exasperated I had a pencil in my hand, and I just broke it in two. I told her, 'Go to Givenchy. They will take care of you. I can't take care of you anymore.' The next day, her husband came in and brought me flowers. He begged me to take his wife back as a customer."

Dealing with the buyers for stores and making sure they received what they ordered was another job that needed to be undertaken. It was also of primary importance to guarantee that the buyers were getting everything they wanted and needed by way of trims, buttons, and fabrics from the sources in Paris. One of the distinctive differences between the House of Balenciaga and the other couture establishments was that Balenciaga did not sell *toiles* (muslin patterns) to the department stores. They purchased a complete haute-couture garment. When the garments were made to order, the timing was critical because all couture orders from every house in Paris were shipped (or later, flown) to New York in one consignment, in order to ensure fairness of distribution. It was also an obligatory part of the business, as the transaction had to go through an agent and clear French customs. The survival of couture during the post-war period and the decade of the fifties was based on this rigidly controlled system.

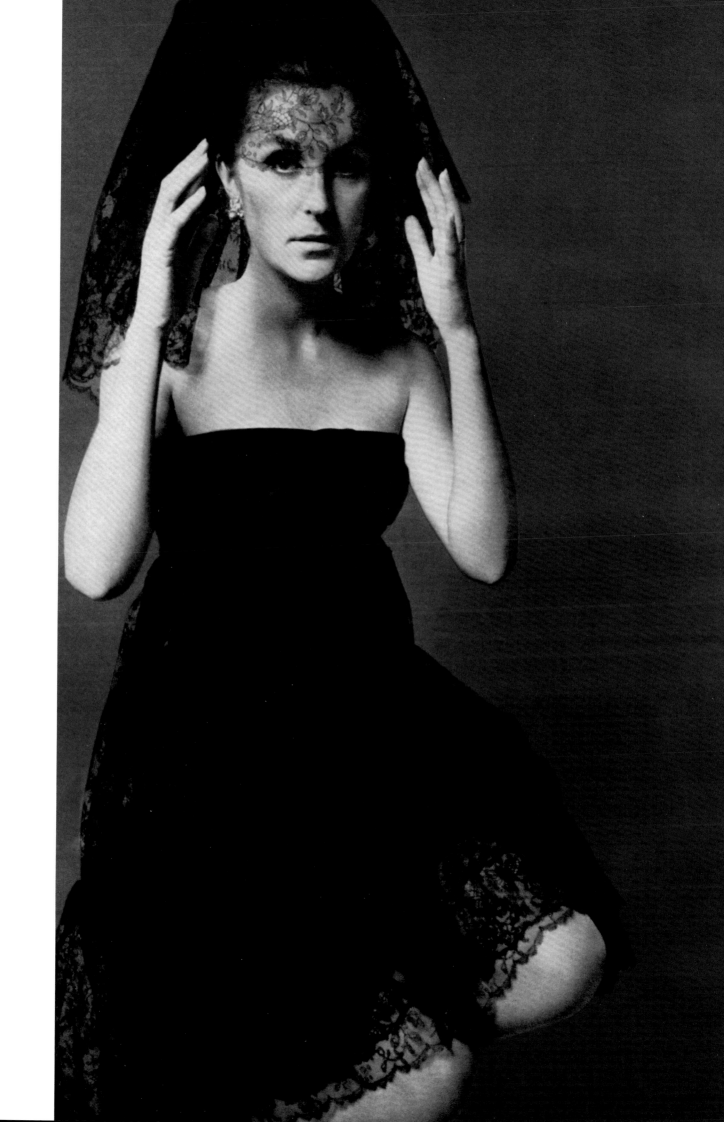

93. Cristóbal Balenciaga, c.1964.
Hat of black satin with beads and sequins.
Gift of Claudia de Osborne.

As far as Balenciaga's couture houses in Spain are concerned, designers from Eisa in Madrid and Barcelona attended the main fashion show in Paris. They would select twenty to thirty designs – never all – to form the collection to be presented later in Spain. Eisa designers would take a muslin *toile* back with them for translation into Balenciaga garments to be made in their ateliers. Because of trade restrictions during the Franco era, the same fabrics used in Paris by Balenciaga were not always available in Spain, and Spanish fabrics were often substituted. The selections for Spain were often not the most complicated nor as expensive as the models shown in Paris. This discrepancy resulted in the collections for Eisa being a little different, but they were still produced to the highest couture standards. Many clients who traveled in Europe preferred to go to Eisa, because the pricing was somewhat lower there.

It is indisputable that the creative vision of Balenciaga is responsible for the artistic heritage that captured the fashion world's respect and admiration, and it continues to command attention to this day. However, thanks to the vital role of the *vendeuse*, who artfully employed a range of personal, business, and diplomatic skills, the House of Balenciaga thrived as a commercial enterprise and assured the loyalty of its many clients.

1 Mame Florette Chelot, interview by the author, 7 March 2005.

2 Ibid.

3 Ibid.

4 Ibid.

5 Mme Odette Sourdel, interview by the author, 9 March 2005.

6 Ibid.

7 Ibid.

8 Ibid.

9 Mme Marie-Andrée-Jouve, interview by the author, 7 March 2005.

10 Ibid.

11 Michelle Handjian, interview by the author, 9 March 2005.

12 Lesley Ellis Miller, *Cristóbal Balenciaga* (New York: Holmes and Meier Publishers, Inc., 1993), 33.

13 Mme Marie Andrée-Jouve, Mme Florette Chelot, Mme Odette Sourdel, Mme Michelle Handjian, interview by the author, 5 March 2005.

14 Jacques Brunel, "Barbaric jewelry in fashion."N.d., < HYPERLINK "http://www.pieceunique.com/inthenews/html" http://www.piece-unique.com/inthenews/html > (24 February 2006).

15 Hubert de Givenchy, interview by the author, 8 March 2005.

16 Mme Florette Chelot, interview by the author, 7 March 2005.

17 Ibid.

18 Mme Odette Sourdel, interview by the author, 9 March 2005.

19 Mme Florette Chelot, interview by the author, 7 March 2005.

20 Ibid.

21 Ibid.

22 Ibid.

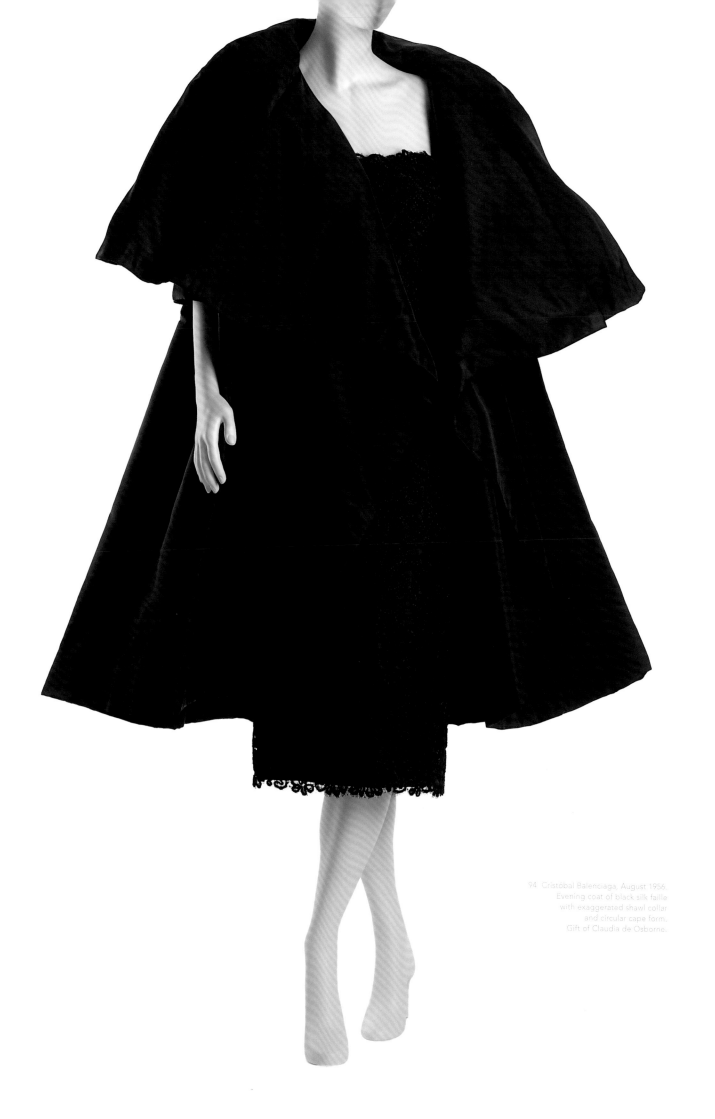

94 Cristóbal Balenciaga, August 1956.
Evening coat of black silk faille
with exaggerated shawl collar
and circular cape form.
Gift of Claudia de Osborne.

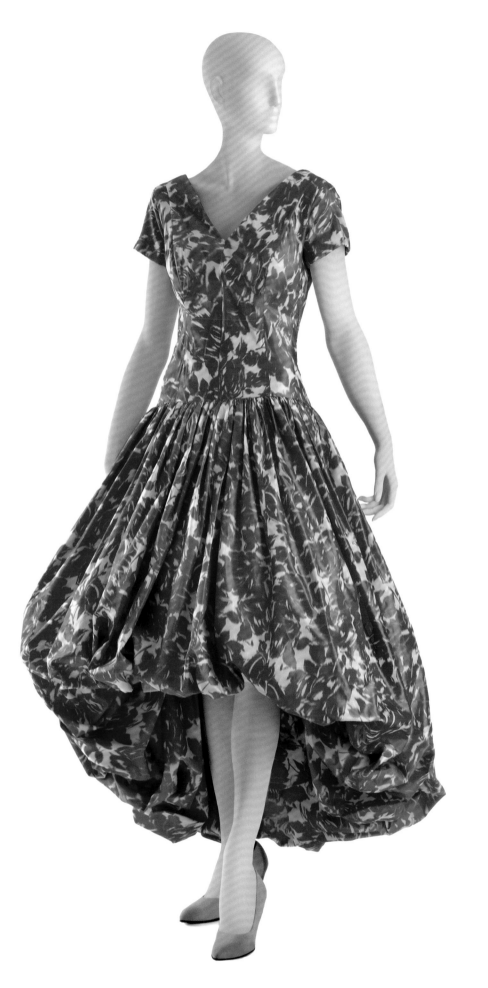

95 Cristóbal Balenciaga, c.1957.
Evening dress of red and white floral print
tissue silk with a balloon hem.
Mrs. Wilson bought this dress in Madrid
to wear to a party given by Algur Meadows.
Gift of Mrs. Dewitt Ray for Mrs. Malcolm Wilson.

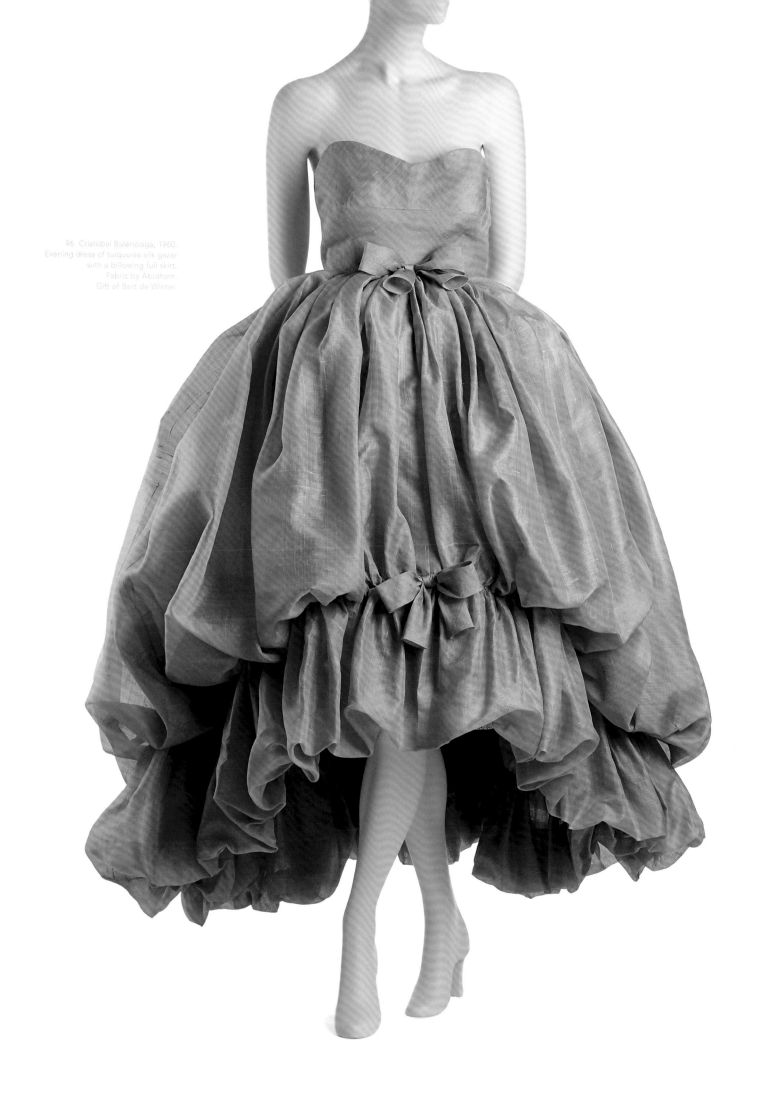

96 Cristóbal Balenciaga, 1960.
Evening dress of turquoise silk gazar
with a billowing full skirt.
Fabric by Abraham.
Gift of Bert de Winter.

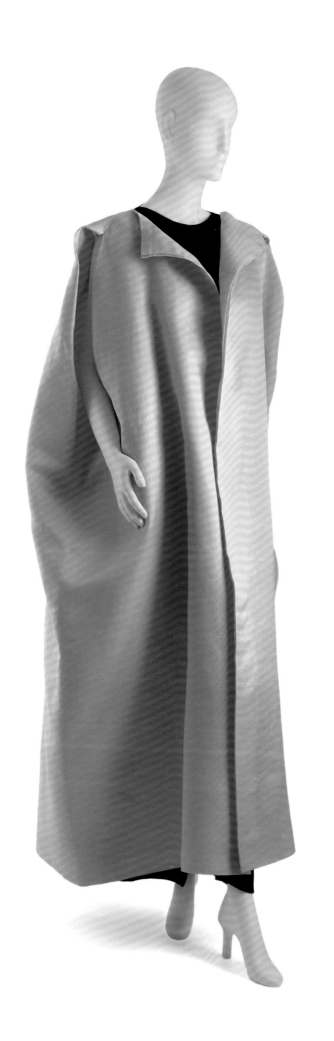

97 Cristóbal Balenciaga, c.1960.
Evening cape of double-faced pale pink silk
gazar constructed with only two seams
at the shoulders.
Gift of Claudia de Osborne.

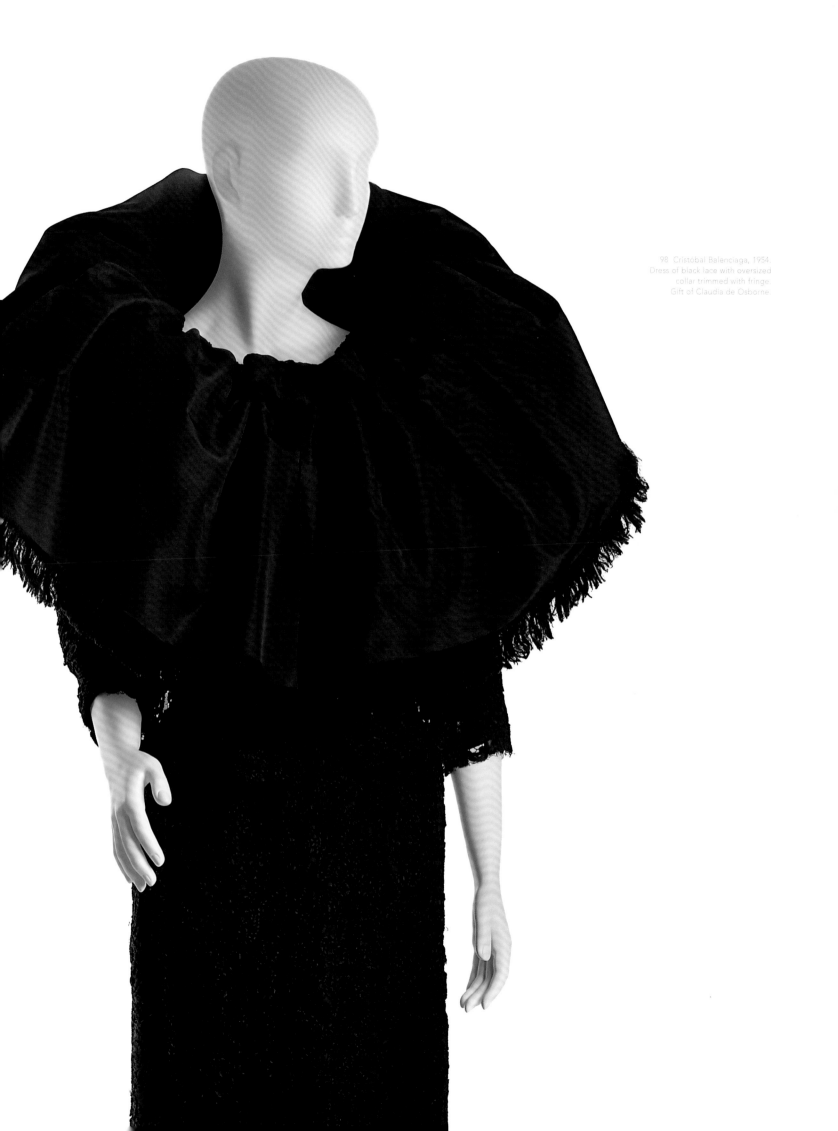

98 Cristobal Balenciaga, 1954.
Dress of black lace with oversized
collar trimmed with fringe.
Gift of Claudia de Osborne.

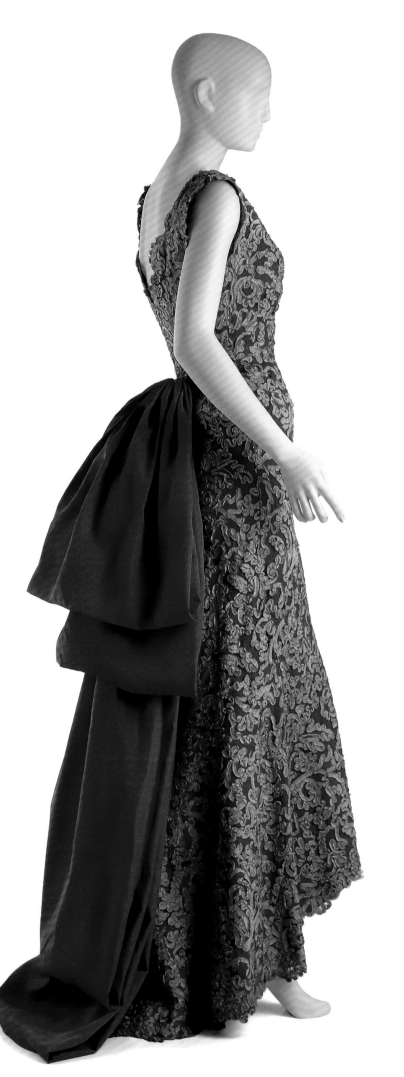

99 Cristóbal Balenciaga, c.1956.
Evening dress of red ribbon lace with red
taffeta bustle and train. Frances Billups, who
often visited Claudia de Osborne in Europe,
purchased this dress at Eisa in Madrid.
Gift of Mrs. James S. Billups.

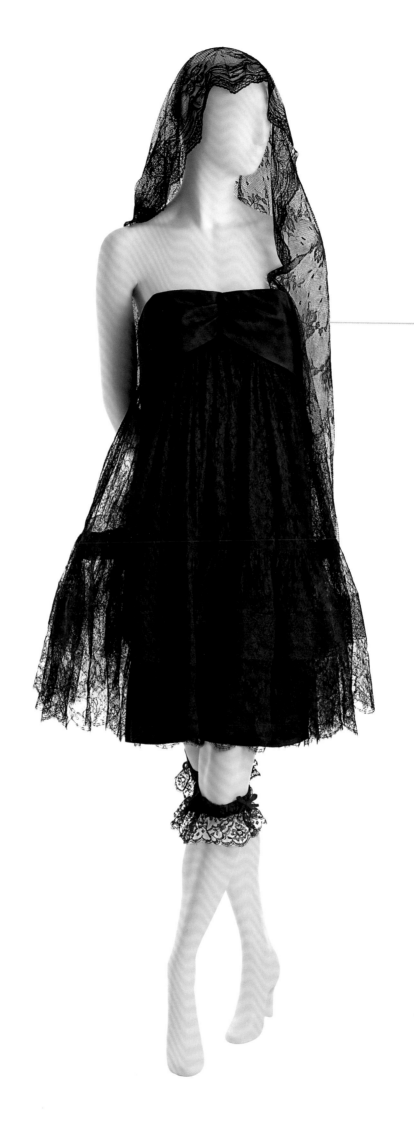

100 Cristóbal Balenciaga, February 1967.
Strapless baby-doll evening dress of black
lace and silk faille with lace garters.
Originally presented in 1958, Balenciaga
revived this style in the sixties.
Gift of Claudia de Osborne.

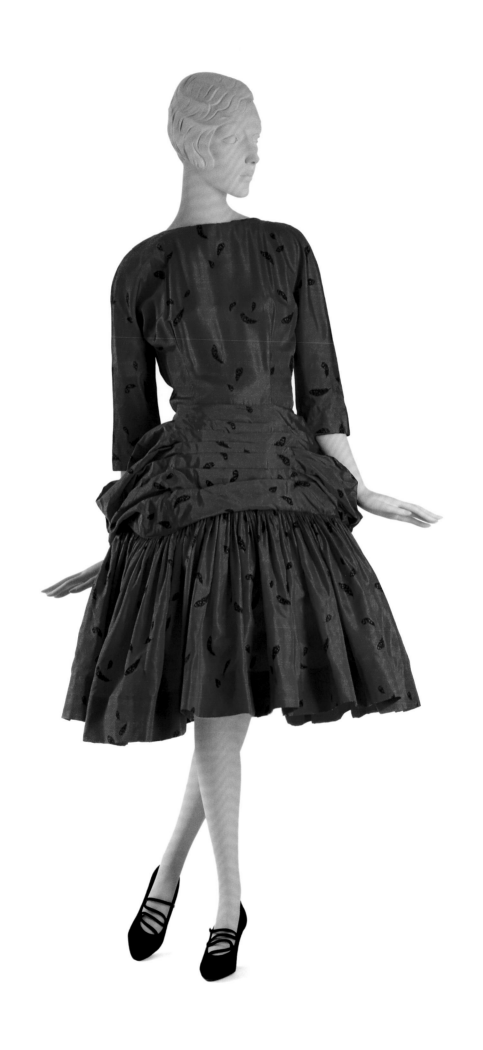

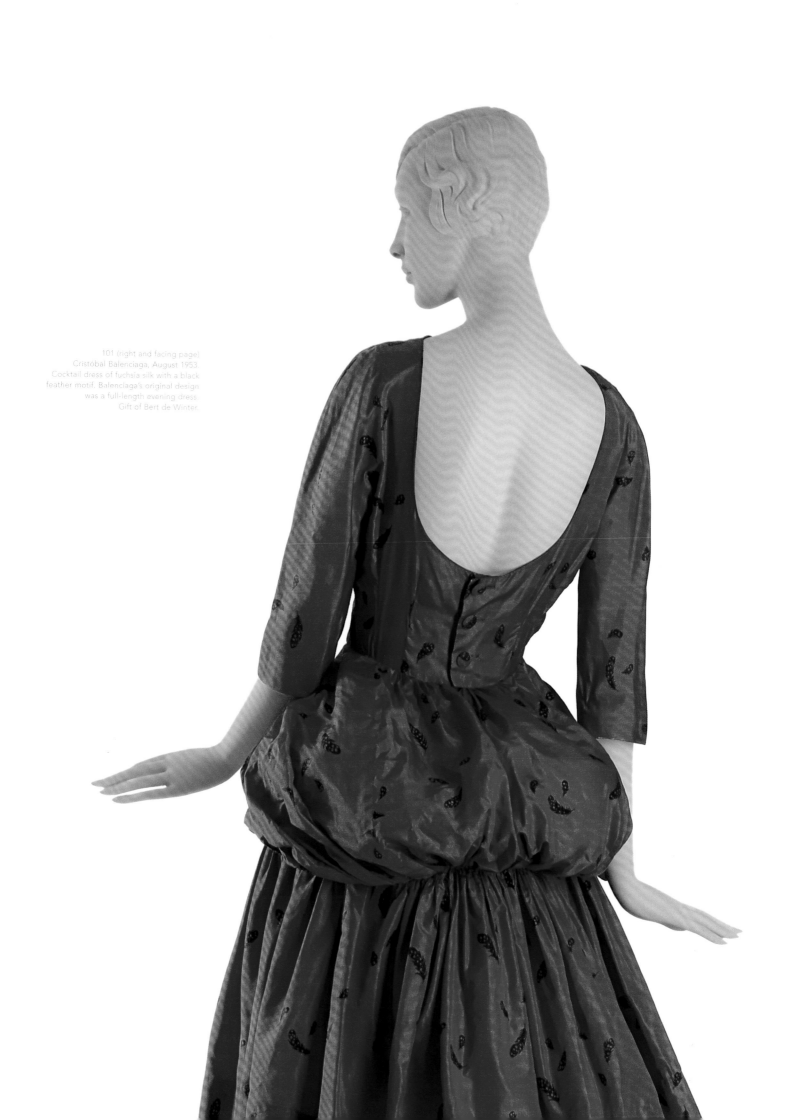

101 (right and facing page).
Cristóbal Balenciaga, August 1953.
Cocktail dress of fuchsia silk with a black
feather motif. Balenciaga's original design
was a full-length evening dress.
Gift of Bert de Winter.

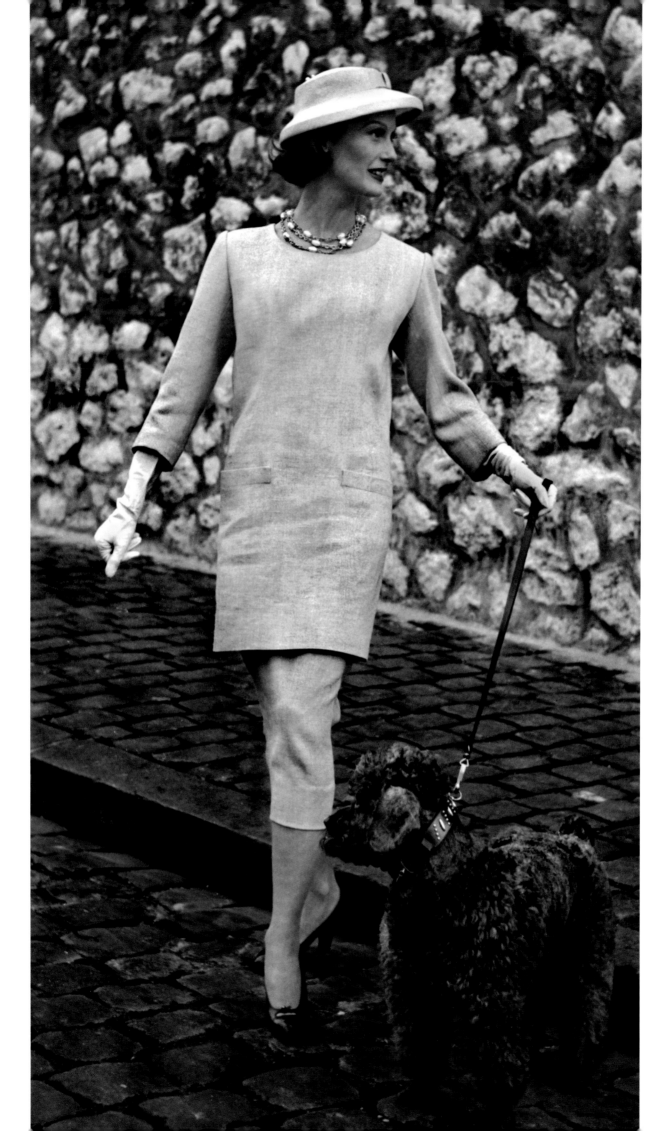

Myra Walker

THE BALENCIAGA LEGACY ENDURES

Just as Charles Frederick Worth, an Englishman in Paris, came to be known as the first couturier during the nineteenth century, Cristóbal Balenciaga achieved acclaim as the master of twentieth-century fashion. "Mastery" is defined as possession of consummate skill, a quality of an individual who has dominion or control; it is demonstrated by one who is in full command of his subject. The word mastery is relevant when considering the work of Balenciaga. As an intelligent, creative individual, he could have no doubt been successful in another area of expertise. However, he chose to devote himself to creating fashion. Richard Martin, the late curator of the Costume Institute at the Metropolitan Museum of Art in New York, eloquently wrote of Balenciaga:

> Cristóbal Balenciaga's primary fashion achievement was in tailoring; the Spanish-born couturier was a virtuoso in knowing, comforting, and flattering the body. He could demonstrate tailoring proficiency in a tour-de-force one-seam coat, its shaping created from the innumerable darts and tucks shaping the single piece of fabric. His consummate tailoring was accompanied by a pictorial imagination that encouraged him to appropriate ideas of kimono and sari, return to the Spanish vernacular dress of billowing and adaptable volume, and create dresses that could swell with air as the figure moved. There was a traditional Picasso–Matisse question of postwar French fashion: who was greater, Dior or Balenciaga? Personal sensibility might support one or the other, but it is hard to imagine any equal to Balenciaga's elegance, then or since.[1]

Balenciaga sharpened his skills and developed his tailoring techniques in Spain during the first twenty years of his career. It has been suggested by author Lesley Miller that living in San Sebastián provided a young Balenciaga with a nurturing environment that was firmly grounded in the tailoring tradition[2] and in addition to tailoring, Balenciaga was intent on becoming proficient in draping. During the 1920s and 1930s, he attended the collections of Madeleine Vionnet and Coco Chanel to absorb Paris fashion at first hand, sometimes obtaining couture examples for study. It was with this wealth of experience that he moved to Paris in 1937 at the age of forty-two, to establish the House of Balenciaga, arriving as a mature artist whose talent and vision were fully formed.

Balenciaga returned continuously to one silhouette in particular throughout his career: the simple T-shaped tunic. Working with the basic tunic, one of the oldest sewn garments in the history of dress, Balenciaga extracted the quintessence of perfect form. The tailored tunic was always an essential part of Balenciaga's design repertoire, even before he opened for business in Paris. It became one of his primary forms of expression in almost every collection. He manipulated its properties to suit his creative purposes. He fashioned garments that barely skimmed a woman's body, deflecting attention from problematically shaped figures and flattering the mature woman who was past her fashionable prime.

Richard Martin compared Balenciaga to an artist whose medium was fabric:

> Like a twentieth-century artist, Balenciaga directed himself to a part of the body, giving us a selective, concentrated vision. His was not an all-over, all-equal vision, but a discriminating, problem-solving exploration of tailoring and picture-making details of dress. Balenciaga was so very like a twentieth-century artist because in temperament, vocabulary, and attainment, he was one.[3]

Martin also described Balenciaga as a master of illusion and a perfectionist: "Balenciaga's garments lack pretension; they were characterized by self-assured couture of simple appearance, austerity of details, and reserve in style."[4] The tunic is an example of the ultimate lack of pretension employed by Balenciaga. When he was praised by fashion journalists in 1955 for his "first" tunic suit, it was most certainly not the initiation of a "new" style by his own standards, but more likely an idea whose time and place had finally caught up with him (fig. 102).

The tunic was cleverly retooled by Balenciaga. In 1956, he morphed the shape into the radical "sacque" dress for day and evening wear. Many of Balenciaga"s tunics existed as a slowly revealed surprise: throughout the 1950s, he paired tunics with an underskirt that peeked out at the hem, functioning as a foil for the jacket. Extraordinary sleeves and collars that rolled away from the neckline were details that flattered a woman and often garnered the most attention. He fearlessly introduced the tunic concept into evening wear and lavishly embellished it. The tunic was the workhorse of Balenciaga couture.

In 1957, Balenciaga presented the tunic alone, in all its beauty and simplicity. The October cover of *L'Official Paris* shows a chic model standing in a modern interior wearing a shockingly contemporary, tobacco wool dress, with a clean, shortened hemline that revealed a lot of leg (fig. 107). Balenciaga had unknowingly unleashed the basic concept of what would become his own nemesis: the mini-dress. It was a genie that could not be put back into the bottle.

In 1950, a young André Courrèges joined the House of Balenciaga. He was sent to Eisa in Madrid for a brief training period and was then assigned to the atelier of Salvador at the House of Balenciaga in Paris. There Courrèges, whose previous studies had included architecture, honed his tailoring skills for a decade. In 1960, with the blessing of Balenciaga, Courrèges, along with his wife and partner, Coqueline, opened their own design studio. The first collection by Courrèges in 1961 included a stark, modern tunic dress. Whether this garment can be designated as the first mini-dress is not certain; but it is apparent that Courrèges was poised to design for the burgeoning youth market that Balenciaga was not ready to contemplate. Courrèges intended to design clothing that was more affordable than traditional couture and thus more accessible (fig. 108). The mini-skirt concept was also introduced by Mary Quant during the early sixties, but it was André Courrèges whose work emerged straight out of the couture tradition.

By the mid-sixties, the mini-dress had become the uniform of young women all over the world. The short hemlines mocked everything for which the establishment culture stood. The "mini" became symbolic of sexual freedom, and girls who wore them were denounced as sinful, vulgar, and, most especially, "un-ladylike." The clientèle of the House of Balenciaga was dismayed by these developments in fashion, and no one was more apprehensive than Balenciaga himself. By 1965, he was seventy years old. He steadfastly refused to consider designing a boutique line or to cater to what he viewed as passing fads and trends. American and European cities were growing increasingly unsettled by protests and demonstrations against the war in Vietnam. There was also a pervasive sense of unrest in Paris. Balenciaga confided to Mme Florette Chelot, "No more, I cannot dress people like this. I am not made to dress people in the street."[5] The House of Balenciaga in Paris was closed in 1968.

Curator Pamela Golbin, of the Musée de la Mode et du Textil in Paris, recently declared that "the time period of the sixties was not only a youth-quake, but also a fashion industry quake."[6] The glorious reign of couture ended, displaced by ready-to-wear collections and a more casual approach to dressing. Balenciaga had participated in the world of fashion for more than fifty years. After leaving Paris, he spent his last years at Igueldo, his private home in northern Spain, where he cooked his favorite dishes and received close friends. Shortly before his death, in 1972, he designed a bridal gown, for the duquesa de Cadiz – a final masterpiece. It was made by Felisa and Hosé Luis Molina in Madrid. When Balenciaga died, he was buried in the family mausoleum, on top of a hill in Guetaria, in the Basque country, with a dazzling view of the bay.

The numerous employees of Balenciaga in Paris, as well as those in Spain, had to adjust to the sudden change in their lives. There was no corporate sponsor or other designer to succeed him. But the seeds of his legacy had been sown, especially with Hubert de Givenchy:

> Balenciaga was a revelation to me, because he never chose the facile solution. In one of his ensembles with just a single seam in the middle of the back, the line was so pure, so clear, that it conveyed simplicity in its very perfection. When one realized that everything stemmed from the line of the body, that the fabrics themselves were vibrantly alive, simplicity became a form of great art. There was no element of subterfuge in Balenciaga. He had the most scrupulously honest attitude to his profession of any couturier I know.[7]

Givenchy's life was profoundly changed by meeting Balenciaga, as he has recounted above, and as has been discussed in the first chapter above. Many people consider Givenchy to be the heir to the Balenciaga legacy. It is true that Givenchy had many authentic Balenciaga designs passed on to him by Balenciaga himself, and later, by many of Balenciaga's former clients. It is also true that Givenchy was able to examine these couture garments closely and to refer to them as a source of influence. But the results of Givenchy's own prolific creativity did not

emerge as mere copying, or in the form of a contrived "homage" designed after a particular dress or suit. Instead, he respected the gift of having those precious objects on hand as familiar items that informed and inspired him for many years, much as the British nineteenth-century designer William Morris responded to the vast collection of illuminated manuscripts that he gathered around him. Givenchy's cherished Balenciaga collection could be equated to possessing a "piece of the true cross."

Subsequently, Givenchy has donated his personal collection to the Balenciaga Foundation and serves as the President of the Board. This museum appropriately preserves an important part of Balenciaga's legacy in the designer's native Guetaria. With this gift, Givenchy has made Balenciaga's work available to a greater public audience for posterity.

•

Other designers continued to emulate the work and make use of the lessons learned at the right hand of Cristóbal Balenciaga. André Courrèges and Emanuel Ungaro, who both spent many years first as tailor's assistants, then as tailors and designers at the House of Balenciaga, have always acknowledged his influence and remain in awe of his mastery. Known for decades for their own unique contributions to fashion since leaving Balenciaga, the work of these two designers is universally recognized for its quality of tailoring, beautiful craftsmanship, and attention to detail.

During the 1980s, fur designer Michael Mouratidis, whose business in Washington, D.C., served such exclusive clients as the Kennedy family and the wives of diplomats from around the globe, was engaged to spearhead the first American design firm to work with the House of Balenciaga. Mouratidis was an ardent admirer of Balenciaga. In a press release announcing the arrangement, he did not suppress his enthusiasm: "I have followed the Master all of my working life. For as long as I can remember, I have wanted to do with fur what Balenciaga did with cloth, to combine sophistication and simplicity in line and design, to flatter the feminine form as Balenciaga did. For me, Balenciaga was by far the greatest designer of the century."[8] According to his long-time assistant Helen Noumas, now of San Antonio, who is well acquainted with the Mouratidis furs made especially for Balenciaga, Paris, Mouratidis always emphasized the principle of balance in the construction of his elegant furs (fig. 119). Balance, proportion, and scale were all significant elements in the work of Balenciaga. The same press release from Mourtadis referred to above included an often-repeated quotation attributed to Balenciaga: "A designer must be an architect for the plans, a sculptor for the shape, a painter for the color, a musician for the overall harmony, and a philosopher for proportions."[9]

•

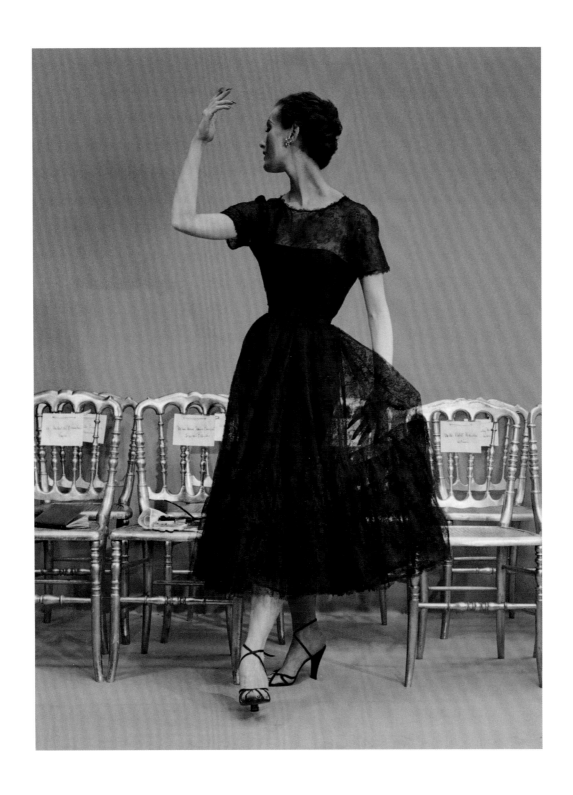

The career of Oscar de la Renta has an indisputable link with the Balenciaga legacy. Born in Santo Domingo, in the Dominican Republic, de la Renta was drawn as a young art student to study in Madrid. When he was inspired by fashion, the reputation of Balenciaga loomed as a very large presence. De la Renta soaked up Spanish culture and social graces, landing an early design opportunity to create a dress for a young debutante at the American embassy in Madrid. His creation appeared on the cover of *Life* magazine in 1956, when he was only twenty-four.[10]

One of the hallmarks of de la Renta's work that is closely associated with Balenciaga is his use of vivid color. The vibrant, sure color choices and beautiful fabrics selected by Balenciaga were always the impetus of ideas for his next collection. In Paris, Balenciaga did business with the manufacturers of some of the most exquisite specialty textiles produced in the twentieth century. These companies produced small runs and were always eager to show him new, experimental fabrics. Balenciaga inspired them and they, in turn, offered him their most prized creations. He was drawn to fabrics that had enough body to stand-up to his radical designs, but he did not want added weight. Gustav Zumsteg, of the Swiss textile firm, was one of the top suppliers who developed a close relationship with Balenciaga. Zumsteg created the famously expensive fabric known as "Gazar" exclusively for Balenciaga. Other notable firms were Ascher of London, which made mohairs, tweeds, and chenilles, and Staron and Bucol of France. Gorgeous laces came from Bataille, and, of course, the House of Lesage in Paris created embroidery samples for Balenciaga's perusal.[11]

This kind of attention to elegant, luxurious fabrics made a distinct impression on Oscar de la Renta. For decades, his work has concentrated on the sumptuous quality of couture. In a remarkable tribute to his talent, de la Renta became the designer for the House of Pierre Balmain in Paris in 1992, the first instance of an American designer occupying such a position at a French couture house. Famous international clients, such as Mercedes T. Bass, relish wearing clothes by de la Renta and appreciate his approach to the couture tradition.

In 1998, Nicolas Ghesquière unveiled his first collection for the House of Balenciaga. The Gucci Group, the current corporate owners, are gambling on Ghesquière's talent. For the moment, he is a fashion prince, the newly anointed heir to the Balenciaga throne. A recent article in *Women's Wear Daily* begs the question: "Balenciaga as a megabrand?"[12] Ghesquière is challenged by the conflicting desire to create haute couture and the pressure to design high-end ready-to-wear. Significant corporate investment is being directed toward the accessory market. All discussion in the press emphasizes strategic growth, volume sales, and product expansion. Such an approach marks a striking departure from the original business model of the House of Balenciaga.

While the artistic accomplishments of Cristóbal Balenciaga have not dimmed with time, even they are not immune to the realities of the modern business culture. Fashion has become an extremely competitive industry.

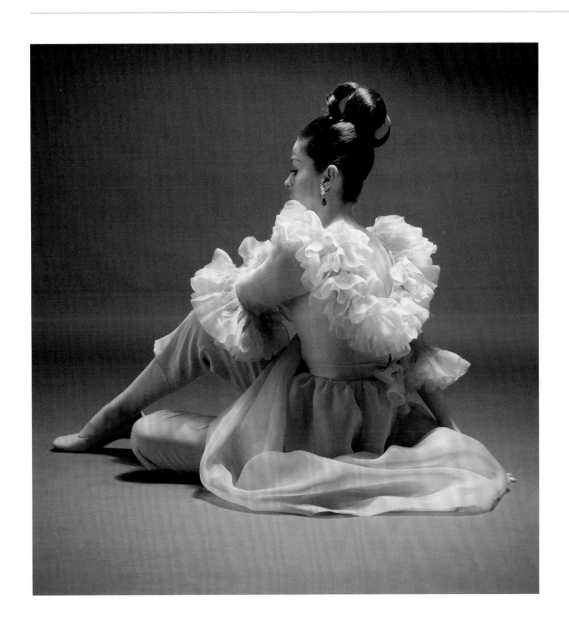

Most design houses are now owned by conglomerates. The business executives who run them expect every division to turn a profit, and they are typically unmoved by creative considerations. The aspirations of designers, therefore, are likely to meet with even greater resistance in the future. It remains for history to decide what ultimate shape Balenciaga's legacy will take.

1 Taryn Benbow-Pfalzgraf and Richard Martin, eds., *Contemporary Fashion* (London: St. James Press, 2002), 41.

2 Ibid., 37.

3 Ibid., 41.

4 Ibid.

5 Mme Florette Chelot, interview by the author, 7 March 2005.

6 Pamela Golbin, public lecture, Museum at the Fashion Institute of Technology, New York, 18 February 2006.

7 Paris-Musées, *Givenchy: 40 Years of Creation* (Paris: Paris-Musées, 1991), 26.

8 Press release from Balenciaga, Paris, June 1988, Texas Fashion Collection Archives.

9 Ibid.

10 Sarah Mower, *Oscar: The Style, Inspiration and Life of Oscar de la Renta* (New York: Assouline Publishing, Inc., 2002), 34.

11 Mme Marie-Andrée-Jouve, interview by the author, 7 March 2005.

12 Miles Socha, "Balenciaga in the Black, Now Goes for Growth," *Women's Wear Daily*, 28 February 2006, p. 10.

106. Hubert de Givenchy, c 1989.
Dress of beige wool with a suede belt.
Gift of Mercedes T. Bass.

107. Cristóbal Balenciaga, 1957.
Tunic dress of brown wool.
This dress appeared on the cover of
L'Official Paris in October 1957.
Gift of Bert de Winter.

108. André Courrèges, 1961.
Mini-dress of beige wool with long sleeves.
This dress was introduced in
Courrège's first collection after leaving the
House of Balenciaga.
Gift of Bert de Winter.

109 Emanuel Ungaro, c.1998.
Suit of black wool with pink silk lapels
and curved cuffs.
Gift of Mercedes T. Bass

110 Emanuel Ungaro, c.1969.
Mini-dress of navy and white with tailored
placket trimmed with bound button holes
and buttons. Worn by actress Lauren Bacall.
Gift of The Museum at FIT

111 André Courrèges, c.1966.
Mini-dress of white wool with round collar
and scalloped hem.
Gift of Bert de Winter.

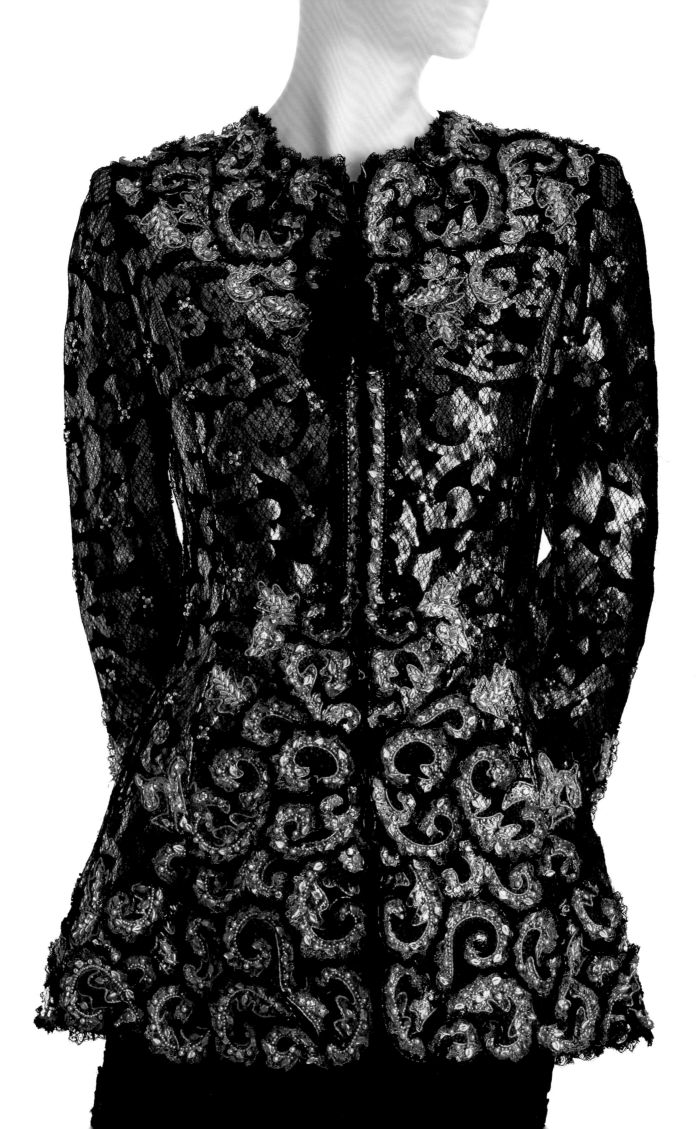

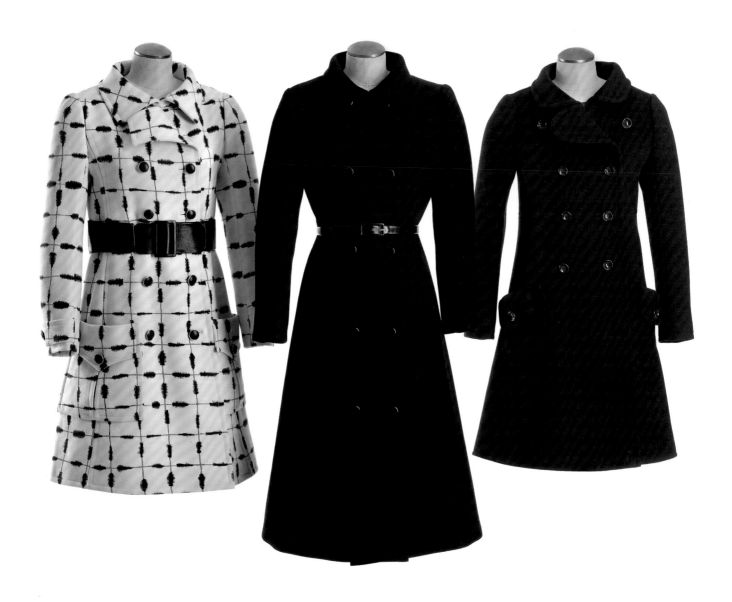

113 Emanuel Ungaro, c.1967.
Coat of brown and white wool with black belt.
Gift of Bert de Winter.

114 Cristóbal Balenciaga, c.1959.
Tailored coat of black wool in an A-line shape.
Gift of Claudia de Osborne.

115 Emanuel Ungaro, c.1968.
Coat of brown wool jersey with
round notch collar.
Gift of Mrs. Lois Monk Watson.

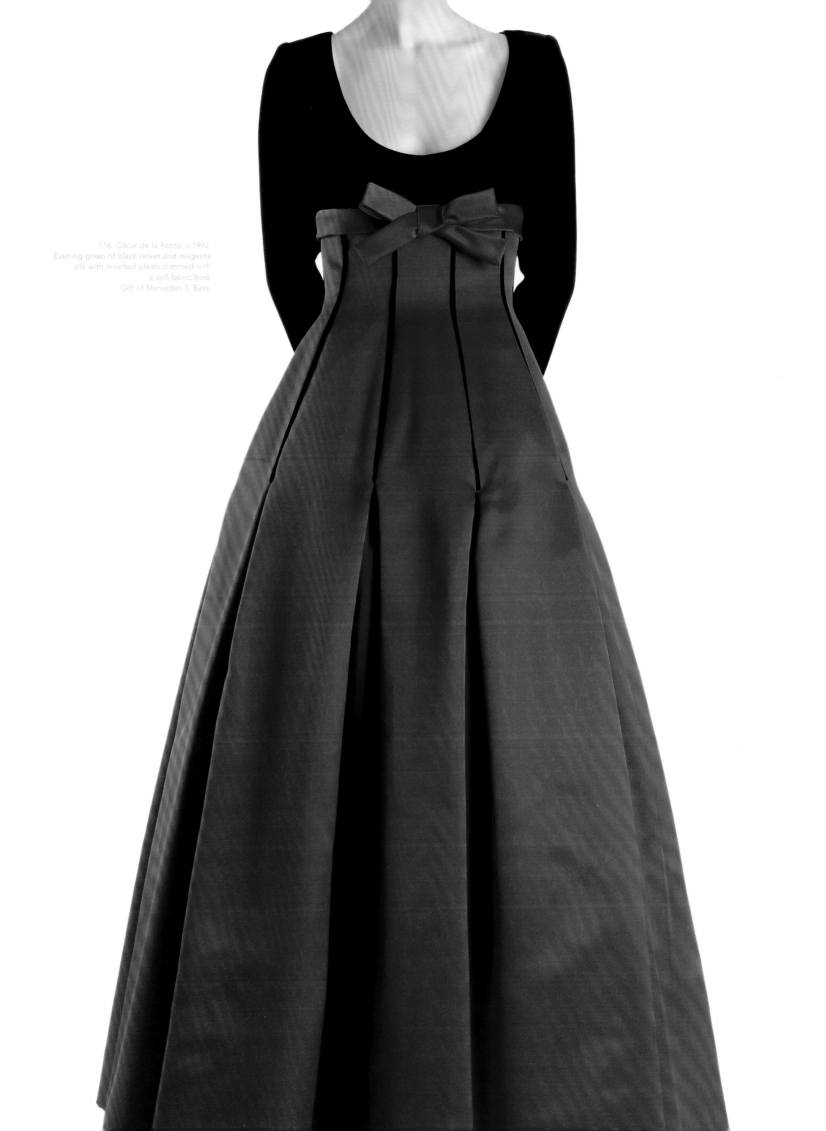

116 Oscar de la Renta, c.1992
Evening gown of black velvet and magenta
silk with inverted pleats trimmed with
a self-fabric bow.
Gift of Mercedes T. Bass

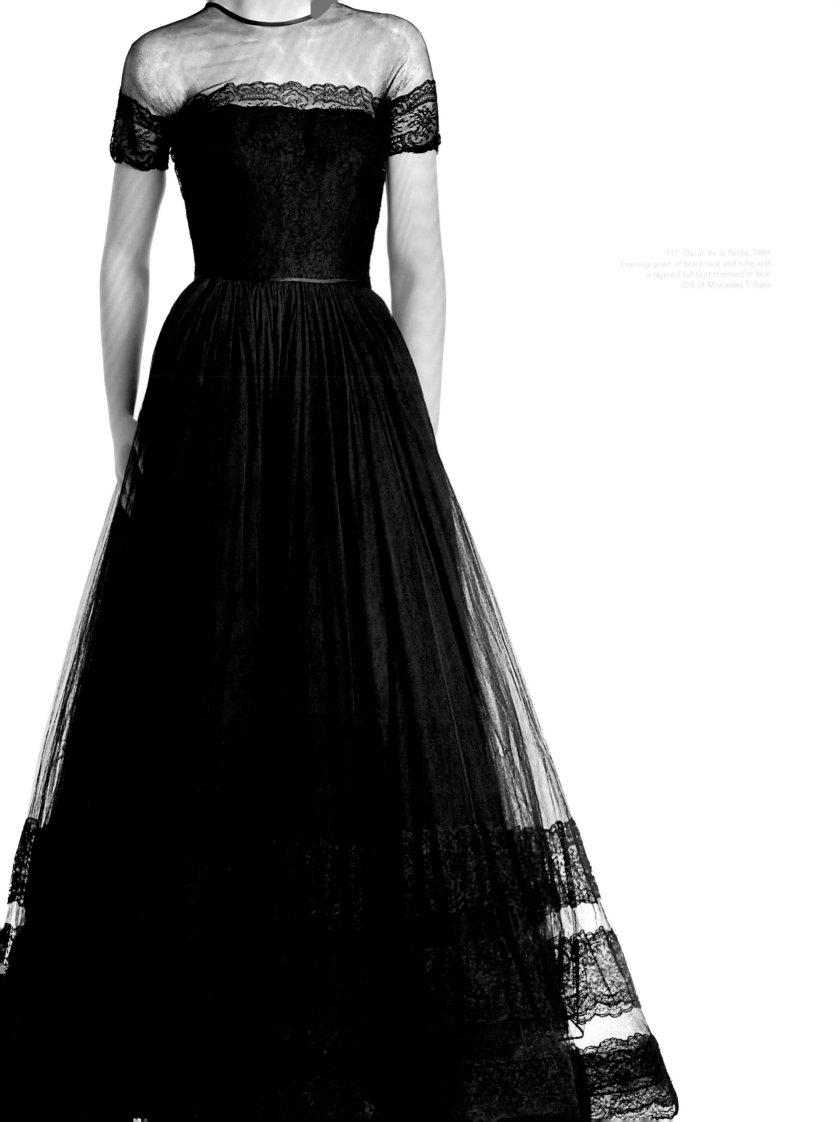

117 Oscar de la Renta, 1989.
Evening gown of black lace and tulle with
a layered full skirt trimmed in lace.
Gift of Mercedes T. Bass.

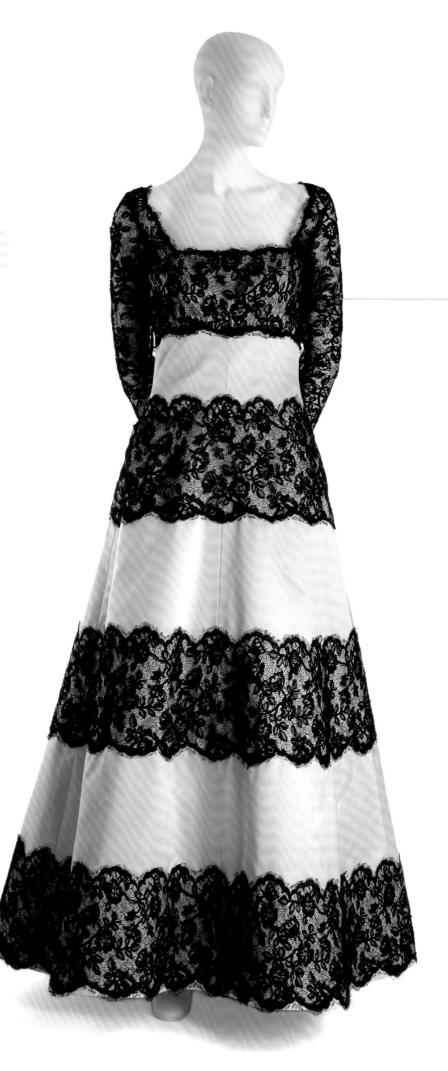

118. Oscar de la Renta, c.1990
Evening gown of black lace and cream satin
with a square neckline and full A-line skirt.
Gift of Mercedes T. Bass.

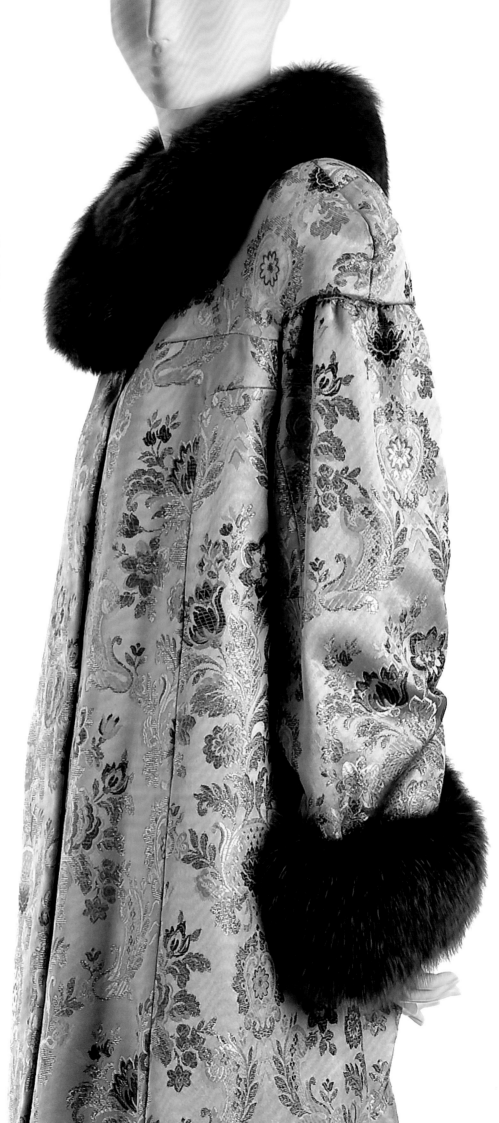

119 Michael Mouratidis, c.1989.
Evening coat of gold silk brocade trimmed
with purple fox fur.
Mouratidis Furs, Inc., of San Antonio, Texas,
became the only American company to be
licensed by Balenciaga, Paris, in the 1980s.
Gift of Helen Noumas.

SELECTED BIBLIOGRAPHY

Beaton, Cecil Walter Hardy. *Glass of Fashion*. Garden City, N.Y.: Doubleday, 1954.

Biddle, Margaret Thompson. "The Story of Balenciaga." *Woman's Home Companion*, November 1953, 37–39.

Benbow-Pfalzgraf, Taryn and Richard Martin, eds., *Contemporary Fashion*. 2nd ed. London: St. James Press, 2002.

Carter, Ernestine. *Magic Names of Fashion*. Englewood Cliffs, N.J.: Prentice–Hall, 1980.

Christie's. *Four Decades of High Fashion: The Wardrobe of the Late Mrs. Heard De Osborne*. London: Christie's South Kensington Ltd., 1994.

Dahl-Wolfe, Louise. *Louise Dahl-Wolfe*. New York: Harry N. Abrams, 2000.

Fairchild, John. *Chic Savages*. New York: Simon and Schuster, 1989.

Fundación Cristóbal Balenciaga Fundazioa. *Cristóbal Balenciaga and La Marquesa de Llanzol*. Getaria, Spain: Fundazioa-Fundación, 2004.

The Galleries at F.I.T. *Givenchy: 30 Years*. New York: The Fashion Institute of Technology, 1982.

Ginsburg, Madeline and Leslie Ginsburg." The Balenciaga Armada." *Harper's and Queen*, March 1980, 130–33.

Horyn, Cathy. "A Creative Jolt Just in from Paris." *New York Times*, 10 February 2002, national edition.

Howell, Georgina. *In Vogue: Sixty Years of Celebrities and Fashion from British Vogue*. New York: Penguin Books, 1978.

Howell, Georgina. "Gaga for Balenciaga." *Vanity Fair*, September, 1986, 118–21, 138.

Jouve, Marie-Andrée, ed. *Balenciaga*. Text by Jacqueline Demornex. Trans. Augusta Audubert. New York: Rizzoli International Publications, Inc., 1989.

Jouve, Marie-Andrée. *Balenciaga*. New York: Assouline Publishing, 2004.

Kerwin, Jessica. "A Stitch in Time." *W* Magazine, January 2006, 56.

Kirke, Betty. *Madeleine Vionnet*. San Francisco: Chronicle Books, 1998.

Klensch, Diana. "Balenciaga: Fashion Changer." *Vogue*, May 1973, 150–53.

Lynam, Ruth, ed. *Couture: An Illustrated History of the Great Paris Designers and Their Creations*. Garden City, N.Y., Doubleday, 1972.

Martin, Richard. "Balenciaga." *American Fabrics and Fashions*, September/October 1986, 25–28.

Martin, Richard, and Harold Koda. *Flair: Fashion Collected by Tina Chow*. New York: Rizzoli, 1992.

McColl, Patricia. "We are all his family." *Women's Wear Daily*, 27 March 1972, national edition.

The Metropolitan Museum of Art. *The World of Balenciaga*. New York: The Metropolitan Museum of Art, 1973.

Milbank, Caroline Rennolds. *Couture: The Great Designers*. New York: Stewart, Tabori, & Chang, 1985.

Miller, Lesley Ellis. *Cristóbal Balenciaga*. New York: Holmes and Meier Publishers, Inc., 1993.

Mona Bismarck Foundation. *Mona Bismarck, Cristóbal Balenciaga, Cecil Beaton*. Paris: Mona Bismarck Foundation, 1994.

Mower, Sarah. Oscar: *The Style, Inspiration and Life of Oscar De La Renta*. New York: Assouline Publishing, 2002.

Mulvagh, Jane. *Vogue History of 20th Century Fashion*. London and New York: Viking, 1988.

Musée Historique des Tissus de Lyon. *Hommage à Balenciaga*. Paris: Herscher, 1985.

Museo Nacional de Escultura. *Cristóbal Balenciaga*. Spain: Hemen Art, S.L.U., 2000.

"Nothing Left to Achieve, Balenciaga Calls It a Day." *New York Times*, 25 March 1972, obituaries.

Palacio de Bibliotecas y Museos. El Mundo de Balenciaga. *Barcelona: Productoras Nacionales de Fibras Artificiales y Sintéticas*, 1974.

Palmer, Alexandra. *Couture & Commerce: The Transatlantic Fashion Trade in the 1950s*. Vancouver, BC: The University of British Columbia Press in association with the Royal Ontario Museum, 2001.

Paris-Musées. *Givenchy: 40 years of Creation*. Paris: Paris–Musées, 1991.

Purdy, Daniel Leonhard, ed. *The Rise of Fashion: A Reader*. Minneapolis: University of Minnesota Press, 2004.

Sheppard, Eugenia. "The Master at the Museum." *New York Post*, 15 February 1973, national edition.

Snow, Carmel. *The World of Carmel Snow*. New York: McGraw–Hill Book Company, Inc., 1962.

Spindler, Amy M. "Keys to the Kingdom: A Fashion Fairy Tale wherein Nicolas Ghesquière finally inherits the Throne." *New York Times Magazine*, 14 April 2002, 52–57.

Troy, Nancy J. *Couture Culture: A Study in Modern Art and Fashion*. Cambridge, Mass.: MIT Press, 2003.

University of North Texas. "An Interview with Stanley Marcus." The Texas Fashion Collection, 1995, 10–11.

White, Palmer. *The Master Touch of Lesage: Embroidery for French Fashion*. Paris: Editions du Chêne, 1987.

"The King is Dead." *Women's Wear Daily*, 27 March 1972, biographies, national edition.

"They Remember Balenciaga." *Women's Wear Daily*, 27 March 1972, national edition.

EXHIBITION
Checklist and Acknowledgments

1 Cristóbal Balenciaga, 1957 (fig. 83)
Day dress with a tie sash and matching jacket of purple mohair.
Label: Neiman Marcus
Gift of Bert de Winter,1962 (TFC 1900.259.001)

2 Cristóbal Balenciaga, 1953 (fig. 80)
Three- piece suit of brown felted wool with a sleeveless weskit; jacket with a shawl collar and a matching straight skirt.
Label: Balenciaga, 10 Avenue George V Paris
Gift of Bert de Winter,1961 (TFC 1900.260.001)

3 Cristóbal Balenciaga, c.1954 (fig. 81)
Suit of grey wool with a charcoal wool skirt.
Label: Balenciaga, 10 Avenue George V Paris
Gift of Bert de Winter in 1961 (TFC 1900.264.001)

4 Cristóbal Balenciaga, c.1954 (fig. 84)
Three-piece suit of brown wool tweed with a sleeveless weskit; jacket and skirt trimmed with matching buttons.
Label: Made in France
Gift of Neiman Marcus, 1961 (TFC 1900.265.001)

5 Cristóbal Balenciaga, 1950 (fig. 71)
Suit of grey moiré satin with a fitted jacket.
Label: Neiman Marcus
Gift of Neiman Marcus, 1961 (TFC 1900.412.001)

6 Cristóbal Balenciaga, 1956 (figs. 69, 70)
Evening dress of ivory satin and dotted tulle net with ivory satin bow.
Label: Balenciaga, 10 Avenue George V Paris
Gift of Bert de Winter, 1963.(TFC 1900.436.001)

7 Cristóbal Balenciaga, 1955 (figs. 67, 68)
Evening ensemble of cream, pink, and blue watered silk with a sleeveless tunic over a skirt with a gathered train.
No label
Gift of Neiman Marcus, 1962 (TFC 1900.437.001)

8 Cristóbal Balenciaga, 1957 (not illustrated)
Cocktail dress of black silk faille with a balloon skirt over a straight underskirt.
No label
Gift of Bert de Winter, 1962 (TFC 1900.438.001)

9 Cristóbal Balenciaga, 1955 (fig. 21)
Evening gown of white tulle net.
Strapless tunic over layered net petticoats with floral motif embroidery by Lesage.
Label: Balenciaga, 10 Avenue George V Paris
Gift of Bert de Winter,1962 (TFC 1900.490.001)

10 Cristóbal Balenciaga, 1958 (fig. 77)
Cocktail dress of black silk brocade with a bateau neckline.
Label: Balenciaga, 10 Avenue George V Paris
Gift of Bert de Winter,1962 (TFC 1900.815.001)

11 Cristóbal Balenciaga, 1959 (fig. 86)
Three-piece suit of black and beige herringbone tweed; jacket trimmed with a double row of bone buttons; bodice of black wool.
Label: Balenciaga, 10 Avenue George V Paris
Gift of Bert de Winter, 1962 (TFC 1965.007.005)

12 Cristóbal Balenciaga, 1957 (fig. 85)
 Dress and jacket of oatmeal wool tweed with a fabric
 sash belt at waist.
 Label: Balenciaga, 10 Avenue George V Paris
 Gift of Bert de Winter,1965 (TFC 1965.043.015)

13 Cristóbal Balenciaga, 1960 (fig. 96)
 Evening dress of turquoise silk gazar with a billowing
 full skirt. Fabric by Abraham.
 Label: Balenciaga, 10 Avenue George V. Paris
 Gift of Bert de Winter, 1966 (TFC 1965.043.090)

14 Cristóbal Balenciaga, 1957 (fig. 7)
 Dinner dress of black wool with matching bolero
 jacket with a jeweled button.
 Label: Balenciaga, 10 Avenue George V Paris
 Gift of Bert de Winter, 1966 (TFC 1966.050.001)

15 Cristóbal Balenciaga, c.1959 (fig. 78)
 Cocktail dress of fuchsia pink silk brocade with
 a draped bustle.
 No label
 Gift of Bert de Winter,1966 (TFC 1966.050.003)

16 Cristóbal Balenciaga, 1958 (fig. 82)
 Day dress of light blue wool bouclé with a sash belt;
 matching jacket of light blue wool bouclé.
 Label: Balenciaga 10 Avenue George V Paris;
 Neiman Marcus
 Gift of Bert de Winter,1966 (TFC 1966.050.004)

17 Cristóbal Balenciaga, c.1960 (fig. 19)
 Evening gown of gold silk satin in a floral motif with a
 gold stole; trimmed at bodice and waist with rhinestone.
 embroidery by Rébé.
 No label
 Gift of Bert de Winter, 1966 (TFC 1966.050.015)

18 Cristóbal Balenciaga, 1965 (fig. 79)
 Evening gown of blue silk gazar with a blue feather boa.
 Label: Balenciaga, 10 Avenue George V Paris (Made in
 France).
 Gift of Bert de Winter, 1968 (TFC 1968.049.002)

19 Cristóbal Balenciaga, c.1961 (fig. 23)
 Evening ensemble of pink taffeta tunic with a long skirt
 and matching gathered cape.
 Tunic embroidery of vinyl, chenille and rhinestones
 by Lesage.
 Label: Made in France
 Gift of Bert de Winter,1969 (TFC 1969.049.003)

20 Cristóbal Balenciaga, 1953 (fig. 101)
 Cocktail dress of fuchsia silk with a black feather motif.
 Label: Balenciaga, 10 Avenue George V Paris
 Estate of Bert de Winter, 1972 (TFC 1973.001.016)

21 Cristóbal Balenciaga, 1958 (not illustrated)
 Cocktail dress of black lace with pink satin sash.
 Label: Balenciaga, 10 Avenue George V Paris
 Estate of Bert de Winter, 1972 (TFC 1973.001.040)

22 Cristóbal Balenciaga, 1958 (fig. 74)
 Evening ensemble of gold brocade with white mink trim
 and detachable train with matching evening coat.
 Label: Balenciaga, 10 Avenue George V Paris
 Estate of Bert de Winter, 1972 (TFC 1973.001.043)

23 Cristóbal Balenciaga, 1959 (fig. 4)
 Dinner dress of silk taffeta floral print;
 Matching bolero jacket (not shown).
 Label: Balenciaga, 10 Avenue George V Paris
 Estate of Bert de Winter, 1972 (TFC 1973.001.053)

24 Cristóbal Balenciaga, 1957 (fig. 107)
Tunic dress of brown wool
Label: Balenciaga, 10 Avenue George V Paris
Estate of Bert de Winter, 1972
(TFC 1973.001.058)

25 Cristóbal Balenciaga, c.1958 (figs. 34, 35)
Evening gown of pale pink tulle; sash and stole with
floral motif embroidery by Lesage.
No label
Gift of Claudia de Osborne (TFC 1975.003.002)

26 Cristóbal Balenciaga, Winter 1965 (fig. 49)
Evening dress of fuchsia silk crepe and feather boa.
Label: Eisa
Gift of Claudia de Osborne (TFC 1975.003.003)

27 Cristóbal Balenciaga, Winter 1956 (figs. 31, 42)
Evening dress of white cotton lace with a tobacco
overskirt and matching silk gloves.
No label
Gift of Claudia de Osborne (TFC 1975.003.005)

28 Cristóbal Balenciaga, 1966 (fig. 13)
Tunic-style short evening dress of embroidered
silver fabric.
Label: Eisa
Gift of Claudia de Osborne (TFC1975.003.008)

29 Cristóbal Balenciaga, Winter 1963 (not illustrated)
Evening gown of black brocaded net with beads.
Label: Eisa
Gift of Claudia de Osborne (TFC1975.003.009)

30 Cristóbal Balenciaga, c.1964 (fig. 25)
Evening dress of black silk crepe with silver embroidery,
attributed to Rébé.
No label
Gift of Claudia de Osborne (TFC 1975.003.010)

31 Cristóbal Balenciaga, c.1965 (fig. 48)
Ensemble of dress and matching coat of green and black
in a textured motif. Fabric attributed to Abraham.
Label: Eisa.
Gift of Claudia de Osborne (TFC 1975.003.013)

32 Cristóbal Balenciaga, 1954 (fig. 98)
Dress of black lace with oversized collar trimmed with
fringe.
No label
Gift of Claudia de Osborne (TFC 1975.003.016)

33 Cristóbal Balenciaga, 1962 (fig. 47)
Ensemble of black silk damask. A sleeveless tunic dress
over an underskirt with a matching double-breasted coat,
similar to Givenchy's ensemble for Audrey Hepburn.
Label: Eisa
Gift of Claudia de Osborne (TFC 1975.003.020)

34 Cristóbal Balenciaga, c.1953 (fig. 41)
Evening ensemble of cocktail dress of brown ribbon lace
and a brown silk cape.
Label: Eisa
Gift of Claudia de Osborne (TFC 1975.003.021)

35 Cristóbal Balenciaga, 1958 (figs. 44, 45)
Baby-doll dress of champagne lace with short
cap sleeves.
No label
Gift of Claudia de Osborne (TFC 1975.003.023)

36 Cristóbal Balenciaga, c.1967 (fig. 51)
Pantsuit of a tan and cream striped wool jacket with brown faux fur pants.
No label
Gift of Claudia de Osborne (TFC 1975.003.026)

37 Cristóbal Balenciaga, c.1967 (not illustrated)
Blue shorts, cape, and socks with pink vest.
Label: Balenciaga, 10 Avenue George V Paris
Gift of Claudia de Osborne (TFC 1975.003.036)

38 Cristóbal Balenciaga, 1967 (fig. 52)
Suit of black and cream windowpane plaid wool.
Label: Eisa
Gift of Claudia de Osborne (TFC 1975.003.037)

39 Cristóbal Balenciaga, 1968 (fig. 53)
Short pantsuit with red and cream plaid wool jacket over red cotton jumpsuit.
Label: Eisa
Gift of Claudia de Osborne (TFC 1975.003.049)

40 Cristóbal Balenciaga, c.1956 (fig. 99)
Evening dress of red ribbon lace with red taffeta bustle and train.
Label: Eisa
Gift of Mrs. James S. Billups (TFC 1976.014.003)

41 Cristóbal Balenciaga, c.1957 (fig. 33)
Suit of charcoal grey wool with a fitted jacket.
No label
Gift of Claudia de Osborne (TFC 1977.017.002)

42 Cristóbal Balenciaga, c.1956 (fig. 46)
Evening dress of black ribbon lace and silk taffeta with a balloon pouf skirt.
Label: Eisa
Gift of Claudia de Osborne (TFC 1977.017.053)

43 Cristóbal Balenciaga, c.1959 (not illustrated)
Dress with sash and bolero jacket of black wool.
Label: Eisa
Gift of Mrs. James S. Billups (TFC 1977.018.006)

44 Cristóbal Balenciaga, 1967 (fig. 50)
Pantsuit of a silver metallic coat with black wool pants.
No label
Gift of Claudia de Osborne (TFC 1978.013.008)

45 Cristóbal Balenciaga, Winter 1967 (fig. 17)
Evening gown of white silk with a sleeveless coat of red silk gazar and jeweled brooch by Robert Goossens of Paris.
Label: Balenciaga, 10 Avenue George V Paris
Gift of Claudia de Osborne (TFC 1978.017.017)

46 Cristóbal Balenciaga, c.1967 (fig. 18)
Evening gown of black silk "Ziberline" with black mink trim.
Label: Balenciaga, 10 Avenue George V Paris
Gift of Claudia de Osborne (TFC 1978.013.013)

47 Cristóbal Balenciaga, 1967 (fig. 22)
Evening gown of black velvet with beaded embroidery attributed to Lisbeth.
No label
Gift of Claudia de Osborne (TFC 1978.013.014)

48 Cristóbal Balenciaga, c.1964 (fig. 16)
Evening gown of black velvet with a bustle trimmed in ermine tails.
Label: Balenciaga, 10 Avenue George V Paris
Gift of Claudia de Osborne (TFC 1978.013.015)

49 Cristóbal Balenciaga, 1960 (fig. 37)
Evening coat of black silk faille with gathered yoke, full sleeves and large front pockets.
No label
Gift of Claudia de Osborne (TFC 1979.011.010)

50 Cristóbal Balenciaga, 1953 (fig. 36)
 Evening gown of black wool with silk taffeta gathered
 skirt and matching stole.
 Label: Balenciaga, 10 Avenue George V Paris
 Gift of Claudia de Osborne (TFC 1979.011.018)

51 Cristóbal Balenciaga, 1967 (figs. 92, 100)
 Strapless baby doll evening dress of black lace and silk
 faille with lace garters.
 No label
 Gift of Claudia de Osborne (TFC 1979.011.021)

52 Cristóbal Balenciaga, c.1960 (fig. 24)
 Evening gown of black and white silk taffeta with
 embroidery, attributed to Rébé.
 No label
 Gift of Claudia de Osborne (TFC 1980.014.001)

53 Cristóbal Balenciaga, 1956 (fig. 94)
 Evening coat of black silk faille with exaggerated shawl
 collar and circular cut.
 Label: Balenciaga, 10 Avenue George V Paris
 Gift of Claudia de Osborne (TFC 1980.014.011)

54 Cristóbal Balenciaga, c.1952 (fig. 38)
 Evening dress of tiered black lace ruffles
 Label: Balenciaga, 10 Avenue George V Paris
 Gift of Claudia de Osborne (TFC 1981.022.001)

55 Cristóbal Balenciaga, 1954 (fig. 20)
 Evening gown of red velvet with pearl embroidery by
 Lisbeth.
 Label: Eisa
 Gift of Claudia de Osborne (TFC 1981.022.003)

56 Cristóbal Balenciaga, 1955 (figs. 27, 28, 29)
 Ball gown of cerise silk taffeta and white lace with a
 crinoline hoop petticoat.
 No label
 Gift of Claudia de Osborne (TFC 1981.022.014)

57 Cristóbal Balenciaga, c.1957 (fig. 95)
 Evening dress of red and white floral print tissue silk with
 a balloon hem.
 Label: Eisa
 Gift of Mrs. Dewitt Ray for Mrs. Malcolm Wilson
 (TFC 1982.018.001)

58 Cristóbal Balenciaga, 1956 (fig. 43)
 Evening dress of white taffeta in a red carnation print
 with a harem-style pouf skirt.
 No label.
 Gift of Claudia de Osborne (TFC 1982.028.001)

59 Cristóbal Balenciaga, c.1960 (fig. 97)
 Evening cape of double-faced pale pink silk gazar
 constructed with only two seams at the shoulders.
 No label
 Gift of Claudia de Osborne (TFC 1982.028.004)

60 Cristóbal Balenciaga, c.1959 (fig. 114)
 Tailored coat of black wool in an A-line shape.
 No label
 Gift of Claudia de Osborne (TFC 1982.028.010)

61 Cristóbal Balenciaga, 1956 (fig. 87)
 Dress and jacket of charcoal gray tweed with a short
 jacket and a matching sash.
 Label: Balenciaga, 10 Avenue George V Paris
 Gift of Jimmie Henslee (TFC 1993.001.003)

62 Cristóbal Balenciaga, *c.*1958 (not illustrated)
Cocktail dress of black crepe wool. Strapless with
a deep ruffle at hem.
Gift of Del Frnka (TFC 1983.011.003)

63 Hubert de Givenchy, *c.*1972 (not illustrated)
Ensemble of "stained glass" printed silk dress with
matching coat, hat and shoes of silk gazar. This ensemble
was created for Claudia to wear to the wedding of
General Franco's granddaughter.
Label: Givenchy
Gift of Claudia de Osborne (TFC 1978.013.053)

64 Hubert de Givenchy, *c.*1970 (fig. 9)
Tunic top of pink mink with black satin knickers and a
black ribbon sash.
Label: Givenchy
Gift of Claudia de Osborne (TFC 1978.013.054)

65 Hubert de Givenchy, *c.*1972 (fig. 10)
Coat dress of black gazar with red and white dots worn
over a sleeveless black dress, fabric by Abraham.
Label: Givenchy
Gift of Claudia de Osborne (TFC 1979.011.050)

66 Hubert de Givenchy, *c.*1959 (fig. 8)
Evening jacket of embroidered flowers with chenille trim,
embroidery by Lesage.
Label: Givenchy
Gift of Julie Benell (TFC 1980.007.001)

67 Hubert de Givenchy, *c.*1989 (fig. 5)
Evening dress and jacket of gold ikat silk with jeweled
embroidery.
Label: Givenchy
Gift of Mercedes T. Bass (TFC 1993.007.071)

68 Hubert de Givenchy, 1963 (fig. 6)
Ensemble of black silk damask with tunic dress, under-
skirt, and matching double-breasted jacket.
Label: Givenchy
Gift of Mr. Hubert de Givenchy in honor of Ms. Audrey
Hepburn (TFC 1995.006.001)

69 Hubert de Givenchy, *c.*1989 (fig. 106)
Dress of beige wool with a suede belt.
Label: Givenchy
Gift of Mercedes T. Bass (TFC 2002.003.046)

70 Oscar de la Renta, *c.*1990 (not illustrated)
Dress of black silk and velvet with braid and tassels.
Label: Oscar de la Renta
Gift of Mercedes T. Bass (TFC 1996.013.014)

71 Oscar de la Renta, 1989 (fig. 117)
Evening gown of black lace and tulle with a layered full
skirt trimmed in lace.
Label: Oscar de la Renta
Gift of Mercedes T. Bass (TFC 1993.007.136)

72 Oscar de la Renta, *c.*1990 (fig. 105)
Evening dress with a black velvet bodice and a skirt of
vertical panels of gold and brown silk trimmed in velvet.
Label: Oscar de la Renta
Gift of Mercedes T. Bass (TFC 1993.007.113)

73 Oscar de la Renta, *c.*1990 (fig. 118)
Evening gown of black lace and cream satin with a
square neckline and full A-line skirt.
Label: Oscar de la Renta
Gift of Mercedes T. Bass (TFC 1993.007.116)

74 Oscar de la Renta, *c.*1992 (fig. 116)
Evening gown of black velvet and magenta silk with
inverted pleats trimmed with a self-fabric bow.
Label: Oscar de la Renta
Gift of Mercedes T. Bass (TFC 1995.012.001)

75 Oscar de la Renta, *c.*1993 (fig. 112)
Evening jacket of black net with holographic appliqués,
lace and beaded embroidery by Lesage.
Label: Pierre Balmain, Paris
Gift of Mercedes T. Bass (TFC 1996.013.004)

76 Emanuel Ungaro, *c.*1967 (fig. 113)
Coat of brown and white wool with black belt.
No label
Gift of Bert de Winter (TFC 1969.049.009)

77 André Courrèges, 1966 (fig. 111)
Mini-dress of white wool with round collar and scalloped
hem.
Label: Courrèges Paris
Gift of Bert de Winter (TFC 1969.049.011)

78 André Courrèges, 1961 (fig. 108)
Mini-dress of beige wool with long sleeves.
Label: Courrèges Paris
Gift of Bert de Winter (TFC 1969.049.013)

79 Emanuel Ungaro, *c.*1969 (fig. 110)
Mini-dress of navy and white with tailored placket
trimmed with bound button holes and buttons.
Label: Couture Paris, Emanuel Ungaro
Gift of Museum at FIT (TFC 1977.014.030)

80 Emanuel Ungaro, *c.*1989 (not illustrated)
Dress of black silk gazar with detachable bow.
Label: Couture Paris, Emanuel Ungaro
Gift of Bert de Winter (TFC 1995.019.003)

81 Emanuel Ungaro, *c.*1968 (fig. 115)
Coat of brown wool jersey with round notch collar.
Label: Emanuel Ungaro Parallèle; Made in Italy for
Bonwit Teller
Gift of Mrs. Lois Monk Watson (TFC 2001.014.004)

82 Emanuel Ungaro, *c.*1998 (fig. 109)
Suit of black wool with pink silk lapels and curved cuffs
Label: Emanuel Ungaro
Gift of Mercedes T. Bass (TFC 2005.008.037)

83 Michael Mouratidis, *c.*1989 (fig. 119)
Evening coat of gold silk brocade trimmed with purple
fox fur.
Label: Mouratidis Furs
Gift of Helen Noumas (TFC 2005.010.007)

84 Nicolas Ghesquière, Spring 2006 (not illustrated)
Cocktail dress of white silk taffeta.
Label: Balenciaga Paris
Courtesy of Heidi Dillon (T2006.001)

Shoes

85 Salvatore Ferragamo, 1962
Pumps of fuchsia silk with embroidery.
Gift of Claudia de Osborne (TFC 1975.003.003)

86 Salvatore Ferragamo, date unknown
Heels of black silk with beaded vamp and sides
Label: Salvatore Ferragamo
Gift of Claudia de Osborne (TFC 1978.013.067)

87 Roger Vivier, date unknown
Heels of fuchsia silk with bow on vamp.
Label: Roger Vivier
Gift of Claudia de Osborne (TFC 1978.013.069)

88 Roger Vivier, 1972
Heels with "stained glass" print & ankle strap.
Label: Roger Vivier
Gift of Claudia de Osborne (TFC 1978.013.082)

89 Herbert Levine (Neiman Marcus), c.1962
Ankle boots of black velvet with fur trim at top.
Label: Herbert Levine Neiman Marcus
Gift of Claudia de Osborne (TFC 1979.011.062)

90 Roger Vivier, c.1965
Boots of black silk with ribbon lacing in front.
Label: Roger Vivier
Gift of Claudia de Osborne (TFC 1979.011.063)

91 Roger Vivier, c.1972
Heels of black with red and white dots.
Label: Roger Vivier
Gift of Claudia de Osborne (TFC 1979.011.076)

92 Roger Vivier, c.1960
Pumps of black silk with bow on vamp.
Label: Roger Vivier
Gift of Claudia de Osborne (TFC 1979.011.079)

Hats

93 Cristóbal Balenciaga, 1956 (fig. 76)
Toque hat of magenta silk leaves and net.
Label: Balenciaga, 10 Avenue George V Paris
Gift of Adele Simpson (TFC 1900.874.001)

94 Cristóbal Balenciaga, c.1960 (fig. 56)
Hat of black satin trimmed with black coq feathers and
black satin ribbon.
Label: Balenciaga, 10 Avenue George V Paris
Gift of Claudia de Osborne (TFC 1977.017.005)

95 Cristóbal Balenciaga, c.1962 (fig. 55)
Hat of black satin trimmed with black feathers and a
fabric bow.
No label
Gift of Claudia de Osborne (TFC 1977.017.044)

96 Cristóbal Balenciaga, 1962 (not illustrated)
Hat of black silk chiffon with conical draped back.
No label
Gift of Claudia de Osborne (TFC 1977.017.049)

97 Cristóbal Balenciaga, c.1960 (fig. 15)
Pillbox hat draped with a pink and black dotted silk scarf.
No label
Gift of Claudia de Osborne (TFC 1977.017.054)

98 Cristóbal Balenciaga, c.1963 (fig. 61)
Hat of green satin covered with green feathers with a
jeweled brooch.
No label
Gift of Claudia de Osborne (TFC 1978.013.018)

99 Cristóbal Balenciaga, c.1963 (fig. 61)
Hat of pink satin covered with pink feathers and a
rhinestone brooch.
No label
Gift of Claudia de Osborne (TFC 1978.013.021)

100 Cristóbal Balenciaga, *c.*1960 (fig. 63)
Pillbox hat covered in magenta silk flowers.
Label: Eisa
Gift of Claudia de Osborne (TFC 1978.013.022)

101 Cristóbal Balenciaga, *c.*1964 (fig. 93)
Hat of black satin with beads and sequins.
No label
Gift of Claudia de Osborne (TFC 1978.013.023)

102 Cristóbal Balenciaga, *c.*1960 (fig. 60)
Hat of brown velvet with gold jeweled brooch by Robert
Goossens of Paris.
Label: Eisa
Gift of Claudia de Osborne (TFC 1978.013.028)

103 Cristóbal Balenciaga, *c.*1960 (fig. 65)
Hat of leopard fur with a curved brim and black leather
hatband.
No label
Gift of Claudia de Osborne (TFC 1979.011.025)

104 Cristóbal Balenciaga, 1965 (fig. 66)
Large brimmed hat of natural straw trimmed with white
organza sash at crown.
No label
Gift of Claudia de Osborne (TFC 1979.011.028)

105 Cristóbal Balenciaga, 1960 (fig. 57)
Derby of green velvet trimmed with mixed feathers.
No label
Gift of Claudia de Osborne (TFC 1979.011.031)

106 Cristóbal Balenciaga, *c.*1960 (fig. 59)
Hat of black velvet with a jeweled brooch attributed to
Robert Goossens of Paris.
No label
Gift of Claudia de Osborne (TFC 1979.011.037)

107 Cristóbal Balenciaga, 1955 (fig. 54)
Pillbox hat of purple silk satin with large bow loops.
No label
Gift of Claudia de Osborne (TFC 1980.014.016)

108 Cristóbal Balenciaga, *c.*1960 (fig. 66)
Pillbox hat of white organdy trimmed with a large
fabric bow.
No label
Gift of Claudia de Osborne (TFC 1980.014.017)

109 Cristóbal Balenciaga, 1962 (fig. 58)
Pillbox hat of black satin; black feathers on right.
No label
Gift of Claudia de Osborne (TFC 1980.014.031)

110 Cristóbal Balenciaga, 1962 (fig. 64)
Pillbox hat of black satin trimmed with green feathers.
No label
Gift of Claudia de Osborne (TFC 1980.014.032)

111 Cristóbal Balenciaga, *c.*1955 (fig. 62)
"Bird of Paradise" hat of black silk net and
black feathers.
No label
Gift of Claudia de Osborne (TFC 1981.022.026)

112 Cristóbal Balenciaga, *c.*1960 (fig. 14)
Hat of black velvet trimmed with white feathers and a
jeweled pendant, attributed to Robert Goossens of
Paris
Label: Balenciaga, 10 Avenue George V Paris
Gift of Claudia de Osborne (TFC 1982.028.012)

113 Cristóbal Balenciaga, *c.*1960 (fig. 75)
Bowler hat of pink stitched wool trimmed with a small
black bow.
Label: Balenciaga, 10 Avenue George V Paris
Gift of Mrs. Lee Hudson (TFC 1990.003.009)

Acknowledgments

All loan objects included in the checklist above are from the
Texas Fashion Collection, School of Visual Arts, University of North Texas, www.tfc.unt.edu

We extend special recognition to First Lady Laura Bush for her loan of an Oscar de la Renta
evening gown to the Meadows Museum of Art

Thanks are owed to the following:

Mary Durio and Edward Hoyenski of the University of North Texas Rare Books Collection

The Balenciaga Archives, Paris, for permission to use images in the exhibition

The SMU DeGolyer Library staff for their assistance with research and photographs
 loaned to the Meadows Museum of Art

Photographer Neal Barr of California graciously lent his work to the exhibition

Fashion photographs by Henry Clarke, Louise Dahl-Wolfe and Frances McLaughlin-Gill
in the exhibition are courtesy of Staley-Wise Gallery, 560 Broadway, New York, New York 10012
www.staleywise.com

Other selected photographs are courtesy of the Center for Creative Photography,
The University of Arizona, 1030 North Olive Road, P.O. Box 210103,
Tucson, AZ 85721-0103

THE HOUSE OF BALENCIAGA
chronology

1895	Cristóbal Balenciaga is born 21 January in Guetaria, Spain, to José and Martina.
1912	A young Balenciaga hones his tailoring skills, becoming chief tailor in a dressmaking establishment called the "Lourve" in San Sebastián.
1919	Balenciaga formally establishes his first couture house in San Sebastián under the name of "Balenciaga y Compañia" with the Lizaso sisters, Benita and Daniela; the business is renamed "Cristóbal Balenciaga" after a brief period of reorganization, then later reopens as "Eisa."
1933	Balenciaga opens a second location in Madrid, also named "Eisa."
1935	Balenciaga introduces a third Eisa atelier located at Sant Teresa 10, in Barcelona.
1937	Balenciaga establishes the House of Balenciaga in Paris at 10, avenue George V, in collaboration with two business partners, Nicolas Bizcarrondo and Vladzio d'Attainville; Balenciaga presents his first Winter collection in August which generates immediate acclaim.
1938	Balenciaga begins to sell to American and British department stores and private dressmakers; new couture houses are opened in Barcelona and Madrid.
1938–39	The first known Balenciaga advertisements to be widely published appear in French *Vogue* in July 1938 and March 1939.
1940–45	The House of Balenciaga closes at the beginning of World War II; Balenciaga reopens to operate in a limited capacity in order to protect his premises from being conscripted by the Germans and to secure work for his employees.
1947	Launch of the first perfume, "Le Dix."
1948	Launch of a new perfume, "La Fuite des Heures" ("Fleeting Moment").
1955	Launch of a new perfume, "Quadrille."
1950–60	Balenciaga ascends to the top of the international fashion world, where he reigns as the "King of Fashion" throughout the entire decade; by the early sixties, *prêt-à-porter* (ready-to-wear) collections emerge to challenge the establishment of haute couture.
1962	Balenciaga steadfastly continues to innovate and please a loyal international clientèle but refuses to cede to pressure to create for the *prêt-à-porter* market.
1968	Balenciaga presents his last collection in the spring of 1968; the retirement of Balenciaga is announced after the Summer collections; the houses in Paris and Barcelona are closed, but the perfumes remain in production.

1969	The house in Madrid closes.
1978	Hoechste purchases Balenciaga from the nephews and nieces of the founder.
1986	The House of Balenciaga is bought by the perfume group Jacques Bogart and relaunched under the management of Jacques and Régine Konckier.
1987	French designer Michel Goma creates the first Balenciaga ready-to-wear collection entitled "Le Dix."
1987	Mouratidis Furs becomes the first American company to be licensed by Balenciaga Paris.
1988	"Rumba," the first Bogart/Balenciaga perfume is introduced.
1989	The first Balenciaga boutique in Tokyo opens.
1990	Launch of men's fragrance "Balenciaga pour Homme." Japan and Southeast Asia represent 65% of all Balenciaga accessory sales.
1992	Dutch designer Josephus Melchior Thimister takes over in 1992 for a five-year tenure.
1995	French designer Nicolas Ghesquière is hired by the Jacques Bogart Group to design for Japanese licenses held by the company.
1997	Ghesquière debuts under the Balenciaga label for the Spring/Summer 1998 season.
2001	Gucci Group purchases the Balenciaga label.
2002	Ghesquière introduces first menswear line for Fall 2002.
2003	A Balenciaga boutique is opened in New York on 22nd Street; flagship boutique at 10, avenue George V is renovated.
2004	Ghesquière revives select designs from the Balenciaga archives through the line Balenciaga Edition.
2007	Ghesquière continues to make his mark on the fashion world at the House of Balenciaga: his emphasis on accessories and his stylistic appeal to a younger fashion audience is reinforced with an elite group of designs for the ready-to-wear market.